FIFTY PLACES TO TRAVEL SOLO

FIFTY PLACES TO
TRAVEL SOLO

**Travel Experts Share
the World's Greatest Solo Destinations**

Chris Santella *and* DC Helmuth

FOREWORD BY KATE McCULLEY

ABRAMS IMAGE

NEW YORK

For my wife, Dee, who always has a backpack ready to go . . . and my daughters, Cassidy and Annabel, who share Mama's wanderlust! *(Chris)*

For my mom, Cindy, and my sisters, Jacole and Kim—for always showing me a woman should never be afraid to explore the world. *(DC)*

Contents

Acknowledgments 9
Foreword 11 / Introduction 13 / Safety Tips for Solo Travelers 15

THE DESTINATIONS

(1) **Alaska:** Glacier Bay and Beyond 19
 RECOMMENDED BY DAN BLANCHARD

(2) **Alberta:** Banff .. 23
 RECOMMENDED BY ASHLYN GEORGE

(3) **Antarctica:** Antarctica .. 26
 RECOMMENDED BY KATE MCCULLEY

(4) **Argentina:** Buenos Aires ... 31
 RECOMMENDED BY AUSTIN COLTRAIN

(5) **Arizona:** Grand Canyon (Colorado River) 35
 RECOMMENDED BY SEAN CRANE

(6) **Australia:** Melbourne ... 39
 RECOMMENDED BY HAYLEY SIMPSON

(7) **Austria:** Vienna ... 43
 RECOMMENDED BY LORRAINE MONTEAGUT

(8) **Bhutan:** Paro .. 47
 RECOMMENDED BY JESSICA NABONGO

(9) **British Columbia:** Emerald Lake 50
 RECOMMENDED BY JESS BAIRD

(10) **British Columbia:** Vancouver 55
 RECOMMENDED BY LAURIE LIU

(11) **Bulgaria:** Rhodope Mountains 59
 RECOMMENDED BY ALINA MCLEOD

(12) **California:** Palm Springs ... 63
 RECOMMENDED BY ADAM GROFFMAN

(13) **Chile:** Patagonia .. 67
 RECOMMENDED BY SABRINA MIDDLETON

(14) **Costa Rica:** Nosara ... 71
 RECOMMENDED BY SHELBY STANGER

| 15 | **Cuba:** Havana . 75
RECOMMENDED BY AMANDA BLACK
| 16 | **Czech Republic:** Prague . 79
RECOMMENDED BY SHANNON BURLA
| 17 | **Denmark:** Copenhagen . 83
RECOMMENDED BY THERESA MCKINNEY
| 18 | **Egypt:** Nile River . 87
RECOMMENDED BY JILLIAN DARA
| 19 | **England:** Lake District National Park . 91
RECOMMENDED BY JEFF APPLEYARD
| 20 | **Georgia:** Savannah . 95
RECOMMENDED BY KRISTIN SECOR
| 21 | **Greece:** Greek Isles . 101
RECOMMENDED BY SANDY PAPPAS
| 22 | **Iceland:** Reykjavík . 105
RECOMMENDED BY AMANDA WILLIAMS
| 23 | **Ireland:** Dublin . 109
RECOMMENDED BY ANTOINETTE O'SULLIVAN
| 24 | **Italy:** Sicily . 113
RECOMMENDED BY MICHELA FANTINEL
| 25 | **Japan:** Tokyo . 117
RECOMMENDED BY STEPHANIE YEBOAH
| 26 | **Louisiana:** New Orleans . 121
RECOMMENDED BY LESLIE BURNSIDE
| 27 | **Maine:** Portland . 125
RECOMMENDED BY KIRSTIE ARCHAMBAULT
| 28 | **Malawi:** The Northern Region . 129
RECOMMENDED BY SABINA TROJANOVA
| 29 | **Massachusetts:** Boston . 133
RECOMMENDED BY FRED SMITH
| 30 | **Mexico:** Oaxaca City . 137
RECOMMENDED BY MATT KEPNES
| 31 | **Mexico:** Tulum . 140
RECOMMENDED BY SHELLEY MARMOR
| 32 | **Montana:** Whitefish . 145
RECOMMENDED BY BRIAN SCHOTT

| 33 | **New York:** New York | 149 |

RECOMMENDED BY DANI HEINRICH

| 34 | **New Zealand:** The North Island | 155 |

RECOMMENDED BY NICOLE SNELL

| 35 | **North Carolina:** Asheville | 159 |

RECOMMENDED BY BILLY ZANSKI

| 36 | **Norway:** The Fjords | 163 |

RECOMMENDED BY SPENCER SEIM

| 37 | **Oregon:** Bend | 167 |

RECOMMENDED BY HOLLY GOODE

| 38 | **Portugal:** Lisbon | 171 |

RECOMMENDED BY CHANTEL LOURA

| 39 | **Puerto Rico:** San Juan | 175 |

RECOMMENDED BY LISA ELDRIDGE

| 40 | **Slovenia:** Bled and Beyond | 179 |

RECOMMENDED BY VIVIEN URBAN

| 41 | **Spain:** The Camino de Santiago | 183 |

RECOMMENDED BY SHERRY OTT

| 42 | **Taiwan:** Taipei | 187 |

RECOMMENDED BY CODY HARRIS

| 43 | **Tennessee:** Nashville | 191 |

RECOMMENDED BY COLLEEN CREAMER

| 44 | **Thailand:** Pai | 195 |

RECOMMENDED BY JACKLYNN BOTWE

| 45 | **Tuvalu:** Funafuti | 199 |

RECOMMENDED BY THOR PEDERSEN

| 46 | **Utah:** Moab | 203 |

RECOMMENDED BY PARKER MCMULLEN BUSHMAN

| 47 | **Utah:** Zion National Park | 207 |

RECOMMENDED BY MICHELLE LIU

| 48 | **Vietnam:** Hanoi to Ho Chi Minh City | 211 |

RECOMMENDED BY KELLY REID

| 49 | **Washington:** Olympic National Park | 217 |

RECOMMENDED BY EMILY PENNINGTON

| 50 | **Washington:** The Pacific Crest Trail | 221 |

RECOMMENDED BY JAC "TOP SHELF" MITCHELL

ACKNOWLEDGMENTS

This book would not have been possible without the assistance of the solo travelers who shared their voices with us. To these women and men, we offer the most heartfelt thanks. We would also like to thank editors Juliet Dore and Annalea Manalili, designer Anna Christian, copy editor Ivy Long, and proofreader Margo Winton-Parodi who helped bring the book into being.

Diana would like to offer special thanks to her agent, Danielle Svetcov, and Chris Santella, for so warmly sharing the privilege of writing another volume in this special series.

Chris would like to offer special thanks to his agent, Stephanie Rostan; and his wife, Deidre; and daughters Cassidy and Annabel; and rescue dog Lola, for their patience and unwavering support.

OPPOSITE: Tulum offers well-preserved ruins, beautiful beaches, and a wide range of accommodations to suit a host of travelers.

FOREWORD

"But . . . you're going alone? Why?"

As I planned my six-month solo trip to Southeast Asia, I faced this question constantly. The hidden context: Would I even have fun if I was by myself? Would I get lonely? And, perhaps most important, would I be safe?

That was back in 2010. In the decade-plus since, solo travel has become more visible than ever, thanks in part to blogging and social media. Even so, the question *WHY?* persists—especially in the United States, where the twenty-four-hour news cycle would have you believe there's danger around every corner.

For thirteen years, I've been sharing my solo travels around the world, teaching women how to travel solo safely. And here's one thing I've learned: "Because I want to" is the only reason you need.

But if you want more reasons, here is why I love traveling solo:

Because you can spend your days the way you want to. Dipping in and out of museums at lightning speed, only visiting the parts that interest you. Taking tours that appeal to you, or spending the afternoon in a cafe, or sleeping in. It's your trip. You can do whatever you want!

Because with the proper research and preparation, nearly everywhere in the world can be traveled safely. And that goes for people of marginalized identities, too—for women, travelers of color, queer travelers, travelers with disabilities, and more. Read, watch, and google relentlessly, listening closely to travelers who share your identity.

Because it makes you feel invincible. Whether it's figuring out the complicated subway of Tokyo, successfully bargaining for handicrafts in the Andes, or walking across the top of Spain to Santiago de Compostela, solo travel leaves you feeling like you can achieve anything!

Because you can always meet people when you want to, on tours, at events, in hostels, and at meetups—or enjoy your solitary time when you don't.

Because traveling solo is not a statement of your relationships. Yes, you can travel solo if you're in a relationship, if you're married, even if you're a parent! (My husband refuses to travel to countries that don't make wine, so you bet I went to Greenland by myself!)

OPPOSITE: Kate McCulley of Adventurous Kate *takes a quick break while exploring the wilds of Antarctica.*

And perhaps most important, because if you wait for someone else to share your travel dreams, they may never come true.

For me, if I waited for someone to come with me, I'd never have danced until dawn with Vikings in Shetland, or slept beneath thousands of stars on a river island in Laos, or kayaked among penguins in Antarctica.

Solo travel is a time of great joy and tough challenges, of invigorating adventures and blissful self-sufficiency.

This is your permission slip. Go take that solo trip you've been dreaming about. I bet you'll be hooked.

—KATE MCCULLEY, SOLO FEMALE TRAVEL EXPERT
AND FOUNDER OF *ADVENTUROUS KATE*

INTRODUCTION

"I want to see the world and don't want to wait for others; if I have a bucket-list trip, I want to do it now!"

"I want to do what I want, *when* I want."

"I want to grow, meet new people, and break out of my comfort zone."

"I have different interests than my friends, and my partner does not enjoy travel like I do—but I don't want to put my travel dreams on hold any longer."

For any number of reasons, more people than ever are taking to the road (or the air, or the water) on their own. *Solo Traveler World* projects that in 2023, more than 83 million Americans embarked on a solo adventure—25 percent of the US population! Indeed, the number of solo travelers has more than doubled from pre-pandemic levels. Solo traveling extends across demographic groups. Many younger travelers are planning solo trips in the year to come, as they prepare to enter their adult lives; likewise, so are many mature travelers, as they weigh their next chapters in life. *Fifty Places to Travel Solo* provides a wonderful mix of welcoming venues around the world for those who opt to go it alone.

"What makes a destination a place to travel solo?" you might ask. A welcoming, inclusive attitude toward strangers? A flexible environment where you're welcome to join a group or maintain a friendly distance? A special opportunity to commune with nature and its many healing benefits? A chance to expose yourself to a private passion—Archaeology? Food? Fine art? Hiking? Whitewater rafting? The answer would be yes to all of the above, and an abundance of other criteria.

One thing we knew when we began this project was: We were *not* the people to assemble this list. So, we followed a recipe that worked well in the first eighteen *Fifty Places* books—to seek the advice of some committed solo travelers. To write *Fifty Places to Travel Solo*, we interviewed a host of people who have built a reputation as dedicated nomads and asked them to share some of their favorite experiences. These experts are diverse in age, race, gender, and physical ability, as a solo travel experience can greatly vary depending on who you are. They range from noted commentators like Parker McMullen Bushman (cofounder of Inclusive Guide, a modern, digital version of *The Green Book*) to solo travel evangelists like Amanda Black of the Solo Female Travel Network to adventure travel pioneers like Captain Dan Blanchard. Some spoke of ven-

ues that are near and dear to their hearts, places they call home; others spoke of places they've only visited once but that made a profound impression. Solo travelers relate to places in many different ways, and we've done our best to reflect that diversity here. (To give a sense of the breadth of the interviewees' backgrounds, a bio of the individual is included after each essay.)

Satisfying solo travel can mean different things to different people. *Fifty Places to Travel Solo* attempts to capture the spectrum of rewarding travel experiences available to those who wish to go it alone. While the book collects fifty great venues, it by no means attempts to rank the places discussed. Such ranking is, of course, largely subjective.

In the hope that you'll use this little book as a guide for embarking on new adventures, we have provided brief "If You Go" information at the end of each chapter. To appeal to travelers seeking different comfort levels, we've highlighted both more modest lodgings available, under "On a Budget," and more luxurious trappings, under "Luxe." On page 15, we've included some safety tips while traveling on your own. It's by no means a comprehensive list, but should give would-be travelers a starting point for making your adventures as smooth and safe as possible.

Traveling with family and friends holds many joys and surprises. But sometimes, heading out on your own can provide unique insights—meeting people you may otherwise have walked past, and having the space and time to find clarity on the recent developments of your life . . . and to chart a more coherent path for the future. It's our hope that this little book will inspire you to embark on a host of such solo adventures.

SAFETY TIPS FOR SOLO TRAVELERS

There has perhaps never been a safer time to travel on your own. Still, there are some useful tips that will help ensure that your solo adventures are both rewarding and safe. The list below will help you on your way.

1. **Understand your strengths/weaknesses as a traveler.**
Does being outside your comfort zone fill you with anxiety? If so, you might think twice about traveling where little English is spoken, or where the culture is far different from yours.

2. **Find people with similar interests or connections.**
If you like hiking, for example, you can easily find people with shared interests with a few online searches. Likewise, a little research before your trip can reveal friends or relatives of friends who might welcome a chance to show off their town to a visitor.

3. **Consider staying with a family.**
Renting a room in a home or apartment is sure to give you some local insight. A hostel with lots of other travelers (many likely solo) is another good way to connect.

4. **Learn some of the local language.**
It's both practical and polite for you to take the time to understand a bit of the local language—even if it's just ordering a coffee or beer, or counting to ten.

5. **Use the common sense you'd use at home or traveling with friends.**
You should be mindful of safety concerns just as you would in a city close to home or if you were with friends. Keep an eye on your valuables, stay on top of local scams, and watch how much you drink. Be aware of any scams that might be occurring in the city where you're staying.

NEXT PAGE: Nyhavn, with its vibrant and captivating atmosphere, stands as one of Copenhagen's most iconic landmarks and is a preferred spot for indulging in people-watching.

The Destinations

Alaska

GLACIER BAY AND BEYOND

RECOMMENDED BY **Dan Blanchard**

Some years, a million people will experience the grandeur of Alaska's Inside Passage. Yet a much smaller number of people will see coastal Alaska via small ship.

Enter small ship cruising.

"A small vessel can get into places that simply aren't available to cruise ships," Dan Blanchard observed. "And if you have too many guests on a cruise, you're limited in terms of the kind of activities that they can participate in. To visit some national park areas, for example, you can only go in with groups of twelve. If you have more than a hundred people, it's hard to cycle people through so that they get to experience all of the places we can visit, and activate all the activities we participate in—paddleboarding, snorkeling, biking, hiking. Eighty or ninety guests is about perfect so that everyone can participate in the activities they wish. And, there are enough folks, so solo travelers can find like-minded people if they're seeking company."

When asked about the small boat cruise from UnCruise Adventures' many Alaska offerings best suited for solo travelers, Dan suggested Wild, Woolly, and Wow. "Couples and other group travelers tend to focus on bigger-name spots that might be considered iconic," Dan continued. "Individual travelers do more research, and aren't as focused on the big names. They're more inclined to wander off the beaten path. Wild, Woolly, and Wow takes us to places I'd go if I were exploring the southeast Alaska coast with my sailboat. We don't waste time on cruising the open ocean; instead, we're immersed in the life along the coast, hiking, and bushwhacking like locals do."

Wild, Woolly, and Wow begins in Juneau, a fitting port of embarkation. "Juneau is the most beautiful capital in the States," Dan enthused. "It's a great place to start our trip." Your home is the 192-foot *Wilderness Legacy*, which can accommodate eighty-six

OPPOSITE:
Guests approach Dawes Glacier via Zodiac boat. UnCruise's smaller craft allow visitors to sail to places larger cruise ships can't reach.

guests in its forty-three cabins. All cabins boast view windows and en suite bathrooms. Multiple viewing decks (plus the amply windowed lounge) let guests take in the scenery as they sail.

"Our guests tend to be adventurous," Dan added, "though the shape a day takes depends on a person's inclination to get out there. Generally, breakfast is at seven A.M.... though if people want an earlier start, we can do that. By 8:15 A.M., we're into our activities. Some will go for all-day hikes or kayaking excursions and take packed lunches. Others may do a morning activity, return to the boat for lunch, and head back out in the afternoon. By six P.M., we try to have everyone back on the boat. A happy hour is followed by dinner. After dinner, our guides will describe what adventure options are available for the following day. Each night, there's an educational presentation in the lounge."

Where large cruise ships may offer a more sedentary experience, Wild, Woolly, and Wow excursions were developed to get guests out in nature. You can opt to hike, kayak, snorkel, or even bike. "We're fortunate to have the only permit that allows visitors to hike and bike on Chichagof Island," Dan explained. "We have fourteen bikes on board and get to ride the old logging roads there." There are many highlights as the *Wilderness Legacy* wends its way among southeast Alaska's many islands and fjords. You'll likely visit LeConte and Baird Glaciers, have the chance to snorkel in scenic Patterson Bay, and search for humpback whales and orcas, which can appear at any time.

Many visit Alaska to view its iconic mammals in the wild. While wildlife encounters can never be guaranteed, your odds are good in the "outback" regions where *Wilderness Legacy* cruises. "People always hope to see brown bears," Dan observed. "We're generally in sections of Alaska where bears may not have encountered a human being. [Most bearwatching is from a boat.] Marine mammals are a huge part of the Alaska experience. Right now, these animals are prospering. Sea otters almost went extinct at one point; now there are an estimated ten thousand in Glacier Bay alone. And there are more humpback and gray whales than any time since Europeans arrived."

The grandeur of southeast Alaska can arouse strong emotions. Dan recalled a kayak outing he led in Fern Harbor. "We paddled up on an incoming tide to reach Grady Glacier. I had a single traveler in my kayak, a woman named Ann. As we started to head downstream with the tide, she began to cry. I asked if she was okay, and she said she'd be fine. A few porpoises came up to our kayak, along with some sea lions. She started crying again, and pulled out a vial.

"'I'm sorry Dan,'" she said. "'I've been carrying this vial of my father's ashes to let go of in a place that had meaning for me. I've had them for three years.' Soon she released the ashes, and we were both crying.

"We all want human connection. We both found it on Fern Harbor, with porpoises and sea lions, on a flat, calm, sunny day."

CAPTAIN DAN BLANCHARD grew up in Washington state, living and working on boats from the time he was a kid. He was a Sea Scout, and National Boatswain's Mate at sixteen. He received his ship Master License at eighteen and has gone on to live a storied tale, from owner of Blanchard Marine to captain of sightseeing vessels to director and vice president of operations at Cruise West; in 1999, he joined American Safari Cruises, and he went on to acquire the company in 2008, launching InnerSea Discoveries, now known as UnCruise Adventures. A natural storyteller, he is an enthusiastic skier and cyclist, energetic hiker, world explorer, accomplished sailor, and lover of the ocean and natural world. Dan connects with nature and culture wherever he goes; in May 2013, he was adopted into a Native Alaskan Tlingit tribe.

If You Go

▶ **Getting There:** The cruise described here (Wild, Woolly, and Wow) departs from Juneau, which is served by Alaska Airlines (800-252-7522; alaskaair.com) and Delta (800-221-1212; delta.com).

▶ **Best Time to Visit:** Wild, Woolly, and Wow cruises are offered from late April through mid-September.

▶ **On a Budget:** You can take in much of the grandiose scenery of the Inside Passage from the decks of the ferries plying the Alaska Marine Highway (dot.alaska.gov/amhs), from Ketchikan to Yakutat (and beyond). There's space to set up a tent for overnight travel, and a canteen.

▶ **Luxe:** UnCruise Adventures (888-862-8881; uncruise.com) can accommodate solo travelers without egregious surcharges. Trips are a week in length, and packages include all meals, beverages, and activities.

Alberta

BANFF

RECOMMENDED BY **Ashlyn George**

There are few locations in the world that can grant you world-class hiking in the morning and five-star dining in the evening. Banff is one such place. "It's an iconic destination," began Ashlyn George. "People at home here in Saskatchewan take weekend trips there even though it is a seven- or eight-hour drive. It's a place you keep going back to, all four seasons."

For a crash course in Banff's history, visit the Cave and Basin National Historic Site. These thermal springs remain an important destination to a number of Indigenous peoples, including the Siksika, Métis, Kainai, and Piikani Nations and the Shuswap Indian Band. It is also considered the birthplace of the Canadian National Park system.

Banff is 2,564 square miles of protected evergreens, imposing peaks, angelically blue lakes, and brilliant alpine meadows. Within this outdoor wonderland sits the Banff townsite itself, a valley village where seven thousand people live, work, and play year-round. "It's a classic mountain town with log-beam and stone-facade buildings reminiscent of Swiss Alpine-style architecture," described Ashlyn. "Whenever I'm there, I love stopping by the Carter-Ryan art gallery to see his bold color-blocked prints. At the Grizzly House, there is an exotic fondue dinner serving ostrich, rattlesnake, buffalo, alligator, frog legs, and venison. The sushi at Sushi House Banff is *Kaiten* style. It comes out on a conveyer belt using a model Canadian Pacific Train, and it is so good, I crave it when I'm not there."

While in the town, be sure not to miss the gondola ride. Pro tip: There is a free shuttle service to the gondola or free fare with the Bow Valley Roam Public Transit if you book your tickets in advance. "I always recommend everyone do this if they're visiting Banff without a car," reflected Ashlyn. "There's a gift shop and three restaurants up top, includ-

OPPOSITE: *Ashlyn George of* The Lost Girl's Guide *enjoys a solo skate atop one of Banff's majestic frozen lakes.*

ing an outdoor patio with 360-degree views. There's also a hiking path that goes the opposite direction, away from the mountaintop discovery center and boardwalk. It's less crowded and has amazing views, especially at sunset. At night, you can see Banff lit up, and the stars shining above you."

The park offers more than nine hundred miles of maintained trails, so picking favorites is a difficult task. Some highlights, though, include the Johnston Canyon hike that leads through the depths of the mountains, along elevated catwalks to the base of two thundering waterfalls. "It's a popular trail," noted Ashlyn, "but I've hiked it repeatedly because it's so beautiful. In the winter it's especially lovely, but microspikes are helpful as the boardwalks are icy. The Upper and Lower Falls freeze into intricate ice pinnacles that are popular with ice climbers. From there you can hike farther up to the Ink Pots. These turquoise mineral pools are liquid in the winter as they have a year-round temperature of 39 degrees Fahrenheit."

Other notable forays include the photogenic Moraine Lake, with its neon-blue waters stretching into the granite walls of the Valley of the Ten Peaks beyond. This glacially fed lake is situated in an avalanche zone, so the road is only open for a few months each year. "Adventurous travelers with proper avalanche gear bike or ski in during the offseason," said Ashlyn. "But if you're going to Banff in summer, it's worth taking the shuttle here. There are so many world-class hikes that start at the lake." Other favorites closer to the town include the wildflower-decked Tunnel Mountain hike, which rewards hikers with an elevated view of the Banff townsite. "You can see the Fairmont Banff Springs Hotel along the way. It looks like a fairy-tale castle in the mountains. Even if you aren't staying there, it's a lovely place to stop. Their back patio looks out over the Bow River and nearby Bow Falls. In the winter you can sit outside by the fire, sip a hot chocolate, and roast marshmallows."

For other luxe encounters with nature, consider joining a trip with Banff Trail Riders, which takes visitors on multiday adventures via horseback. "They take you into the Sundance mountain range on a historic pack trail," remembered Ashlyn. "You stay in log cabins, and yes, there's running water and even an outdoor shower. It's an intimate experience to ride on a horse and feel the power of the animal as you cross rivers together and climb up the mountainside. The guides are knowledgeable about the area, have a great sense of humor, and treat the animals very well. It's a once-in-a-lifetime experience."

Banff is a four-season park, and certain aspects shine in the chill of winter. This

includes all manner of snow sports, and also, the outdoor pools of the Banff Upper Hot Springs. For about $12, visitors can soak in the deliciously warm mineral waters of the park. "They're open year-round, but of course they are extra wonderful in winter because of how cold it is outside. You'll likely strike up a conversation with someone next to you; it's that kind of place."

"While you may be traveling solo, you're often not alone," reflected Ashlyn. "There are lots of Canadians and American visitors, of course, but also lots of Aussies, gap-year travelers, and people who work remotely. Everyone is friendly. From a safety perspective in the wilderness, you'll often meet others also adventuring through the park (but please do carry bear spray). And when you're in the town, you're meeting interesting people from all over the world, people who have been pulled to Banff for the same reasons you were."

ASHLYN GEORGE (BA, BEd) is the award-winning travel writer, photographer, and content creator behind the *Lost Girl's Guide to Finding the World*. She is a go-to travel expert in Canada but is no stranger to trips abroad. Having traveled solo through more than sixty-five countries on all seven continents, she's a passionate storyteller in pursuit of adventure, learning, and discovery. Find her online at @thelostgirlsguide and thelostgirlsguide.com.

If You Go

▶ **Getting There:** Banff National Park begins approximately sixty miles west of Calgary, Alberta, and is served by many major carriers. The park has public transportation that can get you to most places, making a car optional.

▶ **Best Time to Visit:** Most of the hiking trails do not fully thaw until summer. Autumn is cooler and features larch season, when the evergreen hills are spattered with gold. Several ski routes open in the winter.

▶ **On a Budget:** The park hosts more than fifteen campgrounds (some with cabins), which can be reserved at parks.canada.ca/pn-np/ab/banff/activ/camping.

▶ **Luxe:** Banff has a handful of luxurious hotels, including the fairy tale–worthy Fairmont (403-762-2211; fairmont.com/banff-springs) and the historic Rimrock Resort Hotel (888-746-7625; rimrockresort.com).

ANTARCTICA

RECOMMENDED BY **Kate McCulley**

"When was there not a draw to go to Antarctica?" asked Kate McCulley. "It's the mythical seventh continent. It's on every hardcore traveler's bucket list. People hold up Antarctica as an ultimate travel achievement. I think everyone has an idea of what Antarctica will do to them, that they will come back changed, triumphant, and bragging. I agree: Antarctica will change you. But it won't change you in the way you think. Antarctica destroyed me in the best way: It killed my traveler's ego."

With no Indigenous population nor any permanent human residences, Antarctica's appeal is akin to climbing Everest, or taking a suborbital space flight—something we crave to do simply because so few others can say they have. A realm of lethal seas, sub-zero winds, and ice sheets several miles thick, it makes sense that most people venture here for the thrill of conquest rather than the siren song of beauty. However, "Antarctica is far and away one of the most beautiful places I've ever been," noted Kate. "People don't expect Antarctica to be beautiful, but it is truly stunning. The scale of everything is a million times larger than what you are used to. Giant mountains, enormous glaciers, massive icebergs. One day, we sailed past a waterfall of dry, falling snow in the Lemaire Channel. Where in the world can you see something like that? You just can't believe what you're seeing is real."

Access to the world's southernmost landmass is generally granted by organized tour companies, whose trained crew and specialized ships can endure the churning waters of the Drake Passage (where waves sometimes reach more than sixty feet). "A lot of people go to Antarctica as solo travelers, but of course, because you're part of a tour, you're almost never truly alone. The mood on the boat is excited—how could it not be? You're in a large group of adventurous people who are all doing a bucket-list item. People are con-

stantly sharing stories. I ended up becoming good friends with my kayak partner. And two other people I met on the *Ocean Diamond* came to my pre-wedding dinner. They themselves had met on a different trip in Papua New Guinea and had been traveling the world together ever since."

Every expedition sets out with a plan, but in Antarctica, that plan is at the mercy of the sea and the sky. "It's a wild card what conditions you're going to get," explained Kate. "On a sea day—that is, a day they can't dock—they'd offer a full tea service in this nineties-themed room on board called 'the Club.' They also hosted a series of scientific lectures, usually covering famous Antarctic explorers, or interesting geology or wildlife. When I went, the boat was scheduled to cross the Antarctic Circle during the day, and we had a little celebration planned. But we ended up crossing at 2:15 in the morning. Nevertheless, the captain made an announcement over the ship's PA system. And everyone woke up and went outside, and the crew had champagne waiting for us."

When the ship is able to moor, visitors have a chance to explore this most special terrain. Hiking, snowshoeing, or skiing expeditions are favorite pastimes, but perhaps one of the most popular excursions is getting down to the water's level. "If you decide to kayak, it's a pretty big undertaking," explained Kate. "Something travel agents don't always communicate well is that kayaking is not a casual undertaking: If you are one of the lucky people who scored a kayaking spot on your tour, you're going to be doing it every morning and every afternoon. You might miss out on Zodiac tours and shore excursions. But if you're up for an adventure, it's worth it. You will see things no one else will get to see. One day we went out, and there were hundreds—hundreds—of penguins swimming toward us, jumping in and out of the water, coming closer and closer to our boats. Another day, a whale rose out of the water about thirty feet in front of my kayak."

Beyond minke and humpback whales, common wildlife includes seals, albatrosses, and of course, penguins. "Most Antarctica cruises don't go to areas where you can see emperor penguins," noted Kate, "but gentoo and chinstrap penguins are everywhere. Adélie penguins are common south of the Antarctic Circle. And they're fearless. The crew is strict about not allowing tourists to touch them, but the penguins will often wander up to you, which is okay. We were exploring one of the islands, and I heard this little noise and looked down. A penguin was right next to me, looking me up and down, checking me out."

Wild country demands some wild behavior, however, and there are plenty of opportunities to get outside your comfort zone. "Another day we were kayaking out in Paradise Bay, a very calm, placid part of Antarctica, surrounded by these gorgeous mountains. And our guide turned to us and said, 'You know what? I think this is a great place for a primal scream,' and so we all just screamed at the top of our lungs in unison," remembered Kate. "And on every voyage there is a polar plunge. You get in your bathing suit and a robe, and walk down the gangway, where there are two crew members in full winter gear. You take off your robe, they tie a rope around your waist, and you jump off the platform into the water. I was so nervous, I was shaking! Then I got down there, and somehow found the courage to jump in the water. The water temperature was 2 degrees Celsius, or 34 Fahrenheit, and it pierced me like a thousand needles. I poked my head up and screamed, 'Jesus Christ of Latter-day Saints!' which is something I think I've never said before or since. But it did make everyone laugh!"

"Before I left," concluded Kate, "my mom called me and asked, 'Do you really have to go?' She was worried about me being safe. But when I came home, I showed her how nice the boat was, how well we were taken care of, and how attentive and supportive every Quark Expeditions crew member was. There is a strong sense of stewardship and care for the land. Traveling to Antarctica is much more accessible than people think."

KATE MCCULLEY is the woman behind *Adventurous Kate*, one of the internet's most prominent travel blogs focused on solo and independent travel for women. Named one of *Forbes'* Top 10 Travel Influencers, one of Irish America's Top 100 Business Leader, and winner of the Golden Pen Grand Prix travel writing award for her coverage of Croatia during the COVID pandemic, Kate has been advising and inspiring people to achieve their travel goals since 2010. Having traveled to more than eighty-three countries and all seven continents, Kate's genuine, humorous, and candid travel writing has been featured in the *New York Times,* the *Boston Globe,* CNN, *Vogue,* and *Glamour.* Kate's ultimate goal is to show that solo female travel can be safe, easy, and a lot of fun. Whether you need guidance for your first solo trip or you're a seasoned traveler looking for destination inspiration, her blog is an ideal resource.

ANTARCTICA

If You Go

▶ **Getting There:** Most groups depart from Ushuaia, which is served by Aerolíneas Argentinas (800-333-0276; aerolineas.com.ar) and LATAM Airlines (866-435-9526; latam.com).

▶ **Best Time to Visit:** For the best odds at good weather, expeditions are typically scheduled December through March.

▶ **Accommodations:** Quark Expeditions tours can be booked years in advance (866-255-9513; quarkexpeditions.com). Booking a triple cabin can make the trip more affordable, or, if money is not object, treat yourself to the opulence of one of the ship's premium suites.

Argentina

BUENOS AIRES

RECOMMENDED BY **Austin Coltrain**

"It's on my list to go to all 197 countries," began Austin Coltrain. "South America intrigues me because I feel like it gets overlooked. Most solo travelers want to go to Bali, or Paris, or Rome, and there's so many beautiful cities in South America that aren't talked about. I hear people worried there might be a language barrier, or high crime. But there is so much you're missing if you fall into that thought trap. Buenos Aires, specifically, intrigued me because it's this mix of different architectural influences, and it has this unique dialect of Spanish. It felt like a European city with a South American soul."

Buenos Aires is a capital city in every sense of the world. Its streets are lined with wrought-iron balconies, generous public gardens, and ornate facades of French and Italian influence. The city pulses with a unique romance. Tango, of course, is on the menu, but also opera at Teatro Colón, or a tasting flight of velvety-dark malbec wines. Even the presidential palace, La Casa Rosada, is painted a blushing pink. Like most great cities, Buenos Aires has survived revolutions and coups, civil struggles and political upheaval. For this, the heart of the city beats even stronger.

"My jaw was on the floor the minute I got off the train," continued Austin. "In many ways the architecture resembles Paris, but with the city planning grid of Manhattan. Buenos Aires is a truly unique city. In Europe, after a while, the cities start to blend together; in America, after a while, the cities start to blend together. But here you get a real 'whoa.' It didn't feel like any other city in the world."

Getting around Buenos Aires is half the fun of being there. Eminently walkable, it is often described as a brilliant place to get lost. "You don't need Google Maps," enthused Austin. "Just walk out your front door. Different neighborhoods have different cultures, and you can feel the city morph and change as you walk through them." The largest

OPPOSITE:
The flamboyant colors of El Caminito in Buenos Aires inspired the classic tango song of the same name.

neighborhood is Palermo, a haven of posh shopping and vibrant nightlife, and makes an excellent home base from which to see the city's main sights. Across town, the vibrant yellows, reds, and blues of El Caminito in the La Boca neighborhood are a photographer's dream, representing the traditional shacks of the Genoese port workers who migrated here in the nineteenth century. Consider catching a soccer game at La Bombonera to see the hometown heroes, Boca Juniors, play a match. Two miles north, among the crumbling seventeenth-century mansions of San Telmo, you can stroll through the very courtyards where tango was born. The dance's mix of European and African influences reflects this neighborhood's earliest citizens. Nearby, the Mercado de San Telmo is a vast, historic market offering everything from groceries to vintage records (and, of course, live tango shows).

"People often ask if Buenos Aires is safe to walk around," said Austin. "But I didn't feel like I was unsafe in basically any scenario. Locals would warn me to be careful with my phone and my camera, but I never had any issues. There can also be a minor language barrier if you speak no Spanish, but this can be a fun way to get out of your comfort zone. You have to get creative; you have to challenge yourself. You'll pick up slang and common words quickly. And everyone was very welcoming, very smiley. I think if I was with other people, I wouldn't have had this same warm experience. Traveling solo is a better way to immerse yourself, and you'll learn the new culture much faster. When you're alone, you are forced to adapt, and this leads to wonderful experiences you otherwise wouldn't have had.

"For the most part, wherever I travel, I aim to have a low-plan itinerary," continued Austin. "But I also think you should aim to do a few stereotypically touristy things wherever you go. They are usually crowded for a reason. For example, in Buenos Aires, the Cervantes National Theater and the Obelisco were absolutely worth it. They are important pieces of the city's history, and to not go would be shortchanging yourself. But the majority of time I was there, I aimed to just ask people along the way what their favorite places were, their favorite parks, their favorite restaurants. This never failed to lead me somewhere great."

Some popular watering holes include the Gibraltar in El Centro, a bar that more closely resembles a mid-century English library, serving elegant panini and Aperol spritzes among wood-paneled nooks and trailing green vines. Argentina is famous for its beef, served best at steak houses known as *parrillas*. At the upscale La Brigada in San Telmo, said to be a favorite of Francis Ford Coppola, your steak will be brought to your table and served with a spoon, to demonstrate its tenderness.

ARGENTINA

"I remember being in the city center, walking around, and just feeling overwhelmed by the magical, peaceful, positive energy in the air," concluded Austin. "I just kept smiling. I haven't had that kind of first impression in a city in so long. Go to Buenos Aires with an open mind. Don't have set things to do. Learn some basic Spanish, and don't be afraid to chat with people. Start at the national theater and start walking; head off in any direction. Trust your gut. You'll be delighted at what you find."

AUSTIN COLTRAIN grew up in the small town of Byron, Illinois. As a child, he loved his family's vacations, which ignited in him a permanent love of travel. When he got ahold of his first camera, he wanted to create something special to show his friends and family members, thus setting off a passion for filmmaking. He bought his first professional video camera at the start of college and began making his own short films for fun and uploading them to YouTube. After college, he moved to Phoenix, Arizona, where he embarked upon a journey through the United States, documenting his experiences on film as he went. He got his passport after the COVID pandemic, and at last began traveling the world. He is currently pursuing his dream of making a video in all 197 countries. Follow along on YouTube at @Traintin.

If You Go

▶ **Getting There:** Ministro Pistarini International Airport, just outside the city center, handles most of the international traffic coming into Argentina. It's a hub for Aerolíneas Argentinas (800-333-0276; aerolineas.com.ar).

▶ **Best Time to Visit:** Fall and spring are favorites, with sweet air, mild temperatures, and fewer crowds.

▶ **Accommodations:** Opulent hotels are at your service in Buenos Aires, including the regal Palacio Duhau (+54 11 5171 1234; hyatt.com) and Park Tower, where every guest has their own butler (+54 11 4318 9100; marriott.com/en-us/hotels/buepl-park-tower-a-luxury-collection-hotel-buenos-aires). An overview of all options can be found at turismo.buenosaires.gob.ar.

Arizona

GRAND CANYON (COLORADO RIVER)

RECOMMENDED BY **Sean Crane**

"I've done more than ninety river trips through the Grand Canyon," Sean Crane began. "Most of those who join a trip don't know the people in the other groups participating. But over all of those trips, I've only had two groups that haven't meshed. Everyone on a float has an interest in common—to see the Grand Canyon. As you make your way downriver, any differences people might have—politics, religion—start to recede, and they find common ground."

Neither the deepest nor widest gorge in the world, the Grand Canyon is nonetheless recognized as one of the planet's most awe-inspiring erosion events—a 277-mile-long chasm that yawns from four to eighteen miles and reaches depths of more than a mile, a seemingly endless series of abrupt cliffs and gentle slopes. Scientists believe human habitation of the canyon by Native American tribes—or least sporadic hunting and gathering—dates back 13,000 years. Though Spanish explorers spied the canyon in the 1600s, it was not until 1869 that the first people of European descent, under the command of Major John Wesley Powell, navigated the Colorado's roiling waters. Powell (who had lost most of his right arm at the Battle of Shiloh during the Civil War) and his crew did not have the benefit of rubber rafts or detailed guidebooks; they ran the Colorado in wooden dories that had been built in Chicago and transported west.

Though a finite number of permits for *very experienced* do-it-yourselfers are issued each year, most Grand Canyon rafters will opt to go with an outfitter who provides guides to set up your camp, cook, and provide safe passage through the Colorado's famed rapids. "We offer two different experiences," Sean continued. "Our motorized raft trips are shorter—six to eight days—but more intimate, limited to fourteen guests. The oar-powered raft trips (where guests assist with paddling) are longer—usually twelve

OPPOSITE:
Rafters get to enjoy the beauty of the canyon from both the river bottom and the many trails that extend up the sides of the canyon.

days—but have more boats and guests. It's easy to accommodate solo travelers." Sean described how a typical day on the river unfolds. "We have a coffee call at five A.M., as we hope to be leaving camp by eight so we can get in hikes. Breakfast is out by 6:15 A.M. Some favorites include French toast, biscuits and gravy, breakfast burritos, and corned beef hash. After loading up the rafts, there might be a hike from camp, or you'll float a few miles downstream for your first hike. By late afternoon, we'll pull into our camping spot for the evening. Dinners range from freshly prepared Dutch oven lasagna, prime rib, and of course, burgers and brats—your classic camping meal." At night, you're treated to some of the best stargazing anywhere in America, thanks to minimal light pollution.

The section of the Colorado River flowing through the Grand Canyon—either 186 or 225 miles, depending on where you take out—is one of the world's preeminent whitewater adventures. While the rapids are exhilarating (and so large that whitewater experts needed to create a new rating system for their scope and difficulty), anyone who's rafted the Grand Canyon will tell you it's the hikes to hidden waterfalls, crystalline creeks, ancient Native American ruins, and the sandy campsites beneath unblemished night skies that make the Grand Canyon float a must-do experience. Sean described a few favorites. "Nankoweap, on the upper portion of the float, is one of the most photographed spots. There are three ancestral Puebloan granaries where grains and seeds were stored, and you can see several miles of the meandering river down to the canyon that forms the Little Colorado. Another popular hike takes you to the Little Colorado River. The water is a beautiful teal blue, and you can swim and even float through a small rapid. Some people wear their life jackets like diapers. One of our favorites during the shoulder season (it's too hot in the summer) is the hike to Deer Creek Falls. It takes you up to a little oasis where a beautiful waterfall comes out of a cliff face, and you can wade into the creek to cool off. This spot is sacred to many of the area's Tribal people. This hike comes toward the end of our floats. By this time, everyone on a trip has become friendly. It's a spot where people will share stories and further connect."

Of the seventy-two named rapids that punctuate the Colorado's Grand Canyon stretch, Lava Falls—near the trip's conclusion—garners much of the mindshare. This Class Ten (the highest rate of rapid difficulty) rapid is often the topic of discussion for much of the trip; its rumbling can be heard several miles upstream. "Every trip, there's a great build up, and Lava Falls always delivers. Hermit has the biggest wave train—there's a forty-foot standing wave. Whether you're in a 37-foot motor raft or an 18-foot paddle raft, it's a big

rollercoaster ride that always has people laughing, with pure joy on their faces. It's not technical. You just head down the middle of it and get soaked."

The wonders of the Grand Canyon have the power to bring people together. Sean recounted one such occasion. "We had a group from Oklahoma and a few ladies from New Mexico on a trip. One of the ladies was a bit loud and rambunctious at the orientation. Afterwards, the Oklahoma folks said they wouldn't go on the same raft with the ladies. But they'd started to chat a bit over the next few days, and on day three, they ended up on the same boat. One lady was in the 'bathtub' seat [at the front of the raft] with some of the Oklahomans, who were big guys. We went through Sockdolager Rapid, all hooting and hollering. In the second wave, she almost went out, but the guys grabbed her. A brown, hairy thing went rushing down the side of the boat; it looked like a muskrat. It was her wig. After they saved the lady, she became inseparable from the Oklahomans. They were best friends by the end of the trip.

"I'm on an email chain with them all to this day."

SEAN CRANE is the director of Wilderness River Adventures.

If You Go

▶ **Getting There:** Groups generally assemble in Flagstaff, which is served by American Airlines (800-433-7300; aa.com).

▶ **Best Time to Visit:** Most commercial trips run between May and October. Summers can be very warm, limiting some hiking opportunities.

▶ **Guides/Outfitters:** There are a number of outfitters authorized to lead trips through the Grand Canyon, including Wilderness River Adventures (928-645-0343; riveradventures.com).

▶ **Accommodations:** The Flagstaff Convention and Visitors Bureau (800-842-7293; flagstaffarizona.org) highlights onshore lodging options for before and after your float.

Australia

MELBOURNE

RECOMMENDED BY **Hayley Simpson**

"Melbourne is hands down my favorite city in the country," began Hayley Simpson. "You want arts and culture, it's right there. You want to go to the beach, it's right there. You can go from grungy nineteenth-century architecture to beautiful, modern museums in the space of a block."

Melbourne is Australia's second-largest metropole but often considered its first cultural capital (just don't tell Sydney). The city continues to rank at the top of "most livable city" polls, and possesses famously unique, awe-inspiring architecture. This can be seen at the Crown Casino's massive outdoor fire show, the Recital Centre's facade traced in giant blocks of white neon, or the flamboyantly colored bathing boxes on Brighton Beach. Sports fans will never find a dull moment—from basketball, cricket, soccer, football, and Formula 1 racing—Melbourne's arenas and stadiums are regularly packed full of cheering spectators (this is the home of Australian rules football, after all). The city places high value on art as well as creative dining experiences, such as axe-throwing bars and restaurants run by feline robots. "There's lots of premium hotels, of course—it's a world-class city," reflected Hayley. "But there's also lots of hostels. One I liked was called Space Hotel; they have a really cool rooftop with panoramic city views and a hot tub. That's something I like about Melbourne: You don't have to pay much to get incredible views and experiences."

Like most cities that have this much going on, Melbourne is best experienced through walking. "The street art here is one of my favorite things," Hayley shared. "You can take yourself on a self-guided street art tour with a map from the tourist center—it's very easy. Or, you can just go explore the Fitzroy neighborhood, which has these adorable terrace houses. There's wonderful food and boutiques and thrift stores . . . it's just such a cool vibe, without being forced or overly hipster. Another great walk is through the Queen

OPPOSITE: Melbourne is an architectural dream world with captivating murals, rooftop bars, and art installations at every turn.

39

Victoria Market. It's a bit like a farmers' market, but with handcrafts, clothes, art, candles, and all kind of specialty goods. They do a fantastic night market for most of the year that includes hundreds of food stalls. You can travel the world through your stomach."

Outside of the Queen Victoria Market, Melbourne foodie highlights include Sunda, an Australian and Southeast Asian fusion gem serving up Vegemite curry and jackfruit petits fours. At the aptly named Dinner in the Sky, twenty-two guests are vaulted three hundred feet above the earth via crane, to enjoy Michelin-starred dishes under a clear canopy. "A favorite place of mine is called Easey's," said Hayley. "It's a burger place, built inside historic Melbourne train carriages that have been put on the roof of a building. So, you're eating a burger—in a train carriage, in the sky. That's very Melbourne." Great dining experiences can also be found in Melbourne's Chinatown, the oldest continuous Chinese settlement in the Western world. "There's a place there called Shanghai Village that has incredible dumplings," noted Hayley. "Whenever I'm traveling solo, I always try and visit the city's Chinatown, because it's great history, and also, you can usually find the most delicious food without breaking the bank."

Another worthy walk is through the Melbourne Royal Botanic Gardens. Visitors can glean unique insight into the Kulin nation, Melbourne's living, original inhabitants, through the Aboriginal Heritage Walk. The program is led by a member of the Kulin nation, and includes a traditional smoking ceremony, along with introductions to native plants that are still used for food, tools, and medicine.

When your feet do get tired, simply hop onto the city's expertly designed public transportation system. "Public transport can be hit or miss in so many places," reflected Hayley. "Something I love about Melbourne is that is has a free tram service. I didn't have a car the whole time I lived there; even reaching the suburbs is easy with trams and buses."

The city takes advantage of its relatively flat geography, reaching outward into a wheel of more than three hundred suburbs. Walk the long pier over Sorrento Front's cyan waters, cast a line into the smooth, waist-high waves of Half Moon Bay, or glimpse the horses running on sunny Mordialloc Beach. A quick tram ride from downtown Melbourne can take you to the festive shores of Saint Kilda, with its Hollywood-style mansions, European pâtisseries, and seaside carnival rides (don't miss the chance to walk through the clown's mouth at Luna Park). "There are penguins that live at the end of the pier there," explained Hayley. "They waddle up the rocks. Some of them get pretty close to you, but there are volunteers there to make sure nobody does anything stupid, which I

appreciate." For even more incredible ocean views, consider a drive (or chartering a tour) along the famous Great Ocean Road. Surreal limestone rocks stand tall as giants in the lapping waves, and seals, penguins, and even the occasional migrating whale can be sighted in the distance.

"There is an event that happens every year," concluded Hayley, "called White Night. The CBD [Central Business District] essentially closes down, and all the buildings put on these massive light installations. That's one of my favorite memories—standing in the middle of this sea of people, with everyone sharing this incredible experience with each other . . . I'd never seen anything like it."

HAYLEY SIMPSON is a freelance writer who has been traveling solo for ten years, and has visited more than forty countries. She travels because she loves immersing herself in new cultures and learning about the world through firsthand experiences. She's a big believer that if she can travel the world solo on a budget, anyone can. Follow her journeys on Instagram at @hayleyonholiday.

If You Go

▶ **Getting There:** Melbourne International Airport is served by many carriers, including Delta Airlines (800-221-1212; delta.com) and Qantas (800-227-4500; qantas.com).

▶ **Best Time to Visit:** Many people consider spring and fall the best seasons, as they feature lower temperatures and fewer tourist crowds, plus lower airfare. In the summer months of December to February, Melbourne is quite busy and very hot.

▶ **On a Budget:** Melbourne is a backpackers' hub, and cheap lodging abounds. Some favorites include Nomads St. Kilda (+61 3 8598 6200; nomadsworld.com/australia/nomads-st-kilda-melbourne) and Flinders Backpackers, with its free breakfast buffet (+61 3 9620 5100; flindersbackpackers.com.au).

▶ **Luxe:** The W Melbourne is a particular architectural gem (+61 3 9113 8800; marriott.com/en-us/hotels/melwh-w-melbourne/), or for classic luxury, opt for the Langham (+61 3 8696 8888; langhamhotels.com/en/the-langham/melbourne). A list of reliable accommodations is available at visitmelbourne.com.

Austria

VIENNA

RECOMMENDED BY **Lorraine Monteagut**

From its manicured gardens and resplendent architecture to its opulent concert halls and refined cafés, Vienna is a city for those seeking to revel in the finer things in life, or simply anyone seeking a fairy tale.

"When I first came here, I didn't know what I was doing with my life," began Lorraine Monteagut. "I was in my PhD program, right before the dissertation. I was languishing after a breakup. I needed to get out of where I was. So, I took what money I had and decided to do a forty-day trip through Europe. The movie *Before Sunrise* inspired me to visit Vienna. I was a hopeless romantic and trying to reform my heart, and Vienna made me feel like there was nothing but future ahead of me, that I would be ready to fall in love again someday. The premise of the film is that these two people meet on a train, and spend the whole day and night walking and talking around Vienna. I decided I was going to re-create their journey."

Vienna may come across as a touch traditional—most shops are closed on Sunday, locals dress conservatively, and manners are reserved—but it is also a hub of arts, education, and progressive politics. Pedestrian crosswalk lights feature all gender couples, and a unique social housing program prevents residents from paying more than 25 percent of their income on rent. A robust subway and bus system (known as the U-Bahn) connects neighborhoods with ease, and you'll be hard-pressed to find a scrap of litter on the streets.

"I started walking from the Westbanhof train station, taking my time," continued Lorraine. "Vienna is a great place to just wander; it's so pedestrian friendly, and so clean. I made my way to the Zollamtsbrücke Bridge, which is a little green metal bridge that goes over the Danube. Nearby, there's a little red tram you can hop on that will take you through the Ringstrasse, which has all the main sights."

OPPOSITE:
Vienna's timeless elegance beckons our inner romantic.

Vienna's Ringstrasse doubles as a tidy tour of some of the city's best shopping, gardens, and monuments. These include the neo-renaissance-style State Opera House, the gothic spires of the Votive Church, and the palatial domes of the Natural History and Fine Arts Museums. "The Natural History Museum is so vast," reflected Lorraine. "I remember wandering rows of beetles and crystals, ogling dinosaur bones and Neanderthal artifacts. It was the first time I was in a museum by myself. You really could do most of these museums over multiple days; it's hard to pop in and out, or see everything in one go."

Vienna is a city that brings to life the concept of "third places"; that is, free locations where the public can mingle, stroll, and generally relax outside of either home or work. Victor Gruen, a 1940s Austrian architect who designed the original American shopping mall, did so with the third places of Vienna's Ringstrasse in mind. While Gruen's goal may have fallen short on American soil, Vienna's third places continue to welcome the general public with open, elegant arms.

"Vienna has so many public squares, but the best is probably Maria-Theresien-Platz," continued Lorraine. "There's a gorgeous, massive statue of the empress you can see. The city has so many parks. Gardens burst with rows of manicured tulips in the spring. I made my way to Prater Park, which has a nearby carnival with carousels and everything, and took a nap there. I mean I actually slept. Vienna is a safest city I've ever been in."

"Vienna is expensive, but everything is high quality," continued Lorraine, "and you can experience a tremendous amount of beauty for very little money. For example, I was continuously struck by the quality of the musicians on the street. It's like they are rehearsing for the orchestra. I heard a violinist playing under a bridge once, and he was so talented, and the acoustics were so good, I stayed and listen for an hour."

While a ticket to one of Vienna's famous balls or operas may set you back a pretty penny, one place where you can partake in luxury without breaking the bank is a Viennese café. "You can get a baguette and a rind of cheese for nothing and just nibble on it all day," reflected Lorraine. "You can pop into any of the cafés; there seems to be two on every block." If money is no object, on the other hand, check out Café Landtmann, a plush, wood-paneled nineteenth-century coffeehouse famous for its artful espressos, once frequented by Sigmund Freud and Paul McCartney. At Oberlaa Konditorei, a beloved citywide chain, visitors can partake in immaculate petits fours and ten-layer cakes so artfully decorated that it seems a crime to eat them. In the summer, sit on the terrace and enjoy a cocktail of house-made grapefruit ice cream, Aperol, and prosecco, served in long-stem flutes.

"Vienna is a city that preserves and reveres the fine arts," concluded Lorraine. "It's not a party city. It's not gritty. It's a safe place to be with your thoughts. It's the place where I felt most comfortable being alone in all of Europe. In Vienna you can move at your own pace, an observer of incredible beauty and the full range of human emotion. I'd say it's almost better to take it all in alone, so you don't get overstimulated and you have the breadth to absorb everything. I was heartbroken and trying to channel this beautiful love story. And in a lot of ways, Vienna offered that romance. It's a romantic city. You find romance everywhere, in yourself."

LORRAINE MONTEAGUT, PhD, is a world traveler, writer, and teacher based in Florida. She is the author of *Brujas: The Magic and Power of Witches of Color*, which has been featured in *Cosmopolitan, Book Riot, Bustle,* the *Witch Wave,* and more. She lives in St. Pete, Florida, with her partner, dog, cat, three beehives, and 100 plants and counting. You can find her teaching community workshops about tarot, astrology, and magic at @witchyheights.

If You Go

▶ **Getting There:** Vienna International Airport is served by several airlines, but is the hub for Austrian Airlines (800-843-0002; austrian.com).
▶ **Best Time to Visit:** Christmas markets and light displays make December a particularly charming time to visit. Spring plays host to the famous ball season and fields of colorful tulips. Summer has the least rain and warmest temperatures.
▶ **On a Budget:** Hostel Ruthensteiner (+43 1 893 42 02; hostelruthensteiner.com) is a perennial favorite of backpackers, along with the sleek JO&JOE hostel and hotel (+43 14 18 00 60; joandjoe.com/vienna).
▶ **Luxe:** A stay in a Viennese luxury hotel may be the closest most of us will come to being treated like rococo royalty. Favorites include the Hotel Sacher (+43 1 514 560; sacher.com/en/vienna), where even pets are treated like kings, and the Hotel Imperial (+43 1 501 100; marriott.com), a former residence of Duke Philipp of Württemberg. An overview of options can be found at wien.info.

Bhutan

PARO

RECOMMENDED BY **Jessica Nabongo**

All but floating in the sky north of India, Bhutan is a country that has kept itself deliberately hidden from the rest of the world. Never colonized, the Buddhist kingdom has staunchly made a point to maintain its traditional culture, even refusing to allow TV service to be installed until 1990. Today, although the visa cap has been increasing, the Bhutanese tourism council upholds strict policies to preserve the country's unique and unspoiled landscape. "I don't like to say I have favorites," began Jessica Nabongo, "but Bhutan is one of my GOATs [Greatests of All Time]. Everyone should see this place before they die."

Visitors who are lucky enough to make the trip often laud Bhutan as the real-life Shangri-La. Most visitors begin by flying into Paro, which happens to be one of the most precarious airstrips on the planet. "You're basically flying right into the Himalayas," remembered Jessica. "I've been on a ton of flights, and this descent was different. The clouds are hanging low, and then the mountains start to show, and you begin to see these super-lush green valleys. It's terrifying, and at the same time, absolutely stunning. As I got off the plane, one of the first things I noticed is how fresh and clean everything smelled. It makes you wonder what we're breathing elsewhere in the world."

Up until 2022, true solo travel was forbidden in Bhutan. All visitors had to book their travel through a registered tour company. Today, you are able to take on the country without these restrictions. However, there is still a strong benefit to entrusting your time to a local expert. "My guide, Tshewang Tashi, was so amazing," reflected Jessica. "If I didn't have him, it just wouldn't have been the same. You're with your guide every single day, you know? You basically become friends. The thing about Bhutan is that it's expensive to get there, but it's also a very easy country to visit. They set it up like a plug and play—you don't have to organize everything on your own, you can let go. This can be a challenge for

OPPOSITE:
Jessica Nabongo of The Catch Me If You Can *revels in a well-earned vista after hiking up the cliffsides of Bhutan.*

some people, but it's actually a wonderful treat. Also, the country is incredibly safe, and the people are kind and open and welcoming. I did not see another Black person while I was in the country, and I got a few double takes and some stares, but it wasn't like how it is in some other countries. No one was taking pictures or anything. And Tshewang, my guide, really let me do the things I was actually curious about."

Wellness resorts and spas abound throughout the country's landscape, offering weary travelers hot-stone massages and mineral baths with locally harvested herbs. Visitors can also opt to go whitewater rafting on the Mother and Father Rivers, or hike into the lush, green hillsides to visit the county's many cloud-wreathed *dzongs*—ancient Buddhist monasteries. The most famous of these may be the Paro Taktsang (aka "Tiger's Nest,") a steepled, white and red fortress that appears to be hanging off the side of a cliff. "It's a real hike," described Jessica. "I'm sure I was complaining about the elevation, but when you see this temple start to appear on the horizon, it's impossible not to feel fulfilled, to feel spiritual. You get to the top, and you are permitted to enter the temple, but you can't bring any phones in. So, you are forced to be present, in a way we aren't really asked to be present, especially at a tourist site."

A favorite sport in Bhutan is archery, considered by many to be an essential part of daily life. "It's basically the national sport," continued Jessica. "One day Tshewang and I were driving, and I saw this archery field. I asked him if we could pull over and try it. He knew the people at the field, so he went and asked. They said yes, and so there I was, in front of this group of old Bhutanese men, trying to shoot a target ten meters away, after I'd watched them shooting targets a hundred meters away. But they didn't make fun of me. After a few minutes, they came up and started giving me some pointers, so then there I was, getting an archery lesson from these experts. They were so friendly."

One warning for tourists: Although having a guide allows you to form your own unique itinerary, some activities, even if permitted, are perhaps best left to the locals. "When it's time to eat, I always wanna go where the locals go, right? The day we came down off Tiger's Nest, I asked Tshewang, 'Hey can we get some local food?' He tried to warn me. Bhutanese food is spicy—and I mean spicy as *hell*. We go to this local lunch spot, and they have milk on the table already. The food came, and my eyes watered just looking at it. But you know, I didn't want to back down at that point, since it was my idea. So, I dug in, and Tshewang is asking if I'm OK, and I'm like, 'Yeah, I got it!' But it was definitely not an experience I expected," laughed Jessica.

"The thing is," Jessica concluded, "you can do all these wonderful things, and your guide will help you, but you could even just drive around, and that could be enough. Just to experience the countryside would be enough. I just can't overstate how beautiful the country is, how friendly the people are, how safe you feel. I cannot wait to go back."

JESSICA NABONGO is a global citizen, master storyteller, and travel expert, who is the first Black woman to have traveled to every country in the world. Named one of the 50 Most Notable People in Travel by *Travel + Leisure*, Jessica uses her platforms to educate and inspire others to experience the world around them and build a global community, with an emphasis on bringing untold stories to the world. Her first book, *The Catch Me If You Can: One Woman's Journey to Every Country in the World*, published by National Geographic, was an instant bestseller. A first generation American, Jessica was born and raised in Detroit by Ugandan parents. She attended St. John's University in New York, where she earned a degree in English Literature, later completing a graduate degree at the London School of Economics. She is also the founder of the lifestyle brand the Catch. When she's not on a plane, she is home tending to her plants in Detroit and LA.

If You Go

▶ **Getting There:** Most flights connect to Bhutan through Delhi, Bangkok, or Kathmandu. Paro Airport, Bhutan's only international airport, is served by Druk Air (+975 8 276 430; drukair.com) or Bhutan Airlines (+975 7 710 6011; bhutanairlines.bt).
▶ **Best Time to Visit:** October to December is considered the ideal time to visit Bhutan. January and February are colder. In late spring the famous rhododendrons bloom, flooding the valleys with color, followed by a humid summer and the monsoon season from June to September.
▶ **On a Budget:** Paro has a remarkable number of upscale, low-cost hotels and hostels. The Bhutan Tourism Board lists suggestions, as well as guide services, at bhutan.travel.
▶ **Luxe:** There are a fair number of inclusive wellness resorts in Paro, offering guests yoga classes, ayurvedic spa treatments, holistic medicine programs throughout your stay, and more. Bhutan Spirit Sanctuary (+95 8 272 224; bhutanspiritsanctuary.com) is a notable favorite.

British Columbia

EMERALD LAKE

RECOMMENDED BY **Jess Baird**

The high-altitude granite slopes between British Columbia and Alberta boast hundreds of jewels, but one of the most notable—and perhaps overlooked—is Emerald Lake. "It's life changing," began Jess Baird. "There's no other way to say that. And I think people often miss it, even though it's in Yoho National Park. I was on a solo trip heading toward Jasper and just happened to see it on the map on the way. I feel like everyone knows about Banff and the crystal-clear water and all the lovely things in this part of Canada, but Emerald Lake was different. There wasn't any hustle-bustle, no big crowds. I called three days ahead and was able to reserve a cabin. That's not something you can usually do with somewhere this beautiful."

Emerald Lake is named for the fantastical hues of its waters, the product of glacial silt drifting down from the lofty mountains. "I couldn't even pick a single color to describe it to you," reflected Jess. "It changes throughout the day. During the morning and evenings, it's teal, like a tropical beach, and around noon when the sun fully hits the water, it's emerald." Edwin Hunter, a Stoney Indian guide, first took European settler Tom Wilson to the lake in 1882 during the construction of the Canadian Pacific Railway. Wilson would go on to become a guide for Lake Louise, Banff National Park, and other famous Canadian outdoor parks that have seen intense development. Emerald Lake, however, for all its beauty, seems to have remained relatively off the radar.

"When you arrive, it's almost like you're being taken away from your real life," continued Jess. "You park your car in an area that's totally separate from the resort itself. You hop on a shuttle and they take you away from the parking lot, on this bridge over teal water, heading toward a peninsula on the lake. There's a large lodge there, and lots of cabins with trails between them. But there are no cars. So, you're amid this serene

quiet, with the incredible granite mountains all around you. You aren't in the normal world anymore."

The lodge is the only property on the lake's peninsula, built of hand-hewn timber, with centuries-old fireplaces and ample lounging room for guests. The hotel doesn't have "rooms," but rather modern, updated cabins. The serenity and exceptional landscape views make it popular for photographers, elopers, and people who need an escape. "Solo travelers, we're all looking for a personalized experience," reflected Jess. "There's a reason we're traveling solo. Usually, we are trying to get away from our regular lives. We're wanting to escape and rejuvenate. You get here and there is no choice but to do that. There's no cell signal and no Wi-Fi except in the main lodge. People often tell themselves they want to go somewhere where they can unplug, but find themselves staring at their phone or computer once they're there. Here, you really have no choice. It's a real escape, a time to look inward and have a real journey and connect with nature—which I believe is the truest personal vacation you can get. The staff are not your typical hotel concierges; they're very personable, you feel like you're chatting with a friend when you talk to them. In October, when I visited, the place didn't have this busy family-vacation vibe like you might expect from a lot of lake resorts. Most people I saw were actually alone. There were a handful of couples; it's very romantic, of course. But most people there were solo. And it was very safe, which is incredibly important to solo travelers."

The lake is a four-season destination. In the winter, you are surrounded by pristine winter powder, perfect for cross-country skiing and snowshoeing. In the summer, the lake opens to fishing, boating, and swimming, and the mountains reveal their hiking trails. "There's a three-mile hike that goes around the lake, and it is also dog friendly," explained Jess. "You can see bald eagles, and watch the occasional paddleboard or kayak go out on the lake. The lodge is also a popular site for yoga and meditation retreats—a lot of activities around mindfulness and rejuvenation are brought here, and use the lodge as a base.

"One thing to keep in mind," continued Jess, "is there's only one restaurant on the peninsula. It's called Mount Burgess, and the nice thing is that the food is actually phenomenal. I had the spaghetti squash, and it was out of this world. It's a little upscale, yet cozy, with lots of couches and space to lounge. But that's the only thing that's really there. They do have a little café at the main lodge, but it can close if there is a wedding or

another large event. So, it's a good idea to bring your own groceries if you plan on staying for a while. The cabins have fridges and stoves."

For many, this level of solitude and isolation is the ideal. The nature is the goal, rather than merely the backdrop. "I woke up early the first day I was there and went to the main lodge to get a coffee. On my way outside, I noticed the lake was completely still, like a glass mirror. Across the water was this fog, rolling quickly, overtaking the still surface of the lake. It was completely supernatural. I was awestruck, just watching it move. Then I went back to my cabin and picked up my dog for our hike. On the way, I looked up and saw bald eagles. And I remember everything was so, so quiet. I felt like I was the only person there—and I know I wasn't—but I really felt like it was just me and the earth and the mountain and the lake. On the hike, as the sun was rising, it began to light up different peaks in the distance every so often. So, the whole view in front of me was constantly changing. It's like you're seeing mountains appear that you didn't know were there when you first woke up.

"The beauty of this place is the story," concluded Jess. "It's emotionally healing. I believed . . . I don't even know in what. I just felt like I believed. I had this new rejuvenation and enjoyment for life. I've traveled everywhere—everywhere. And there's no other place like this."

JESS BAIRD started writing down her thoughts over a decade ago, growing a collection of poems that caught the attention of more than 350,000 readers. She now tells these stories on Instagram, sharing her journey of love, heartbreak, grief, and healing. Jess' mission is to empower others to embrace the ebb and flow of life, to remind them the days that feel the darkest are actually the days that mold them into their most courageous and joyous selves. Jess' passions are sobriety, mental health, self-love, and taking the road less traveled. She enjoys people: listening, learning, and loving. While Jess resides just outside of Austin, Texas, you can usually find her curled up with a book, dreaming of her next adventure, or chasing the day's sunset. You can follow Jess on all social media platforms as @wordsofajay.

If You Go

▶ **Getting There:** Emerald Lake is 2.5 hours by car from the Calgary International Airport, which is serviced by many carriers, including Air Canada (888-247-2262; aircanada.com).

▶ **Best Time to Visit:** The lodge and Yoho National Park are open every season, with winter and summer sports available.

▶ **Accommodations:** While there is camping in Yoho National Park, Emerald Lake Lodge provides the only lodging on the lake itself (403-410-7417; crmr.com/resorts/emerald-lake).

British Columbia

VANCOUVER

RECOMMENDED BY **Laurie Liu**

"For me, solo traveling is about doing something you haven't done before," Laurie Liu began. "It should be inspirational."

Vancouver is certainly the kind of place with great potential to inspire!

Tucked into the southwest corner of the province of British Columbia, Vancouver is easily one of the most beautiful cities in North America. The city center is bordered by water on three sides—Burrard Inlet to the north, False Creek to the south, and English Bay to the west. On its northern tip is Stanley Park, one of North America's largest urban green spaces. The North Shore Mountains are in view on all but the foggiest days, further enhancing the city's natural beauty. While being British Columbia's commercial center, Vancouver's diverse and cosmopolitan community (including Canada's largest Chinatown) now attracts nearly ten million tourists a year.

"One thing that makes Vancouver great is the easy access it provides to both mountains and ocean," Laurie continued. "It's very easy to navigate Vancouver with public transportation. The SkyTrain will take you from the airport right to downtown. We have buses and sea buses that will get you anywhere you want to go, without needing an Uber or rental car. Visitors will also find that Vancouverites are easygoing, relaxed, and friendly. It can seem fast-paced at times, as it is a city. But if you need help, you shouldn't be afraid to ask. At their core, people want to give, and Vancouverites care a lot."

One of Vancouver's great natural assets is Stanley Park, which encompasses more than one thousand acres—the northwestern half of the city's downtown peninsula. Its amenities include fifteen-plus miles of forested trails, a par-3 golf course, a pool, a water-spray park, an aquarium, a miniature railway, beaches, a lake, an outdoor theater, a few restaurants, and five and a half miles of the Vancouver Seawall. The seawall is divided

OPPOSITE:
The Vancouver Seawall extends around the edge of Stanley Park.

into two sections: The half closest to the water is reserved for walkers and joggers, the inside path for bikers and in-line skaters. "One of my favorite things to do is to bicycle around the park," Laurie continued. "There are lots of bike shops in the area, and you can also rent a bike from public bike-share docking stations [provided by Mobi]. You don't generally get so much greenery right by the coast. And there are mountain views too."

The views from the mountains can be enthralling also. Cypress Provincial Park (just across Burrard Inlet in West Vancouver) is a treasured hiking destination for Vancouverites, boasting old-growth trees and delicious views of the city proper to the south, and snowcapped Mount Baker and the Cascade Range to the southeast. "Cypress Mountain has so many trails," Laurie enthused, "from easy to quite challenging. There's something for every ability level, and it's not far from the central business district." Cypress also offers both Nordic and Alpine skiing in the winter. Another nearby mountain escape is Grouse Mountain in North Vancouver, a half hour from downtown via public transit. "The famous hike here is the Grouse Grind," Laurie explained. "Much of the trail is on stairs, and it goes all the way to the top of Grouse [gaining more than 2,500 feet of elevation over 1.5 miles!]. Locals call it 'Nature's Stairmaster.'"

Most travelers—especially those visiting in the summer months—will want to at least dip their toes into the cool waters that surround Vancouver on three sides. Kitsilano Beach (known locally as "Kits") adjoins English Bay and offers a heated saltwater pool in addition to the Pacific. If you really want a taste of Vancouver beach culture, Laurie recommends heading a bit farther west to Wreck Beach. "The atmosphere is incredible. It's a clothing-optional beach, and some people might be nude, but not everyone. It's a come-as-you-are community gathering; people bring guitars, and there's singing and drum circles and people dancing. At Wreck Beach, you can get a real sense of the local people and how they like to enjoy a sunny afternoon. Make sure to also explore the gorgeous UBC campus while you are there!" Another great way to experience the waters around Vancouver is by boat—namely the city's miniature ferries, which can spirit up to eight passengers back and forth across False Creek on the south side of the downtown peninsula to Granville Island. Once a blighted industrial area, Granville's public market now features more than fifty food vendors; other island tenants include art galleries, performing arts venues, restaurants, brewpubs, and cafés.

Given Vancouver's "foodie" reputation, it's no surprise that you'll find a multitude of excellent dining options beyond Granville Island. "The downtown area—along Robson

and Denman Streets—has many of our best restaurants," Laurie said. "But if you want to feel like a local, you'll want to head to Chinatown to Phnom Penh, a Michelin Guide–recommended Cambodian–Vietnamese restaurant. The area is a little gritty, but there are always lines out the door. Diners order 'the holy trinity'—beef luc lac with fried egg on rice, marinated butter beef, and the most addictive fried chicken wings. You can't call yourself a Vancouverite if you don't go. I also recommend that people seek out restaurants in other parts of the city. For example, our best Chinese food is in Richmond. There are many master chefs from Asia who are cooking there."

Laurie Liu is a Vancouver-based photographer and content creator with a wanderlust soul. She uses her platforms (@laurieliu!) to showcase the most beautiful photo locations, hotels, food, and experiences from Vancouver and beyond. As a local Vancouverite who has lived in the city for more than twenty-five years, Laurie loves to share her extensive knowledge of the best spots around the city. Through her vibrant and whimsical photos, Laurie aims to encourage others to embark on their own unique journeys to discover the beauty of Vancouver and the world.

If You Go

- **Getting There:** Vancouver is served by most major carriers.
- **Best Time to Visit:** Vancouver generally experiences a temperate, if moist, climate, not unlike Seattle. The most reliably dry weather comes from June through September . . . though skiers may wish to visit in the winter, with smaller ski hills just outside the city limits and the mega-resort Whistler Blackcomb just a few hours north.
- **On a Budget:** Vancouver is not an inexpensive place to visit. But Panda Pod Hotel in nearby Richmond (778-308-4083; pandapodhotels.com) provides good value and is less than twenty-five minutes from downtown via SkyTrain.
- **Luxe:** Vancouver boasts a number of luxurious hotels, including the Fairmont Pacific Rim (604-695-5300; fairmont.com/pacific-rim-vancouver) and Marriott Parq Vancouver (604-676-0888; marriott.com).

Bulgaria

RHODOPE MOUNTAINS

RECOMMENDED BY **Alina Mcleod**

"I first came to Bulgaria in 2020, during the pandemic," began Alina Mcleod. "Travel wasn't easy, but it was my livelihood—I couldn't just stop. I had heard a lot of things about Bulgaria. So, I planned to stay for two to three weeks. I ended up staying two months. There are so many wonderful places in the country, but the locals kept telling me I needed to check out the Rhodope Mountains—that it was the most beautiful place, and yet so few foreigners knew about it."

The Rhodope Mountains span from Bulgaria to Northern Macedonia, a countryside of fairy-tale green forests, babbling creeks, and granite ridges. "It's absolutely stunning," continued Alina. "There's a tremendous amount to see and do. What I found most wonderful were the villages, where the architecture hasn't changed in two hundred years. They're using traditional farming techniques; the food is prepared right from the fields and gardens, and it's so incredibly fresh and delicious. And everyone was so welcoming. Even though there's an emphasis on traditional Bulgarian ways of life, most people spoke English. I was expecting that I'd have to rely on Google Translate most of the time—which would be tricky, because cell reception is very bad out there, and it's the kind of place where you want to already have your essentials because there aren't many supply stores—but it was impressive how easy it was to get around. I felt very comfortable and safe traveling by myself."

One of the most well-known towns is Shiroka Laka, particularly famous for its Rodopi singers and players of *kaba gaida* (a type of Balkan bagpipe). "Shiroka Laka has the largest folkloric music school in the country, and the town is very proud of the students. At certain times of year, you can even catch performances. A little town further away, called Gela, even has a bagpipe festival once a year where the musicians march up and down the hills."

OPPOSITE:
A hiker kicks back in the fresh mountain air outside a village in the Rhodope Mountains.

Rodopi architecture is characterized by cobbled streets, arched footbridges, domed monasteries, and inner gardens graced with water fountains. However, the buildings are not just for marveling at. To locals and guests alike, they are just a part of everyday life. "In Shiroka Laka, I stayed at hotel called Kalina, a local, family-run place, and they just were the loveliest people. Everything was reasonably priced, and everyone was so kind. In most of these villages, you're encountering almost exclusively family-run hotels. There are some nicer spa hotels that offer traditional hammams, with massages and steam rooms, but even these are run by families, out of traditional buildings. Almost every hotel has an amazing breakfast for you, as well, with traditional pancakes called *marudnik*, served with homemade yogurt and berry jam. They are on another level, they're so good."

Winter skiing, summer hiking, mountain biking, spelunking, and horseback riding are happy pastimes for those looking to explore the depths of the landscape. "Jeep tours are quite common. I wanted to get up to the lookout point of a place called Eagle's Eye one day. I was having a time of it driving my car, which can happen in some of these places deep in the mountains. The road sometimes turns to one lane and you have to be really careful, and they aren't always maintained. It took me so long to get up the road, and I finally realized that I wouldn't have enough time to actually hike. So, a guy in another Jeep sees me, and he says, 'We can connect you with a group that's going in an hour; it's only $15.' And then an hour later, I'm in this other Jeep with a bunch of young Bulgarian tourists, hanging on for dear life as the driver just whips around this road at the speed of light. But I trusted him, he clearly knew what he was doing. And the view at the top was incredible. After that, I had to take a road to a village two hours away—and there's no street lights on these mountain roads, they can be quite dangerous at night—and the tour driver just told me, 'Don't worry, I'm going that way. Let me drive in front of you.' He basically led me to my next place safely in the dark. I had a few experiences like this. I think it's just Bulgarian nature—they are so kind."

Beyond the famous Eagle's Eye lookout, other natural wonders to explore include the aptly named Devil's Throat Cave, whose entrance resembles a demon's head, complete with a 137-foot waterfall rushing down. The subterranean wonder was said to have inspired the tale of Orpheus descending into the underworld to save his beloved Eurydice. "The inside of the cave is pretty developed, so you can walk around fairly easily," noted Alina. "But if you're interested in going deeper, or exploring other caves, you can join spelunking expeditions."

After a day of exploring, consider dining at the curiously named (to English-speaking ears) Filter Inn "Uncle Jack." A Shiroka Laka staple, diners will admire the handmade tablecloths, vintage candlesticks, and traditional musicians serenading you through your evening. "They have a lot of traditional dishes like barbecue skewers of lamb, homemade cheese, garden-fresh vegetables, and a signature dish called *patatnik*, which is a potato pancake with herbs and spices. The restaurant, and really the whole area, is all about keeping the traditional culture alive, which is so wonderful, because it's heavenly."

ALINA MCLEOD is a Ukrainian/Canadian travel YouTuber who specializes in Eastern European destinations and loves to go off the beaten track. She started solo traveling at fifteen years old and has been to more than forty-five countries and six continents. Exploring a country by foot or public transit is her favorite way to get around and the fastest way to feel like a local in a new destination. She is passionate about helping her audience plan epic trips through her YouTube videos, social media content, and digital travel guides. You can find her on YouTube, Instagram, and TikTok by the handle @alinamcleod or purchase her travel guides on her website: alinamcleod.com. Next up on her travel bucket list is a half-year-long traverse through Central Asia, including Kazakhstan, Kyrgyzstan, Uzbekistan, and Tajikistan.

If You Go

▶ **Getting There:** The Rhodope Mountains are remote and best accessed by car, although there is some bus service. While Plovdiv is the closest airport, most flights are seasonal and private chartered. International visitors will have more options flying into Sofia, which is served by Bulgaria Air (+359 [0] 2 402 04 00; air.bg) and Ryanair (+44 871 246 0002; ryanair.com).

▶ **Best Time to Visit:** For skiing, winter is an excellent time to visit. For full waterfalls and wildflowers, early summer is best.

▶ **Accommodations:** Most villages have family-run guesthouses. The Kalina Guest House (+359 879 977 994; shirokaluka-kalina.com) is one of the few that can be reserved online ahead of time. The Bulgarian Ministry of Tourism can provide direction at tourism.government.bg/en.

California

PALM SPRINGS

RECOMMENDED BY **Adam Groffman**

There is no shortage of sunny getaways in Southern California. But Palm Springs has earned its reputation as *the* vacation spot for actors, writers, producers, and other various Hollywood celebrities seeking to rest and recharge (be sure to catch the Marilyn Monroe statue downtown). The oasis sports an iconic mid-century California aesthetic, complete with palm trees, pink flamingos, and retro-themed hotels. The unofficial motto, according to Steve Piacenza, owner of Boozehounds, where dogs are treated as well as human diners, is "Eat, drink, swim, sleep, relax, repeat."

"When you first fly in, you get off the plane and realize the airport is outdoors," began Adam Groffman. "So, you're immediately feeling like you're in a special place, that you're on vacation. There are birds flying in front of you, and trees over your head. There are no skyscrapers in Palm Springs, the buildings are low and short, and the air is hot and dry. The clean lines of the mid-century architecture contrast starkly with the raw beauty of the mountains. The entire city really feels like a town. It's so peaceful. No one is speeding anywhere; people are always walking and biking. I think that's why so many famous people came in here in the 1950s to get away—it's a place you can go to feel rested."

Although the town itself has much to offer, the unique wilderness around Palm Springs begs for exploration. This includes nearly twenty miles of rolling desert hills in the Mission Creek Preserve, or the cool, stark slopes of Whitewater Canyon, where you can climb up to a bluff that offers arresting views of the high peaks of the San Gorgonio Wilderness. If hiking isn't your thing, take the aerial tramway over the sheer cliffs of Chino Canyon up into the eight-thousand-foot peaks of the San Jacinto range. "There's snow up there almost all year," remembered Adam. "I went in March, and we hopped on the tram down in town, where it's already hot. So, suddenly we're at the top of this moun-

OPPOSITE:
Palm Springs is an oasis of mid-century glamour, sleek parties, and friendly solo travelers.

tain, in our swimsuits and flip-flops, in the snow. They have a bar up there, and an incredible view of the city. It was worth it."

Forty-five minutes from Palm Springs is famed Joshua Tree National Park, whose bizarrely tufted trees and playgrounds of boulders have inspired countless outdoor adventures as well as works of art. "It feels like a very mystical, magical place," reflected Adam. "There's a strange sensation you get when you're there. I went out there for a sunset hike, which, because it's desert, is relatively flat and easy. Everything is very still and quiet, sandy and brown; the trees are very weird and clumpy. I know this sounds strange, but being in Joshua Tree makes you feel like you're at the bottom of the sea. You're surrounded by cerulean-blue skies on a sand floor, and the rocks look like coral formations."

The seasons of Palm Springs are, curiously, opposite of other locations. The winters are relatively warm compared to almost every other place in the Northern Hemisphere. "When every other place is still stuck in winter, Palm Springs still has a vibe—there's people, it's lively, stuff is happening. In the summer, there is less tourism because it's so hot, but personally, that's when I think Palm Springs is best. I love the slow pace that life gets when things are very hot, when people are forced to slow down and take the time to enjoy their lives."

As a dedicated resort town, Palm Springs is dominated by the finer things in life. Public art galleries, serene spas, and posh boutiques reign downtown, and after sunset, a sleek nightclub scene blossoms to life. "I really enjoyed the gay nightlife there," recalled Adam. "Everywhere has a patio—most places are built to be half indoor, half outdoor. Wherever you are in Palm Springs, you feel very at one with nature. I went to one place called Chill Bar, where everything is blue neon, and there's a giant full-circle bar in the center of the main room, so everyone can see each other. The space is designed to inspire conversation. The patio is very green and lush, and they have a big dance floor in the back room that becomes a crazy party on weekends. Across the street is a bar called Hunters, which has a great drag show. And then right next to them is Dick's on Arenas, which has a calmer vibe, a jukebox, and pool tables. But my favorite place might be Paul Bar. The first time I went there, I came in alone and just sat at the bar, on a Tuesday afternoon. I began chatting with another guy who was there, also alone at the bar. I ordered steak tips and a Manhattan, and we just struck up a conversation. Turns out he was Alan Downs, the man who wrote *The Velvet Rage*.

"Palm Springs is a vacation town, but the locals aren't prickly," concluded Adam.

"There's a bridge between the locals and the tourists because the hangout spots are the same for everyone. I think because it's a gay hot spot, the locals get pretty excited about the visitors. Great shows and parties are always happening. Which, for a solo traveler, that is perfect."

ADAM GROFFMAN is the man behind *Travels of Adam*, a blog that inspires a fresh way to travel by featuring unique and personal stories from around the world, including a popular series of Hipster City Guides. The top-rated website strives to be a voice for this new generation of travelers: modern, open-minded millennials with a strong interest in city destinations, alternative tourism, and creative ideas. A self-described hipster travel blogger and one-time graphic designer, in 2010 Adam quit his job as a book designer in Boston, Massachusetts, and set off on a trip around the world. In 2018, *Travels of Adam* was awarded the Silver Prize for Best Travel Blog from the North American Travel Journalists Association (NATJA), and in 2017, the Gold Medal for Best Online Travel Series by NATJA for a series of hipster city guides. The website was also awarded the Lowell Thomas Silver Prize for Best Travel Blog by the Society of American Travel Writers Foundation (SATWF). Check out more guides and stories at travelsofadam.com.

If You Go

▶ **Getting There:** Palm Springs International Airport is served by thirteen airlines, with many routes on Southwest (800-435-9792; southwest.com).

▶ **Best Time to Visit:** Winter and early spring are the most popular times to visit, thanks to the temperate weather and chance to see snow on the mountains.

▶ **On a Budget:** The most affordable places are on the outskirts of Palm Springs proper, but the Vagabond Motor Hotel (760-325-7211; vagabondmotorhotel.com) is a favorite downtown.

▶ **Luxe:** As a vacation town, Palm Springs has a variety of top-tier resorts to choose from, including the sleek L'Horizon Resort and Spa (760-323-1858; lhorizonpalmsprings.com) and the delightfully retro Orbit In (760-323-3585; orbitin.com). Visit Greater Palm Springs lists reliable hotels at visitgreaterpalmsprings.com.

Chile

PATAGONIA

RECOMMENDED BY **Sabrina Middleton**

According to biologists, there are 110 different ecosystems in the world. Chile possesses eighty-nine of them. The promise of snow-cloaked mountains, alien-blue glacial lakes, smoking volcanoes, lush forests, high deserts, majestic glaciers, and rare wildlife make Patagonia a bucket-list destination for backpackers, mountaineers, and rock climbers the world over. Torres del Paine National Park is perhaps the most well-known portal into the region. However, the crowds at Torres are often overwhelming, making the freshly minted Pumalín and Patagonia National Parks especially alluring. "The thing about Patagonia is that the distances are long, and the travel between the parks can take days," began Sabrina Middleton. "I cannot emphasize enough the remoteness of these places. If you can afford it, it's better to take charter flights, to maximize your time. The landscapes just go on forever."

In Alerce Costero National Park, visitors can forest bathe among ancient Patagonian cypresses, including a visit to the Gran Abuelo—a roughly five-thousand-year-old tree that many consider to be the oldest living thing on planet earth. Hundreds of miles south, at Pumalín National Park, a hike up the active volcano, Chaitén, takes visitors past steaming fumaroles and fingers of devilish red mineral deposits. In Patagonia National Park, witness a number of perilously endangered species that are in the process of being reintroduced back to the landscape. These include condors, charismatic chucao tapaculo birds, majestic puma, and rabbit-eared viscacha. "Much of this area used to be barren, desolate land from estancias that Kris and Doug Tompkins bought and then donated back to the Chilean government in the form of parks. They are in the process of rewilding from cattle farming.

"At one point we were walking through the park, and we stumbled upon a guemal mama and her baby," recalled Sabrina. "And you might think, 'Oh, it's just a deer, we have deer back home,' but it's not. It's a symbol. It's this thing that's supposed to be there, that

DESTINATION 13

OPPOSITE:
Patagonia's wild landscapes evoke unparalleled feelings of solitude for those who crave remoteness.

was almost entirely removed due to human development. It's on the Chilean coat of arms! And it's finally returning back. I get goosebumps just thinking about it."

Being in these new parks also offers opportunities to meet the people undertaking this important rewilding work. "Something funny is that when you travel, what you tend to really remember, over any lakes or mountains, are your connections with people," reflected Sabrina. "One of the coolest things we did was visit a rhea bird rehabilitation center. This place had literally one woman in it, Alessandra, who lives there year-round by herself, incubating eggs, raising the birds, and then releasing them into the wild right there.

"We also visited a Mapuche village, one of the Indigenous communities," continued Sabrina. "And this wasn't a song-and-dance kind of thing. They didn't perform for us. It really was more an exchange of knowledge. We had an outdoor ceremony thanking the earth, and had lunch together. They take a big log, maybe six feet long and ten inches in diameter, and smash corn paste onto it and then roast it over a fire like it's a spit. We got to learn about their weaving techniques and explore the greenhouse. It wasn't kitschy, it wasn't staged. It felt really nice, just talking and seeing what our two cultures are all about."

In Pumalín and Patagonia National Parks, amenities are slim, in part due to their newness. That is to say, competition for backcountry camping permits is nonexistent. However, if you don't feel like sleeping outside, the parks' lodges are at your service. "You don't need to come with a perfect, massive itinerary. Explora Lodge in Patagonia National Park offers full- and half-day tours for kayaking, hiking, puma-watching, everything. They have amazing guides and they are all-inclusive; the hospitality was the best. In Pumalín, they have Caleta Gonzalo, where you can stay in little rustic cabins, set on the fjords where dolphins are swimming. The food is really good, which is nice, because, well, there's nothing else there. Nobody is going to these parks. Everybody is going to Torres del Paine. And that's epic, it's classic, sure. But Patagonia National Park had similar landscapes, and they are so much more intimate. The staff knew my name after the first two days. They knew I liked avocado with my breakfast, that kind of thing.

"If you're traveling alone, you don't have to worry too much about what's safe and what's not," concluded Sabrina. "In Santiago, where you'll likely have a layover, I walked around by myself with no problems. In the parks, there's amazing wildlife, yet nothing is dangerous. The pumas never attack humans—they are satiated with guanaco. There are no poisonous insects or snakes. There are not a lot of other people around. And when there are, they are very like-minded. If you like your solo time in mountains—this is it."

SABRINA MIDDLETON is the director of client services at Geographic Expeditions. She believes in the power of travel to make the world a kinder place and calls herself an ambassador for peace. She joined GeoEx in 1995 after returning from an eighteen-month around-the-world journey and realizing that she couldn't continue in litigation consulting. Her wanderlust has led her to cuddle koalas in Australia, venture into the impenetrable forest of Uganda to observe a gorilla family, hike to Machu Picchu, ride camels in India, trek in the Himalayas, zip-line through the jungles of Guatemala with her sons, waddle with penguins in Antarctica, crash through ice in the fjords of Greenland, ride the Trans-Siberian Railway across Russia, and much more. Sabrina wears many hats at GeoEx, including lining up polar cruises, planning custom trips for individuals, and arranging complex flight routings for GeoEx guests as part of GeoEx's air team. She loves getting to know GeoEx travelers so that she can hone in on the best options for them and then handle all the details to make their journeys seamless. And when guests are home, she enjoys hearing all about their experiences—which often leads to brainstorming their next adventures.

If You Go

▶ **Getting There:** For Pumalín National Park, visitors can take a combination bus/ferry route from Puerto Montt, home of El Tepual Airport served by Sky (1-786-405-0680; skyairline.com) and LATAM (866-435-9526; latamairlines.com). For Patagonia National Park, catch a flight to Balmaceda Airport (also served by Sky and LATAM), then either charter a flight to Cochrane Airport, or catch the private, seven-hour bus ride to the park's entrance.

▶ **Best Time to Visit:** October through February (spring and summer) offer the best weather.

▶ **Accommodations:** Explora Lodge can be booked at explora.com and Caleta Gonzalo at lodgecaletagonzalo.cl. No overnight camping permits are required in Pumalín National Park. For Patagonia National Park, backcountry camping is limited, and some routes require permits, which can be obtained at ranger stations.

Costa Rica

NOSARA

RECOMMENDED BY **Shelby Stanger**

"We used to never say the name of the place to outsiders," began Shelby Stanger. "We were trying to keep it a secret, although I think the secret is out now."

Nosara has spent decades establishing itself as a paradise for surfers, bird-watchers, and yogis. In the early 1970s, President Rodrigo Carazo Odio remarked, "Why would we cut down a tree and sell it once when we could keep it standing and sell it over and over again?" Costa Rica has preserved nearly 25 percent of its interior wilderness, with a warm, friendly attitude toward curious ecotourists while maintaining a brilliantly high quality of life for locals. "Nosara is in a Blue Zone," explained Shelby. "That's an area of the world with a high population of people who consistently reach the age of one hundred, with few cases of diseases like diabetes and heart disease—diseases that result from a more processed diet and typical Western attitude toward stress and mental health. So, the people here tend to be really healthy and also really happy. They have a phrase: *pura vida*, pure life, and it's really exhibited."

The emphasis on ecotourism and *pura vida* makes Nosara an ideal destination for travelers following their own itineraries or traveling as a part of a group retreat. Popular tours focus on hiking the depths of the emerald jungle, spelunking in ancient caves, glimpsing parrots and toucans in the Sibu Wildlife Sanctuary, or watching the gentle stirrings of baby sea turtles at the Ostional National Wildlife Refuge. However, the most famous pastime in Nosara is probably surfing. "I can wake up, walk outside in just my bikini, throw a couple bucks into my swimsuit, surf, and then when I get tired and thirsty, get out of the water, walk down the beach, give the dollar bills to a Costa Rican guy nicknamed Gato, and he'll take a machete and cut up a coconut for me, then I'll chug it, and go back into the water. That's a typical morning," reflected Shelby.

DESTINATION 14

OPPOSITE:
Nosara is a haven for surfers, yogis, and coconut lovers.

"Nosara is great if you're a solo traveler, and especially if you don't yet know how to surf," continued Shelby. "The beach is wide, the bottom is soft sand, and there are tons of surf schools. But you don't have to be a surfer, of course. Many people are there for healing. Classes at the Yoga Institute are open to the public so that prospective teachers can hone their skills. Almost all are all held in open-air huts, with a roof to prevent any sudden tropical showers from lessening your grip. The walls, however, are rainforest," added Shelby. "A monkey might pop his head in, or a bird will fly through. The birdsong in Nosara is constant, incredible."

There's an almost overwhelming amount of outdoor adventures to partake of in Nosara, but visitors need not feel like they should arrive with a firm plan. This is a location for practicing release and meeting new friends. "It's a really user-friendly town; you can walk everywhere or take a tuk-tuk. You can rent a quad and take it out to the local waterfall, or check out a monkey sanctuary. Wherever you go, there are places to meet people: on the beach, at a bar, getting a smoothie. If you surf or do yoga, it's easy to meet people because you'll probably keep running into each other wherever you go. I accidentally got in someone's way while surfing once—I stole his wave—and he was a local. I was so embarrassed. I apologized profusely. And he just said, '*Pura vida!* No worries, plenty of waves!' I'll never forget that moment. It really crystallized how kind people are here, how it inspires kindness in everyone who comes here. I actually met my husband there while surfing. We ran into each other in the water at six A.M. And if you get banged up, there's a town doctor. He plays in a punk band."

A plethora of restaurants and hotels await travelers of any budget, but for a particularly memorable experience, visit the juice bar at the Harmony Hotel, or take your dinner on the beach at La Luna in Playa Pelada. "I would really recommend breakfast at the Beach Dog Cafe, coffee at Olo Alaia, or for amazing local food, go to Rosi's Soda Tica—they do such a great *casado* with fish," advised Shelby. "Another interesting place to visit is called the Apothecary. The woman there, Kathryn, makes her own herbal potions and lotions. There are a lot of really cool spots like that."

Although tourists should keep in mind not to walk around alone late at night (the kindness of *pura vida* does not extend past common sense), Nosara, in a word, could be summed up as: easy. "It's an easy adventure with the comforts of home. The busy season is December through April, but I find the offseason, the summer, to be better. Listening to the jungle in a rainstorm is like listening to a rain track on steroids. It's simply magical.

It's getting expensive in some parts—it's getting popular—but it's still Nosara. Every time I go there, I feel restored and renewed."

SHELBY STANGER is an award-winning podcast host, author, journalist, and speaker. In 2016, she created the *Wild Ideas Worth Living* podcast, which she sold to REI Co-op four years later and still hosts. The show features high-impact interviews with world-class adventurers, authors, scientists, athletes, health experts, and explorers who have turned their own wild ideas into a reality. She also created a podcast about health and humor called *Vitamin Joy* in 2020, and has hosted a travel show for Lufthansa. In 2023, Shelby released her first book, *Will to Wild: Adventures Great and Small to Change Your Life,* with Simon & Schuster, and also did a TEDx talk of the same title. In addition to her work as a storyteller and journalist, Shelby is a longtime board member for Outdoor Outreach, a nonprofit that helps empower at-risk kids in San Diego through outdoor programming like rock climbing, snowboarding, and hiking. The common thread to everything she does: A little adventure is life's antidote. Here's to second chances. To soul seeking. To success.

If You Go

▶ **Getting There:** Liberia Guanacaste Airport is the nearest international airport to Nosara and is served by several carriers, including Alaska Airlines (800-252-7522; alaskaair.com) and JetBlue (800-538-2583; jetblue.com). From here, it's a roughly two-hour drive.

▶ **Best Time to Visit:** The best surf—and the driest skies—lasts from mid-December through April. For magical jungle rainstorms and fewer crowds, visit between June and August.

▶ **On a Budget:** Affordable digs can be found, usually set back a bit from the beach, on Route 160. Favorites include Selina Nosara (+506 8919 4914; selina.com) and Hostel Nicoa (888-881-2131; casa-nicoa.hotelsguanacaste.com/en).

▶ **Luxe:** Beachside wellness resorts in Nosara feature organic breakfast bars, afternoon yoga classes, and custom spa treatments. Tierra Magnifica (800-600-0881; tierramagnifica.com) and Bodhi Tree Yoga Resort (+506 2682 0256; bodhitreeyogaresort.com) are among the most luxurious.

Cuba

HAVANA

RECOMMENDED BY **Amanda Black**

Cuba spent a healthy part of the nineteenth and twentieth centuries under the yoke of Spanish and American military power. Today, it is a country often described as being frozen in time—more precisely in the late 1950s, when the United States imposed a trade embargo in retaliation to Fidel Castro's communist revolution. American tourists were officially forbidden to visit the island until the so-called Cuban Thaw of the early 2000s. Even now, visas are only approved for twelve official reasons. These include visiting family, conducting business, and providing "support for the Cuban people." That last one works well—especially since it's what most tourists end up wanting to do.

"Some people who've never been there might argue that Cuba is this poor, sad country, but it's more complicated than that," Amanda Black began. "The people are so kind and they do their best to be happy. They are resilient. The politics, history, and the story of revolution is an interesting aspect of the culture. What Cubans really have is an amazing history of perseverance. They have limited resources and what many call political repression. But they're making art, they're making music, they're smiling at tourists, they're laughing, even when the power is out and there's no food, and there's just been a hurricane . . . they always seem to make the most of their circumstances, and it's a lesson that everyone needs, I think."

Located ninety miles off the Florida Keys, Cuba is in many ways an idyllic Caribbean island, complete with swaying coconut trees, salsa clubs, blissfully uncrowded beaches, and (arguably) the clearest ocean you'll ever see. Snorkeling, diving, and soaking up tropical sunshine are all on the menu. But it also offers significantly more than your typical island paradise vacation might. "There are some challenges to traveling to Cuba solo. It is not a place with a lot of frills, so you have to roll with the punches. The internet

OPPOSITE:
The residents of Havana love to chat with outsiders, and the interior of Cuba contains incredible farm tours.

is unreliable. Bottled water can be hard to find sometimes, and sometimes restaurants won't have food to serve," noted Amanda. "But it's also great for a solo traveler because you don't have to pay a lot of money to have wonderful experiences, and you don't need a guide—you can do a lot on your own. Cuba is very safe. You can walk around by yourself. Tons of people will talk to you, but they don't want anything from you except to chat. Go sit on a bench in a random park (of which there are many), and within a few minutes, a local will come and sit next to you and just chat with you about anything: politics, their life, their dog . . . I've had some of the deepest conversations I've ever had with random strangers in Cuba."

The capital and main city, Havana, is a haven of colorful, tightly packed, neoclassical buildings, historic churches, open-air markets, green parks, and of course, salsa clubs. "You can take a salsa class anywhere. One of the most fun things to do is just go to a bar, drink a few mojitos, and let the locals teach you how to dance. In Havana, salsa is anytime, anywhere."

Further outside of the capital, Cuba's lush, mist-draped hills beckon. Approximately two hours' drive from Havana, the town of Viñales makes for an excellent stop to explore farmlands and oft-forbidden exports. "Walking through Viñales is a dream. See the animals and wildflowers, roll your own cigars and smoke them with a farmer who grew the tobacco, taste the coffee that was grown next to where you're sitting. In a lot of these small towns, people are cooking with fire—not a stove, but actual fire. One time I went, I met a farmer's daughter in Viñales who decided to take us around her coffee farm—not a big, fancy plantation but to the actual house of the farmer who is growing the beans. So, there I was, just in his coffee plantation; floors are dirt, his granddaughter is playing in the corner. And I sat with him, heard his stories. Now we're friends, and folks can meet him on our tours. On our Meetup Tours, organized adventures just for women, we focus on genuine connections with local people who want to share their world with us.

"I think a condition of going to Cuba is that you have to support Cubans," continued Amanda. "This means not staying in a hotel, because all hotels are owned by the government. Instead, the best thing to do is stay in people's homes who are renting rooms to tourists. This is also great because you get to be involved in family life and see how people actually live their lives. You connect with them, maybe meet their grandma and pet the dog, and you talk with and hang out with your hosts. Some of my best memories happened when I was staying at casas in particular.

"The first time I went, there was this park, with a community center and bar. It was *the* spot to go for nightlife. By the time I returned, the club had been destroyed in the hurricane. On our Meetup Tour, we took a group of travelers to the new building, and had a salsa teacher and a group of local women to teach us to dance, because they're *good* and they wanted to meet us. By the end of the class, it was a party. Everyone who heard the music and felt like dancing came and joined us. It was so much fun, and it shows you how down they are for a good time."

AMANDA BLACK left for a four-month trip to the Middle East, and ten years later, she is still traveling and living abroad. Humbled by her travels and inspired by the women she met along the way, she became passionate about creating a community for like-minded travelers, so she founded the Solo Female Traveler Network. Her company offers incredible small-group adventures just for women. All her tours support local people, include unique itineraries, and put you in the way of new friends and epic travel experiences. The company also has the largest community for solo female travelers, which grew from a small Facebook group of just Amanda's friends to a community of more than five hundred thousand women from around the world.

If You Go

▶ **Getting There:** Havana's José Martí International Airport is the hub of Cubana de Aviación (+537 8381039; cubana.cu), but American Airlines (800-433-7300; aa.com) also runs a number of international routes.

▶ **Best Time to Visit:** Winter is the most popular month, due to less rainfall. The island is relatively warm year-round. The summer months are notoriously muggy, although Carnival celebrations in August are often worth the rain.

▶ **Accommodations:** Most homestays are best booked on the ground, or you can see options at peer websites like homestays.com.

Czech Republic

PRAGUE

RECOMMENDED BY **Shannon Burla**

"Prague has always had this kind of mysterious attraction for me," began Shannon Burla. "It has this compelling, ancient aura to it. Most of the Old Town has survived centuries of violence and wars. Just being able to stand in the presence of all of these ancient, preserved buildings is incredibly special."

Nicknamed "the city of a thousand spires," Prague is a mecca for artists, architecture buffs, and history geeks with a penchant for darker stories. Nearly every architectural style in Europe's history is on display along the city streets, from the intricate details of the gothic Saint Vitus Cathedral to the modern glass waves of the 1980s Dancing House. It is a city that embodies mystery, elegance, and the heavy, dark intensity that characterizes so much of Eastern Europe.

"Prague has this fragrance to it," reflected Shannon, "and the only comparison I have is ancient stone. It's this kind of deep musk—like a basement, but more interesting. It's intriguing, not pungent. The air in Prague is heavy, and humid, like you can feel the weight of its history."

Walking through the streets can give the sensation of walking through time, strolling over medieval bridges toward baroque castles, on the way to museums dedicated to cubism and art nouveau (be sure not to miss the Mucha Museum, dedicated to the king of art nouveau himself). Stroll the grounds of the ninth-century Prague Castle, the largest castle complex in the world and the seat of power for dozens of emperors of the Holy Roman Empire. From there, head east and walk toward the famous arches of the Charles Bridge and enter the Old Town, which is the site of countless historical gems. Walk along the "Royal Way" to the gothic Powder Gate, under which Czech kings once crossed as part of their coronation processions. On the way, be sure not to miss the

DESTINATION 16

OPPOSITE: *Prague has much to offer to a wandering artist with a shadowy side.*

Prague Astronomical Clock, a machine that resembles a relic from a fantasy film. "It's hard to believe it was installed in the 1400s," said Shannon, "and that they've only had to maintain it. The structure is original; it's one of the oldest working astronomical clocks in the world. You're really looking at ancient, functioning technology."

The Old Town is also the site of one of the oldest public squares in Prague, which served as a marketplace for international traders traversing the crossroads of Europe as far back as the tenth century. "There are tons of street performers in this square," explained Shannon, "and they're really good. I saw a guy who swallowed a balloon, followed by a sword. I saw an amazing santour player as well, and he was the nicest person. His music just evoked these feelings that made you want to sway right there. He was so precise and meticulous. The caliber of performers in the Old Town Square is so incredibly high. And these are just the people busking on the street. If you're an artist, you need to go to Prague."

Before heading out of the Old Town, be sure to stop at Wenceslas Square, which has seen some of the most important moments in Prague's history, including national hero Alois Jirásek reading the Czechoslovak Declaration of Independence for the first time in 1918, public demonstrations against Nazi Germany, and the self-immolation of student Jan Palach to protest the Warsaw Pact's invasion.

Prague's history is endless, and historical walking tours, river tours, and ghost tours are offered in abundance. "Prague's streets and trains are easy to navigate as a solo traveler," explained Shannon. "Everyone speaks English. I learned how to say thank you and hello, but if I needed help, I could often find it. It's a popular tourist spot, so you have safety in numbers, in that sense. It can be annoying, but I also realized there's a sense of safety when other people are doing exactly what you are doing.

"I wasn't intending to be there alone," remembered Shannon, "so I decided to do things that I knew my boyfriend wouldn't want to. I had the space to do the things I really wanted to do."

If you crave more of Prague's macabre side, take the half-hour train ride to Sedlec Ossuary. In 1511, legend holds that the task of exhuming some forty thousand to seventy thousand bodies (most from the Black Death and Hussite Wars) was given to a half-blind monk who worked at the Sedlec Abbey. Then, in 1870, a woodcarver named František Rint was tasked with putting these bone heaps into order. The result is a chapel decked in bones in the way a child might build a house of LEGO. A massive

chandelier made of every bone in the human body hangs from the ceiling, and frescos made of skulls and femurs decorate archways. "It's surprisingly symmetrical, considering what they were working with," remembered Shannon. "It's one of the darkest places you'll ever see. For anyone who has any morbid fascinations, it's worth the effort."

After checking out the ossuary, it's time to explore Prague's food scene, of course. Some highlights include a tasty bowl of goulash or a plate of *knedlíky* dumplings at Pivovarský dům, a traditional Czech restaurant with a microbrewery in the New Town neighborhood. Or, if you don't want to leave the Old Town, head to Kantýna, for what is rumored to be the best pastrami sandwich in the city (without breaking the bank).

If you need a palate cleanser from the shadows of Europe's past, head to the John Lennon Wall, a graffiti mural dedicated to the man who told the world that "all you need is love." "There is a candy shop right near there," remembered Shannon. "You walk in and you're handed a scoop and a bag, and you just go to town. I'd never seen anything like it. There's all kinds of candy you've never seen before, so beautifully arranged. You feel like you're in some fairy tale.

"Before I went to Prague, I thought of vampires and mystery and Mucha," concluded Shannon. "And after going to Prague . . . I feel the exact same way. The mystery bubble wasn't popped. It's a rare place that actually lived up to its reputation. Prague has a lot to offer an artist with a shadowy side."

SHANNON BURLA is an international fusion belly dance artist and instructor who has performed and taught across the world. She was born and raised in the San Francisco Bay Area, and disappears into the Sierras as often as she can, finding peace in the solitude and wisdom that can only be found among the endless cliff faces of granite, ancient sequoias, and alpine lakes. She is a certified Bohemian Belly Dance Foundations instructor, dance company member of Jill Parker's Little Egypt, and director of the Dancers of Nyx. She loves monster makeup, chocolate, beasties large and small, and world travel.

If You Go

▶ **Getting There:** Few international airlines fly direct routes to Prague's Václav Havel Airport. Many opt to fly into Berlin Brandenberg Airport and catch a regional flight to Prague on Ryanair (+353 1 255 5212; ryanair.com) or easyJet (easyjet.com). Alternately, the five-hour train ride from Berlin is picturesque.

▶ **Best Time to Visit:** Visiting in spring or fall is the best way to avoid the crowds of summer.

▶ **On a Budget:** A plethora of unique, artistic hotels exist in Prague for very little per night. A Women's Only Hostel (wohprague.cz) is situated in the heart of Old Town, and nearby Hotel Golden Crown (+420 222 944 114; hotelgoldencrown.com) offers private rooms for near-hostel prices. The Prague City Tourism website (prague.eu), has a list of many different accommodation types.

▶ **Luxe:** There are a handful of premium hotels within the Old Town itself, including the Grand Mark Prague (+420 226 226 111; grandmark.cz), a former baroque palace. Across the bridge, below the Prague Castle, the five-star Augustine Hotel (+420 266 112 233; marriott.com) incorporates an Augustinian monastery within its grounds.

Denmark

COPENHAGEN

RECOMMENDED BY **Theresa McKinney**

The capital of Denmark is filled with elegant green spaces, legendary castles, and *hygge*—that quintessentially Danish word that roughly translates to a kind of cozy contentment. In other words, Copenhagen exemplifies some of the best parts of Nordic life.

"Copenhagen got on my bucket list because of the US Virgin Islands, actually," began Theresa McKinney. "I'd vacationed there repeatedly, and there's a large Danish colonial influence in the Caribbean. It got me really curious about what Copenhagen was like. I'd seen pictures of the Nyhavn Harbor, the colors and boats. But I wanted to learn more about the history. It was calling my name."

Denmark's land is divided between Jutland (the mainland, which "juts" into the North Sea) and the more than four hundred islands that fan east toward Sweden in the chilling, steel-blue waters of the Kattegat Sea. Denmark is often considered a land of fairy tales, inspiring such classic works as "The Little Mermaid" and "The Snow Queen." The whole country is covered with fairy-tale lore, from the Gisselfeld Kloster (the royal estate said to inspire "The Ugly Duckling") to Egeskov Castle in Funen, whose gardens and grounds inspired much of Hans Christian Andersen's writings. In Ærøskøbing, a meticulously preserved old town where some parts are actually more than 750 years old, the cobblestone streets seem to radiate magical history.

Copenhagen is filled with this folktale aura, and at the same time, is a modern, bright metropolis with a supremely high quality of life. "Copenhagen is extremely modern but without that cold feeling," described Theresa. "It's very warm. You have cobblestone streets and buildings painted vibrant oranges, reds, and blues. It's very artistic. There are so many sculptures and other little colorful murals that brighten up the cloudy days. Overall, the city has a happy feeling. And I don't think I've encountered

17

DESTINATION

better public transportation anywhere else. Wherever you are going, if you can't walk there, you can get there by train and bus. You don't have to know anything about how it works ahead of time. When you travel alone, you often have to learn how to get around alone, and here it is simply so easy. I just showed up and navigated everything with a little help from Google Maps."

The most popular tourist destination is probably Nyhavn, a colorful row of seventeenth-century houses snuggled sweetly on Copenhagen's harbor, where Hans Christian Andersen himself once lived. "Nyhavn was just as charming as I imagined it to be," reflected Theresa. "It's not historical on the inside. It has trendy little restaurants and modern shops. But it's not kitschy; everything in there is high quality, romantic, quite charming." Just north of Nyhavn is Langelinie Pier, home to Copenhagen's (arguably) most visited landmark: a statue of a beautiful young woman with fins instead of feet, sitting on a rock and staring into the sea in eternal contemplation about where she belongs—also known as *The Little Mermaid*. "*The Little Mermaid* is in one place where you have to walk a half mile to get to, even with public transportation," reflected Theresa. "When I made my way there, it was drizzling a bit, and then started pouring rain—I mean just pouring. My jeans were completely soaked. Then it cleared up suddenly, and there was a rainbow behind the statue, which felt very special."

Denmark is home to more castles than any other country in Europe, and Copenhagen includes some of the most impressive. This includes the Christiansborg Palace—a resplendent estate still in official possession of the Queen of Denmark—used for balls, banquets, and other occasions of states. "It is very polished and manicured," remembered Theresa. "The queen's library there reminded me of the one in Disney's *Beauty and the Beast*, with all those high, white walls of bookcases."

Just up the road is Rosenborg Castle, built in the seventeenth century and showcasing four hundred years of royal treasures, including the Danish Crown Jewels and Royal Regalia. Spiral staircases lead to rooms filled with lavish portraits, and tapestries commemorating battles between Denmark and Sweden. The Knights' Hall contains the country's coronation thrones, decorated with narwhal tusks and three life-size silver lions standing guard. "Rosenborg Castle hasn't really been altered," noted Theresa. "It gives you an idea of what it really looked like in the past.

"I'm drawn to history," continued Theresa, "so I made sure to go to the National Museum of Denmark. The museum covers all the way back to Danish prehistory, but

the *Stories of Denmark* exhibition covers the period from 1660 to 2000. It does an awesome job of telling the complete story of modern-day Denmark in a concise way: why and how the buildings look like they do, what rulers were in charge, why there are canals, and the motivations behind the colonial campaigns. You could go in knowing nothing about Denmark and leave with a much better understanding just by strolling this one exhibition."

Traditional Danish foods include smørrebrød (open-faced sandwiches), *kartofler* (a caramelized-potato side dish), and of course, a host of pastries so delectably iconic, the English simply refer to them as "Danishes." "When I travel alone, I tend to keep things simple when it comes to food," reflected Theresa, "but one highlight of Copenhagen is Tivoli Food Hall across from Tivoli Gardens Amusement Park. I got a lobster roll there that was extremely delicious. Hot dogs are also a big thing in Denmark, as they are in many Nordic countries. One of my favorite dishes, though, was the porridge bowls. They're a bit like oatmeal, except even more cozy and heartwarming, and with fancy toppings like coconut and cacao nibs. I really enjoyed the ones at Grød, a local café chain.

"My final advice, if you're planning to visit Copenhagen, is to not overplan. Everything is centered on the weather. It's so variable, it's not even worth looking at the forecast. It can be hailing one minute and sunny the next. So, it's good to leave room for being spontaneous, and it's easy to change your mind to do other things because everything is easy to access. I got to do a canal tour at the last minute simply because the sun was out so I thought, 'I should do this right now!' Copenhagen is just a lovely place to walk around, get lost in the winding streets, and explore history."

THERESA MCKINNEY is a travel writer based outside of Cleveland, Ohio, who has been featured in outlets like *Outside* magazine, *Fodor's Travel*, and *Atlas Obscura*. After working as an accountant at a CPA firm for eight years (while moonlighting as a travel blogger for three of them), Theresa left her comfortable tax job to pursue the wild world of travel writing full-time. Her endless curiosity has brought her to twenty countries and counting, although she also loves to revisit her favorite destinations, like France and Iceland. When not writing on her travel blog, *Fueled by Wanderlust*, Theresa loves getting lost in the US Virgin Islands, taking walks along Lake Erie, and learning French.

If You Go

▶ **Getting There:** Most visitors fly into Copenhagen, which is served by most major carriers.

▶ **Best Time to Visit:** July through September offer the most consistent weather, albeit with more crowds.

▶ **On a Budget:** A number of high-quality budget hotels are located just near Tivoli Gardens and the central train station, which is a connection hub for routes throughout the city.

▶ **Luxe:** There is no shortage of elegant, historical hotels in Copenhagen. Some of the landmarks include the Hotel d'Angleterre (+45 33 12 00 95; dangleterre.com), whose marble columns and chandelier-clad ceilings have been hosting diplomats and celebrities since 1755, or Kurhotel Skodsborg (+45 45 58 58 00; skodsborg.dk), an opulent spa hotel just outside the city limits with stunning views of the sound.

Egypt

NILE RIVER

RECOMMENDED BY **Jillian Dara**

It's no surprise that Egypt had been on Jillian Dara's radar for a while. "Egypt is one of those world-class destinations that's on everyone's bucket list," she began. "I had visited Morocco and Jordan a few years before and fell in love with the desert landscapes. I was eager to see not just the pyramids, but the ruins and landscapes of Egypt."

Given some of the political unrest in Egypt and the challenges of a woman traveling solo in an Islamic country, Jillian had some concerns about tackling the trip alone. "By nature, I'm not much of a group traveler," she continued. "I never travel with tour operators on the ground in Western cities. But in a destination as complex as Egypt—with the many intricacies of the culture—it seemed to be a good idea to consider. I'd booked a cruise through a company called Exodus Adventure Travels, and they suggested I look into their Tailor Made guide program. For a modest fee, I'd have a personal guide for my entire trip. He'd be able to take care of any confusing details on the ground, and hopefully provide a richer context for my understanding of the history and culture."

The notion of visitors experiencing the beauty and mystery of Egypt by floating down the Nile goes back more than a hundred years. In the mid-nineteenth century, one might board a large cross-sailed houseboat (called a *dahabiya*) for a trip that might take fifty days to move from Cairo to Luxor.

In 1870, the travel innovator Thomas Cook Ltd. brought steamships to the Nile, cutting the travel time between attractions by half or more. With the introduction of steam cruisers, Egyptian travel itineraries become more standardized, and an infrastructure was developed along the river to appeal to travelers. Today, Nile cruises are the backbone of Egypt's tourism industry.

There are a number of Nile cruising options, ranging from four nights on board to nearly two weeks. Jillian opted for a shorter cruise. "This was my first river cruise, and I didn't have any expectations," she explained. "But I came away thinking this was definitely the way to see Egypt. You're floating past places you wouldn't see by train or plane—sailing ships on the river, children playing on sand dunes, the reflections of the sky on the water. These sights were as special as visiting the ancient temples. Traveling by boat lent the adventure an old-world sense of travel. I could retire to my stateroom and reflect on the day while the countryside drifted by."

Jillian traveled downriver from Luxor to Aswan on MS *Sonesta*; nearly all of the ships plying the Nile offer air-conditioned cabins with river views.

One of the benefits of the Tailor Made approach to Egyptian travel is the ability to customize an itinerary to the individual traveler's desires. "I was only going to have a couple days in Cairo before the cruise," Jillian continued. "A friend had told me that a visit to the Dendera Temple was a must. Though it wasn't on the schedule, my guide, Mahmoud, brought me there. The hieroglyphics are so prolific and remarkably intact. The temple is so well preserved, it gives you an idea of what the temples looked like six thousand years ago. Thanks to Mahmoud, I was also able to dine at a very local restaurant in the midst of the Khan el-Khalili bazaar, a coffee shop tucked into a storefront with stunning tilework and hookahs hanging off the walls. It was entering a different dimension from the bazaar . . . and I had the best falafel I've ever had."

Days upon the Nile tend to begin early—at least for tourists eager to avoid the heat. "Most days, I set my alarm for 4:45 or 5:00 A.M.," Jillian offered. "You know it's going to be very hot before you arrive, and that it's best to avoid touring during the heat of the day. The latest I got started was seven A.M. It was a reprieve to return to the boat. In the afternoon, we'd set sail for the next destination. Lunch was served on board, a chance to mingle with other guests. A cool breeze would come up off the Nile later in the afternoon, and I might sip a glass of Egyptian white wine, delicious and refreshing."

Stops along the way included the Valley of the Queens in Luxor (once known as Thebes), which was the final resting place of pharoahs' wives, and the Valley of the Kings across the river, where the pharaohs were interred. "The Valley of the Kings was remarkable," Jillian described. "Outside, there was no sign that anything special was present, just sand dunes. When you enter the tombs, there's just a bit of light. But the carvings of the kings are so well preserved. I've never spent much time thinking about archaeology, but

I was completely engaged. I can't emphasize how much having a guide added to my experience. Mahmoud must have spent more than fifty hours with me over seven days. [There are separate cabins on the ship for guides.] Not only was he a talented Egyptologist but also a cultural ambassador. I was able to see Egypt through his eyes and ask any questions I had; I wouldn't have received the knowledge I did otherwise."

Most of the historical landmarks left an indelible impression on Jillian. But nothing quite matched the wonder of the Great Pyramids. "I saw them flying in," she recalled, "but what really struck home their otherworldliness was waking up in the Marriott Mena House, looking right out at the pyramids. Walking along them, trying to trace the walls, prepares your imagination to run wild the rest of the trip."

JILLIAN DARA has worked for the last decade as a researcher, writer, editor, and fact-checker for more than a dozen publications in the lifestyle genre. She covers travel, culture, spirits, wine, and personalities, and contributes to *Travel + Leisure*, *USA Today*, *Elite Traveler*, *Forbes*, *Wine Enthusiast*, the Michelin Guides, and *Hemispheres*, among others. Traveling, eating, and imbibing may be part of the "job," but Jillian truly believes in the whimsical power of a local culinary experience or traditional spirit to bond strangers in the most chance of circumstances.

If You Go

▶ **Getting There:** Cairo is served by many major carriers. Egyptair (212-581-5600; egyptair.com) offers direct flights from New York and Washington, DC. A number of carriers provide service to Luxor from Cairo, including Egyptair.

▶ **Best Time to Visit:** Visitors will find slightly cooler weather from October to April.

▶ **On a Budget:** Rooms in mid-range hotels in Cairo can be found for $50 or less a night. Cruise packages (including most meals, rooms, and small-group guides) are available from Exodus Adventure Travels (844-373-9212; exodustravels.com) from $2,099.

▶ **Luxe:** For a bit more, you can stay in the shadow of the pyramids at Marriott Mena House (+20 2 33773222; marriott.com). Book your cruise through Exodus, but add a personal guide to your package for roughly $150 a day.

England

LAKE DISTRICT NATIONAL PARK

RECOMMENDED BY **Jeff Appleyard**

Whatever your high school or college English class experience with "Tintern Abbey" or *The Prelude*, most will agree that William Wordsworth nicely captured the romance and beauty of the Lake District in his poem "Daffodils":

> I wander'd lonely as a cloud
> That floats on high o'er vales and hills,
> When all at once I saw a crowd,
> A host, of golden daffodils;
> Beside the lake, beneath the trees,
> Fluttering and dancing in the breeze.

What "Daffodils" may fail to convey is the compactness of the Lake District's offerings. "The area is fairly small—36 by 40 miles," Jeff Appleyard began. "But there's a great deal packed in. The area is famous for its farming heritage, recognized by UNESCO for its landscape of mountains, valleys, lakes, and quaint villages and towns. Almost everything you see has had the touch of man upon it: mining, woodland industries, sheep grazing. But man's impact has enhanced the overall quality of the land. Many come here to walk. The author and illustrator Alfred Wainwright set out to describe the great hikes in the Lake District in 1955, and designated 214 peaks; his depictions of the hikes are considered as much a work of art as the walks themselves. But there's a great deal to do if you're not a hiker. Some places in the National Park can be very busy; we see almost twenty million visitors a year, but you can get away from it all by hiking up a remote valley or mountain, or heading to a lesser visited spot. Unlike

OPPOSITE:
The view over the southern end of Ullswater Lake and the village of Glenridding, with the Helvellyn range of fells (mountains) in the distance

19

DESTINATION

91

when you're on the Pacific Crest or Appalachian Trail, you can be back at a nice, warm pub by teatime. Even the most rigorous day hike—up Scafell Pike, England's highest peak—can be completed in eight hours."

The Lake District National Park sits in the northwest corner of England, in the county of Cumbria, not far below the Scottish border. The park's 885 square miles have a storybook charm that's underscored by its neat, whitewashed cottages and bucolic fields dotted with sheep, all framed by the ever-present mountains (*fells* in the local parlance). If Wordsworth's poetry helped romanticize the region, his travelogue—*Guide to the Lakes*—put it on the vacationer's map. The Lake District was sculpted out during the last Ice Age; the ice left great U-shaped valleys filled with lakes. There are sixteen larger lakes and hundreds of tarns. Four of the larger lakes have steamer service so you can see countryside from the water; the most scenic cruise may be on Ullswater. You can also hire a rowboat or stand-up paddleboard (SUP) or sailboat and go out on your own.

It should be noted that the Lake District is not a national park the way that Yellowstone is a national park. It's a working environment, with villages, farms, and businesses—roughly forty thousand people live within park boundaries. Life goes on here, though there are rigid restrictions on what sort of development can be undertaken. "Elon Musk couldn't build a glass monstrosity here," Jeff added with a laugh. There are key towns that have been developed to provide tourist facilities while most of the region's villages are maintained as they were one hundred or two hundred years ago; they're a bit of preserved older England. "While many of the farms are proper working operations, you can find some that welcome visitors for informational tours, sheep dog exhibitions, and the like," Jeff said. "Some bed-and-breakfasts are based on working farms."

Many international visitors will access the Lake District via Manchester. "From there, it's only 1.5 hours by train to the town of Windermere," Jeff continued. "Many people stay here, but I'd push on to a smaller village. You can take a double-decker bus for £2 to Grasmere, the home of Wordsworth. Like other villages in the Lake District, Grasmere has vernacular architecture, meaning only local materials are used. In Grasmere, that means field stones. Grasmere has a fantastic thousand-year-old church where Wordsworth worshipped. You don't need to be religious to be awed here, it's such a place of calm. I think Wordsworth's grave and cottage are also well worth a visit. A fun time to come to Grasmere is the end of August, during the Grasmere Lakeland Sports and Show. All the farmers come together to show off their Herdwick sheep and

sheep dogs. There's also Cumberland wrestling, an event unique to the region. A few great hikes from Grasmere include Helm Crag, Silver How, and Loughrigg. Whenever you visit, you have a great choice of accommodations—from youth hostels (that accept people of all ages) to B&Bs and fine hotels—and of course, pubs and eateries." The Herdwick sheep, incidentally, are the local breed. They exist in good numbers thanks to the writer Beatrix Potter, of Peter Rabbit fame, who sought to preserve them in the early 1900s when farmers began looking to develop other breeds. One can visit Beatrix Potter's home at nearby Hilltop Farm.

On the south side of the park, you might wish to take in Coniston. "It was once a mining town, and is perhaps not as popular as some villages," Jeff described, "but has lovely, quaint architecture and access to some excellent walks. One favorite is the Old Man of Coniston, a peak of about 2,500 feet that gives you superb views across the southern park. The valley was formerly a copper mine, and there are spoil heaps and rock clefts where minerals have been dug out. Near Coniston Water, there's Brantwood, the home of John Ruskin, a writer who was a great proponent of the Arts and Crafts Movement. It's worthy of a visit, and has a great veranda where you can have tea and cake overlooking beautiful gardens, the lake, and mountains. Coniston is also home of the Black Bull Inn, a fantastic pub that serves Bluebird Bitter, one of my favorite real ales."

While exploring the north side of the park, consider making Keswick your base. "It's a popular hiker's town, surrounded by fantastic peaks, an awful lot of pubs, and hiking shops," Jeff shared. "Cat Bells is one of the more popular walks. Walla Craig is a great walk, though a bit quieter. Two bigger mountains are here, Skiddaw and Blencathra ('Seat of Arthur'). Skiddaw has many routes up, easily walkable from town. Blencathra has both easy strolls and death-defying edge walks. If you're seeking an edgier experience, mountain guides are available. While in town, you'll want to visit Friar's Crag. The view across Derwentwater to the Jaws of Borrowdale is memorable; it's sure to be crowded."

Whether getting your steps in climbing the fells or exploring the side streets of the Lake District's villages, you may wish to reward yourself with a real ale. "We have more than fifty independent breweries operating in the Lake District," Jeff said. "When you walk into a pub and aren't sure what you'd like, ask the bartender what they might recommend. They're happy to give you a taste. Some of the beer is served warmer than you might be accustomed to; it's also milder than beer in many places, only 3 or 4 percent. Gin and whiskey distilleries are also taking off in Cumbria."

Will strangers be at a loss for company? "If you're on your own and sitting at the bar, someone will talk to you . . . if you look at all like you'd be interested in a chat," Jeff assured.

JEFF APPLEYARD first fell in love with the Lake District when he came as a young boy and was amazed by its views, lakes, fells, history, and people. He has realized a dream of living and working in Cumbria and the Lake District, leading visitors on a host of tours that highlight the region's natural beauty, dramatic scenery, and rich cultural heritage. Learn more about Jeff's tour services at mylakestour.co.uk. britainsbestguides.org/guides/jeff-appleyard/.

If You Go

▶ **Getting There:** The Lake District is roughly 1.5 hours north of Manchester, England, which is served by most major international carriers. There is also train service from London to Oxenholme for the South Lakes and Penrith for the North Lakes.

▶ **Best Time to Visit:** You'll find the mildest weather in the summer months, though you'll also find the largest crowds. April, May, and June often have the driest weather.

▶ **On a Budget:** YHA Grasmere Butharlyp Howe Hostel in Grasmere (yha.org.uk/hostel/yha-grasmere-butharlyp-howe) offers both private and shared lodging. YHA offers several hostels in Keswick and across the Lake District.

▶ **Luxe:** Near Grasmere, Low Wood Bay Resort and Spa (+44 0330 4044 512; englishlakes.co.uk/low-wood-bay) offers refined lodging. In Keswick, consider a stay at Lodore Falls Hotel and Spa (+44 0330 0564 886; lakedistricthotels.net/lodorefalls). Foodies should note that there are eleven Michelin-starred restaurants in or just outside the Lake District.

Georgia

SAVANNAH

RECOMMENDED BY **Kristin Secor**

"I was at a point in my life where I wanted to travel, but my friends and family wanted to only take family vacations, or simply couldn't afford to come along," began Kristin Secor. "At that point, I also had limited mobility. I had done a lot of research on where would be a good fit for me. One of the reasons I chose Savannah is because of its beauty and history, but also because it's easy to get around. They have free public bus service in the historic downtown, and the buses kneel, which means they lower and a ramp folds out. So, if you are a wheelchair user or someone who can't do steps, it's very helpful."

Savannah is known for its warm ocean breezes, enchanting historic buildings, and rich stories. It's one of the few American cities that was founded before America itself was even a country, and went on to be the backdrop of many critical scenes in both the Revolutionary and Civil Wars. The area's lush, fertile soil and balmy climate gave way to antebellum plantations, which were powered by enslaved people. This, in turn, made Savannah a critical stopping point for those seeking escape and refuge along the Underground Railroad. "Savannah is very historical, very beautiful, and very relaxed—well, that's the vibe of the South anyway," reflected Kristin. "It's full of public squares with huge oak trees with that iconic Spanish moss hanging from them, and a lot of historic mansions that have been turned to B&Bs. They're very big on their green spaces; there are twenty-two different squares in the downtown area, and each one has its own different vibe. It's very common to see musicians, people relaxing and reading, or walking around with their dogs. You can take in the waterfront right from downtown. And there are so many great restaurants. You're gonna gain weight when you go! Overall, it's a very low-key vibe. It's not go-go-go all the time; it's not one of those cities."

Many visitors opt to tour some of the plantations, especially the iconic Wormsloe, with its iron gates and long dirt road framed by towering oaks. However, many of Savannah's most curious and majestic sites are clustered right in the downtown. "The historic area of downtown is very walkable, and between the bus system and the flat streets, I felt like I could see and do a lot," continued Kristin. "Something I would really recommend is taking the trolley tour. I know it sounds corny, but it really helps you get a great overview of the history of the city. One place in particular is the Owens-Thomas House. It's one of the many mansions that's been restored, and it's one of the few places in the South where you can still see 'haint paint'—that's a type of blue paint that enslaved African people put on the ceilings to ward off evil spirits. They painted it on the ceiling in the barn, where they slept." Another famous Savannah landmark is the First African Baptist Church—one of the first churches in America entirely built by former slaves. "It was the first church that wasn't associated with white folks," explained Kristin. "And it was also a stop on the Underground Railroad—you can see in the church that there are holes on the floor, which was so air could get into the tunnels below. On the outside you can see handprints on the bricks, too, from the people who built it. They have a great guide there who can tell you all the hidden meanings in all the symbols in the church, and how they were used to guide people around the Railroad."

With such a history, it is no wonder that Savannah is rumored to be one of the most haunted cities in the United States. From bloody battles to deadly diseases to slave markets, the buildings in Savannah have seen their fair share of the macabre. "I did a tour that took place in a converted hearse," remembered Kristin. "They took us to all the sites of lore and legends, and into the cemeteries outside the city. One of the places we drove by was outside of what used to be the courthouse, and it's the only part of the city that has no Spanish moss. That's because it was the lynching square. And so of course it is quite haunted."

Today's locals are, fortunately, a bit more hospitable than in years past. "It's a very safe city," said Kristin. "For my first solo trip I wanted to go somewhere safe, and Savannah is a place where you feel safe on your own. The people are very welcoming. For example, my first night there, I went out to eat by myself, and I sat next to a group of people, and they just simply invited me to join them, like it was nothing. Whenever I went out to the park, people would just strike up a conversation. It's not like New York state. Up north, there's a big mentality of, you know, you can say hi and make eye contact, but that's the extent of

OPPOSITE:
Savannah's riverfront is a place to luxuriate in Southern cuisine, architecture, and hospitality.

it. Down there it's different. People ask how you're doing. It's a very welcoming atmosphere." For dining, visitors should be sure not to miss the Olde Pink House, a restaurant that appears to be smack-dab in a stranger's home. "They have live music and iconic Southern food—mashed potatoes, mac 'n' cheese, greens. You can just wander around the house too." Another famous eatery is Leopold's Ice Cream, where the line is always out the door for a very good reason. "Another place that sticks out to me is a tea house called the Gryphon. It used to be an old apothecary, and they have all the original woodwork and a stained-glass ceiling made of Tiffany glass. They've endeavored to preserve that traditional feeling. You can have a formal tea with petits fours and cucumber sandwiches. They really envelop you in the surroundings."

"The city left a very big impression on me," concluded Kristin. "I went back the following year with my best friend for a girls' trip. They were having a jazz festival at Forsyth Park, and it was so lovely to just wander around, listening to beautiful music in a beautiful park in a beautiful city, and feeling like you could step back in time. I think it's a great destination for people with limited mobility. With historic sites, it's not always easy to come by accessibility while maintaining history. But there are plenty of things in Savannah to do regardless of your age or mobility, so much to see, such a great experience to have."

KRISTIN SECOR is the woman behind the *World on Wheels* travel blog. She loves exploring, learning about new cultures, seeing ancient architecture, and experiencing a different way of life. Kristin was born with a rare form of muscular dystrophy (congenital myopathy with SEPN1 abnormality). As a result, she has a ventilator to assist in breathing, and usually prefers a wheelchair to get around outside. Despite being differently abled, she loves to travel. Finding all of the resources needed to make a trip successful, however, can take a lot of time, research, and patience. For this reason, she decided to start *World on Wheels*. Her goal is to not only inspire people of all abilities to travel, but to help provide the resources and information needed to make the planning aspect a little less stressful. At *World on Wheels*, she posts trip reports about where she's been (and their accessibility), ideas and inspiration to help you discover new accessible places to journey to, as well as some general resources and things to think about when planning your next trip. You can find Kristin, and more of her travel experiences, at worldonwheelsblog.com.

If You Go

▶ **Getting There:** Savannah/Hilton Head International Airport is served by several carriers, including Delta (800-221-1212; delta.com) and Southwest (800-435-9792; southwest.com).

▶ **Best Time to Visit:** Spring and early summer offer the best weather, clear skies, and full flower blooms. By mid-July, the heat and extreme humidity can become an unwelcome travel companion.

▶ **On a Budget:** Hotel prices drop the further south you head from Forsyth Park. However, there are a few relatively affordable B&Bs and hotels around downtown. The Grant (912-302-3855; stayblackswan.com/savannah) is particularly favored for its historic red bricks and spacious rooms.

▶ **Luxe:** Savannah plays host to many regal, historic hotels. The Historic Inns of Savannah Collection (historicinnsofsavannah.com) has several comfortable offerings downtown, or consider the Hamilton-Turner Inn (888-448-8849; hamilton-turnerinn.com), a grand Victorian mansion bedecked in Second Empire elegance.

Greece

GREEK ISLES

RECOMMENDED BY **Sandy Pappas**

"Many may think of Greece as a romantic destination for couples, or a perfect gathering place for groups of party-going friends," Sandy Pappas began. "It certainly ticks those boxes. But over the many tours I've led, I've found that it's also a fantastic destination for solo travelers. It's safe and clean. And thanks to well-trodden tourist routes and friendly, helpful locals, there's not too much to worry about. And there's just about everything you could wish for in a vacation spot—picture-perfect beaches, vibrant nightlife, and of course, rich history."

For many, the phrase "Greek Isles" conjures up images of amazingly azure skies, white-washed homes perched on hillsides, and clear turquoise waters below . . . and for those of a certain generation, the movie *Mamma Mia!* This is true, at least in part. But the full picture of the Greek Isles is much more complex. "The whitewashed homes image of the Greek Isles is pretty true of Santorini and Mykonos, places that many Americans think of," Sandy continued. "But there are more than six thousand islands off the coast of mainland Greece. Only 227 are inhabited. Most visitors consider only a handful of destinations—Crete, Rhodes, and Paxos, in addition to Santorini and Mykonos. When I speak to people about planning an island adventure, I hope to get people to consider some of the other islands that they probably haven't heard of. They are just as beautiful, have rich culture, and are much less crowded. I should also add that mainland Greece is also astonishing. For a fraction of the cost of the more popular islands, you can find magnificent beaches, heritage-protected areas, and Blue Zones. You can stand on these beaches and not see another person. Of course, most of the historical landmarks—temples and ruins—are on the mainland."

Sandy took a moment to briefly describe Greece's main island groups. "There are six overall groups, plus Crete. Crete, at the southern end of the Aegean Sea, is the largest

OPPOSITE:
These structures on Santorini highlight the blue- and whitewash typical of many homes on the Greek Isles.

island, home to 650,000 people. While it's good for solo travelers, you'll really need a car to get around. On the west side of Greece, you have the Ionian Islands, of which Corfu may be the best known. Here, there's a Venetian influence to the architecture, and its more verdant and forested than the eastern islands. The Cyclades are probably the best known of the island groups. They're in the central section of the Aegean, and include Santorini and Mykonos. In addition to beach-going visits, these islands host popular cruise ship ports. These islands are very dry; there was no concern about fires here during the summer of 2023, as there are no trees! The Dodecanese Islands in the southeast are closest to Turkey, and include Rhodes. The architecture here is Ottoman, as you'd find in Turkey. There was a time that all the Turkish coast was part of Greece. The Argo-Saronic Islands are the closest to Athens. An island I particularly like here is Hydra. It's very small and tranquil, and there's only one town. It's easily walkable, which is a good thing, as there are no motorized vehicles, though there are water taxis. It has a rich naval and shipping history, and one of the most beautiful harbors in Europe. Though it's very upmarket, it has a bohemian reputation. The singer/songwriter Leonard Cohen, among other artists, called Hydra home. Spetses, also in the Argo-Saronic Islands, is also a great destination. There are no airports or cruise ship terminals here, so it's also quiet."

And what of the *Mamma Mia!* island? That would be Skopelos! "Though the movie came out in 2008, I still have people asking me about it," Sandy said. "And it is another great venue for solo travelers. You can fly in—the planes come in low right over the beach—and ferry in or out. I've rented a house on a hill above the town, with blue doors and pink bougainvillea. You don't need a car; there's a bus service and taxis available. When I arrive, I get the phone number of a taxi driver and just ring him when I want a ride to the beach or town. It's magical to wander around the old town of Skopelos. Or to just sit in a taverna along the harbor and watch the world go by." You can visit Agios Ioannis, a former Catholic monastery that was the site of the *Mamma Mia!* wedding scene, in the village of Kastri . . . if you're willing to climb 110 steps.

Whether you while away your island days on the beach, hiking the hillsides, or exploring historical sites, you'll work up an appetite. Local eateries won't disappoint. "Go into any taverna on the islands, and they'll offer a local salad," Sandy shared. "They'll use whatever is freshest. As you'd expect, there's lots of seafood across the islands. Sardines are often on the menu. On Skopelos, they do a variation on spanakopita, where they roll the dough into a circle, then place a variety of fillings in the middle."

Beyond the food, the glorious beaches and the (nearly) ever-present sun, there is the main appeal of a Greek Island escape—the people. "There's a virtue in Greece, ingrained in everyone. It's called *filotomo*, and can be translated as doing the right thing by people. Even if you come upon the crankiest Greek who's having a bad day, he'll still stop and help you."

SANDY PAPPAS is a Gen-X writer, blogger, designer, wife, and mother of three based in Brisbane, Australia. She spent more than thirty years working in the corporate world in leadership and project management positions across recruitment, HR, banking, and construction. Sandy is a qualified interior designer and a Lean-Agile Coach; she specializes in solving problems creatively. She's also an avid traveler and Grecophile . . . and is married to a Greek man. Sandy loves to cook (and eat) Greek food and is a huge advocate for Greek wines and *filotomo*.

If You Go

▶ **Getting There:** Most travelers will fly into Athens, which is served by most major carriers (including a number of direct flights from the United States).

▶ **Best Time to Visit:** The Greek islands are at their best from late May to early October for swimming, suntanning, and beach weather; and from April to early November for sightseeing, hiking, and exploring.

▶ **On a Budget:** There's a broad range of lodging options available on the Greek Isles. Most have hostels (some female-only), guest houses, boutique hotels, or home rentals. Sandy's website, greecetravelsecrets.com/solo-travel-greece, provides a splendid overview.

▶ **Luxe:** As you might imagine, there are many luxurious options available on the Greek Isles. On Corfu: MarBella, Mar-Bella Collection (+30 2661 071183; marbella.gr/hotels/marbella-corfu). On the Cyclades (Santorini): Abyss (+30 2286 073266; abyss-santorini.com). On Rhodes: Kokkini Porta Rossa (+30 2241 075114; kokkiniporta.com). On Hydra: Hotel Leto (+30 22980 53385; letohydra.gr). On Skopelos: Adrina Resort and Spa (+30 210 300 6000; adrinaresort.com).

Iceland

REYKJAVÍK

RECOMMENDED BY **Amanda Williams**

The island of fire and ice is well known for its ethereal landscapes, moody skies, and supremely high quality of life. Perhaps taking some pity on the rest of us on planet earth who don't quite have it so good, in the early 2000s, Iceland embarked on an aggressive tourism campaign. Round-trip flights could be found leaving the American Midwest for half the cost of a trip to New York. Although those days are, unfortunately, over, tourism now accounts for more than 40 percent of Iceland's GDP, and experiencing the best of what the island has to offer is effectively effortless. The famed "Ring Road" directs visitors past explosive geysers, mystical northern lights, and mossy hillsides where you can practically see elves dancing in the gossamer fog.

Most visitors will first fly into Iceland's main (and, really, only) city, Reykjavík. "Iceland itself only has about half a million people, and more than half of them live in Reykjavík," began Amanda Williams. "It's where everything is happening, but it also feels like a small town. It's very walkable—I think it's about the only place in Iceland that's actually flat—with lots of colors and that typically Scandinavian, minimalist architecture. It's also a very artsy city. There's murals, funky cafés, and lots of parties. The population is very young and very hip. One street downtown is painted like a giant rainbow (the whole country is very LGBTQ friendly), and then you have things like an entire bar based on *The Big Lebowski*, or the penis museum. This is where some man who collected penis specimens from all different animals that exist in the world just decided to put them on display. That's very Reykjavík."

Iceland's sagas may be written by sword-wielding Vikings, but today's citizens, while fiercely proud of their history, display peace and tolerance better than most nations. "Reykjavík has to be the safest capital city in the world," reflected Amanda. "Violent crime

OPPOSITE: Amanda Williams of A Dangerous Business *enjoys a fresh taste of Iceland's winter magic.*

isn't really a thing. There's no gun violence. The president lives in a regular house in the city center. I didn't even worry about pickpocketing. I mean, I'm sure it happens. But I feel like it would only come from other travelers, rather than a local. The most dangerous thing in Iceland is probably the weather. When you rent a car, there are so many insurance add-ons, I was going through them all thinking, 'Why does that exist?' Later you realize it's because the wind could literally rip your car door off. Especially if you're traveling in the winter, it's good to remain flexible in your plans, because things will close if a storm is coming in.

"The nice thing about basing yourself out of Reykjavík," continued Amanda, "is that most of the time it's so easy to catch a tour company to book day trips to other parts of Iceland."

Popular day trips include the Blue Lagoon, Iceland's most famous geothermal spa, or the newly minted Sky Lagoon, whose balcony of steaming mineral waters rests right over the ocean. "I'd also recommend a day trip down to the South Coast, where you can see epic waterfalls, black sand beaches, and even more glacier lagoons—all those incredible landscapes Iceland is known for—in one day," advised Amanda. "Then, of course, there's the Ring Road, the popular route that circles the entire island. It takes about ten days to really do it properly, but you'll be able to take in the entire country."

If you opt for the car tour route, be sure not to miss a local delicacy that some tourists might be initially inclined to ignore: gas station hot dogs. "It sounds weird, but they do a whole gourmet hot dog scene in Iceland," enthused Amanda. "Hot dogs aren't officially the national food, but you'd think they might be. They're usually made with lamb, and are available at every gas station. They're the cheapest food you can buy, but they are also some of the best. There's a famous stand down by the harbor in Reykjavík called Bæjarins Beztu Pylsur, and it's indeed quite good. But outside of Reykjavík, gas station hot dogs are amazing. Gas stations there kind of act not only as convenience stores, but cafés and restaurants. They might be the only building you'll see for hundreds of miles. So, the quality of everything they carry is rather high.

"When I think back on my time," concluded Amanda, "what I remember most is how comfortable I felt by myself, as a young woman traveling alone. It's hilarious that I chose to visit Iceland when I was on a tight budget, but it is possible to see the country affordably. One of the day trips that I took was a snowmobiling tour on a glacier—there were three or four other girls who were also traveling by themselves that day, and we all just

clicked. We went and got chowder together afterwards, and hung out, and just became this little girl gang. That's my favorite thing about solo travel—I've been solo traveling for a long time, and people often ask if I get bored or lonely. Never. When you have shared experience with strangers, it builds an instant bond, and it doesn't matter how different you are or where you come from. You meet people on your travels that you become life-long friends with. That's one of my favorite things about traveling solo in general, no matter where it is."

AMANDA WILLIAMS is the award-winning blogger behind *A Dangerous Business*, a travel blog that aims to inspire people to fit more travel and adventure into the lifestyle they already have. Since starting her blog in 2010, Amanda has traveled to more than sixty countries on six continents from her home base in Ohio, and has been working with brands and destinations to promote responsible and thoughtful travel for more than a decade. Amanda's background is in journalism, but she also has a master's degree in tourism management. She's been a full-time travel blogger since 2015, and hopes to continue to provide travel inspiration and tips to travelers for many years to come.

If You Go

▶ **Getting There:** Icelandair (800-223-5500; icelandair.com) is the main airline serving Reykjavík, with flights from several international cities.

▶ **Best Time to Visit:** Summers allow for glimpses of the famed midnight sun and wilderness hikes; winters carry more rain than snow in Reykjavík, while allowing for the possibility of northern lights and other snow sports in the mountains.

▶ **On a Budget:** Lodging leans expensive in Reykjavik, even for those seeking no frills. However, a favorite of backpackers is Kex Hostel (+354 561 6060; kexhostel.is).

▶ **Luxe:** There are a few uber-luxurious properties in and around Reykjavík, but the most interesting are usually outside of the main city, such as the pampering Retreat at the Blue Lagoon (+354 420 8700; bluelagoon.com) or the Ion Adventure Hotel (+354 578 3720; ioniceland.is), which serves sleek opulence on cliffs of frozen lava inside Thingvellir National Park.

Ireland

DUBLIN

RECOMMENDED BY **Antoinette O'Sullivan**

"Ireland has long had a reputation as a friendly nation," Antoinette O'Sullivan began. "Every local king or leader would be sure to have alcohol on hand, and cooked meat, and it was made available to guests for free. We're famous for our hospitality."

This welcoming spirit certainly extends to solo travelers landing in Dublin, Ireland's capital city, straddling the banks of the River Liffey on the Republic of Ireland's northeast coast. Though it may lack the élan of Paris or London, Dublin's rich history and culture—and its compact nature—make it ideal for solo exploration. "It seems that there's always something going on in Dublin, be it free exhibitions at museums and cultural centers, walking tours, or other events. There are always postings on Meetup.com and other social sites."

The first known settlement in what is now Dublin dates to the fourth century CE, though the city's name did not materialize until the ninth century, courtesy of Viking arrivistes. "Dubh Linn" speaks to the black tidal pool created by the confluence of the Rivers Poddle and Liffey at the entrance of Dublin Bay, below Dublin Castle's gardens. (Today, the River Poddle is covered.) Dublin grew over the next few centuries, and was well established as Ireland's principal settlement by the time the Anglo-Normans arrived in the twelfth century. It was not long after that Dublin's famed pub culture began to proliferate. The Brazen Head, Ireland's oldest pub (still in operation!), opened its doors in 1198. While whiskey was the drink of choice in the countryside, historian Kevin Kearns notes that ale was the common beverage in Dublin, with most brewed by women in their homes. It's surmised that homes that brewed ale with a good reputation evolved into public houses as customers began to linger to consume the ale they'd purchased. By the seventeenth century, Dublin had perhaps become a bit too enchanted with its ale houses; records show that for a city with roughly 4,000 families, there were 1,180 taverns.

DESTINATION 23

OPPOSITE:
The Temple Bar neighborhood, which rests on the south side of the River Liffey

No city may be so associated with a beverage the way Dublin is connected to Guinness stout. Whether you're an ale aficionado or not, one tour you might wish to avail yourself of is the Guinness Storehouse Experience. The original brewery was established on this very four-acre site at Saint James's Gate by one Arthur Guinness in 1759. He signed a nine-thousand-year lease for the property, thus assuring Dublin a stable flow of ale, albeit of a darker shade than commonly available.

Antoinette is a great fan of Dublin's many museum properties. "I'd recommend that you take in the National Gallery; admission to the permanent collection is free. The Little Museum of Dublin tells the city's story and is one of the most popular stops. The Irish Museum of Modern Art is also free, as is Collins Barracks, which looks at Ireland's military history. Kilmainham Gaol Museum is fascinating, looking at both common criminals and those fighting for Irish independence. The Irish Emigration Museum is also worth a visit. If you're at all interested in music, you'll want to visit Windmill Lane Recording Studios, which offers tours and has hosted many of today's most prominent music acts. I think it's also worthwhile to tour the grounds of Christ Church Cathedral, which has been in existence since Viking times, and the campus of Trinity College.

"On the odd sunny day, it's nice to visit Phoenix Park, a large green space where guided tours are available. It can also be fun to take a train out to one of the seaside villages, like Greystone, which lies just south of the city. An excellent walking tour is the 1916 Rebellion Tour, which showcases some key events leading to the Easter Rising and the Irish Civil War." English majors who have endured James Joyce's *Ulysses* will surely want to follow in the footsteps of the novel's anti-hero, Leopold Bloom.

Given Dublin's rich pub culture and thriving live music scene, you'll certainly want to save energy for a few evenings out on the town. "I feel that Dublin is overall a safe city, but it's still a big city," Antoinette reflected. "You need to have your wits about you. I wouldn't advise carrying large sums of money or your passport at night if not necessary." She recommended a few spots. "In the north part of the city, there's a collection of three bars in one venue. Murray's Bar is geared at tourists with live Irish music and dance; the Living Room has nice cocktails, etc. and is more 'trendy'; and Fibber Magees has more of a 'dive bar' ambience, with live rock/punk moody dark settings, that serves pizza and other relatively cheap (for Dublin) food and a wide array of beers. All three bars share a huge courtyard with a big screen for sporting events. The Cobblestone in the Smithfield neighborhood is more traditional and has music every night."

If a show is more appealing than a pub visit, Dublin boasts a number of comedy clubs. And you can almost rest assured that a production of *Riverdance* will be playing sometime, somewhere during your stay.

ANTOINETTE O'SULLIVAN recently joined Experiment in International Living (EIL) as group leader coordinator, having led groups for Road Scholar programs. She grew up in the well-oiled tourism machine of Killarney, so it's no surprise that after years of teaching English as a Foreign Language, she followed her parents' footsteps into the world of tour guiding. Antoinette is passionate about travel, and has lived in New York, Australia, Italy, and all over Spain (although she never quite managed to grasp the language!). With a background in classics and English, and an MA in journalism, Antoinette likes to write during her free time, and is an Irish history and mythology fanatic. She loves leading tours around Ireland, and delights in showing visitors the time of their lives while traveling. When not traveling, working, or writing, you'll find her at a gig or camping in the Irish countryside.

If You Go

▶ **Getting There:** Dublin is served by many major carriers, including Aer Lingus (800-474-7424; aerlingus.com) and United Airlines (800-864-8331; united.com).

▶ **Best Time to Visit:** The summer months see the warmest weather, but also crowds. Winters are not oppressively cold and see the fewest tourists; spring and fall may offer a happy medium between clement weather and crowds.

▶ **On a Budget:** Dublin boasts a number of hostels, which are highlighted at Hostelworld (hostelworld.com/st/hostels/europe/ireland/dublin/). Other moderately priced options are highlighted at Visit Dublin (visitdublin.com).

▶ **Luxe:** Dublin offers a number of luxurious hotels, including the Merrion Hotel (+353 1 603 0600; merrionhotel.com), the Westbury (+353 1 679 1122; doylecollection.com/hotels/the-westbury-hotel), and the Marker Dublin Hotel (+353 1 687 5100; anantara.com/en/the-marker-dublin). Road Scholar (800-454-5768; roadscholar.org) offers a number of guided adventures highlighting Dublin as part of the itinerary.

Italy

SICILY

RECOMMENDED BY **Michela Fantinel**

"I started solo traveling when I was very young," began Michela. "This was in the 1980s, and it wasn't so common to see a woman traveling by herself back then, even in Europe. My family would try to talk me out of things, but I stood up for my intentions and just went my way. It's nice to travel with friends too, but if a friend can't come, I don't have a problem. When you travel solo, you don't have anyone else to rely on, only you. You learn a lot about yourself. Also, nothing holds you back from anything you want to do. And in a place like Sicily, having that freedom can be amazing."

The largest island in the Mediterranean bears the influence of Romans, Arabs, Greeks, Phoenicians, and Normans (to name just a few civilizations), resulting in a cultural tapestry like nowhere else on earth.

"Sicilians are proud to say they are Sicilian," reflected Michela. "They say they are Sicilian before they say they are Italian. In a way, it's like all of Italy, condensed into one place. There are so many populations that have been here and left their marks. And I'm not just talking about the temples and the old buildings. It's in the food you eat. It's in the landscape. Everything is so rich, there's just an overwhelming beauty. Often, you'll think, 'I cannot take it, it's just too much.'"

Despite the island's small size, Michela recommends a minimum of ten days to take it all in. Catania houses the international airport, where most itineraries begin. "I'd recommend you go south from Catania to Syracuse and then Ortigia, which is an island off the island," advised Michela. "You have those small, narrow roads like you have in Venice, except cars are allowed. There's a beautiful basilica, plus cathedrals, piazzas—everything is made of pale stone and arches. It's like its own universe." Be sure to stop by the Roman theater and take in the Ear of Dionysius, a vast limestone cave carved out of the rocky hill.

DESTINATION 24

OPPOSITE:
The sun-warmed shores of Sicily contain some of the best food in the world, and staggering archaeological wonders.

Or, travel further south to Modica, a three-thousand-year-old city that cascades down pale cliffs, for a tour of the Caves of Ispica, which Bronze Age residents used as dwellings and burial sites. From there, a turn west takes you to Agrigento. "This is one of the biggest archeological sites in Sicily," explained Michela. "Even if you think you don't like temples, you should go to the Valley of the Temples. They are all different, and all huge, and have so many remains. You'll be amazed at what you see."

"From there, I would go up the west coast to Mazara del Vallo," continued Michela. "It's a small town, but it has districts that represent all the different people who have lived there, from the Arabs to the Hebrews to the Normans to the Romans. The architecture shifts every time you turn a corner." Sicily's northwest coast is noted for its smaller crowds, centuries-old salt flats, and tuna fishing boats, all presided over by medieval villages tucked into the hills. "If you keep going north," described Michela, "you curve around the island, and there's a fantastic coastal trail called Zingaro, west of Palermo. It's touristy, so you should try and get there earlier in the morning, or you may feel like you are on a highway. Nevertheless, it's one of the most spectacular coastal trails I've ever seen. The plants are dark red, dark blue, green, and gold."

No trip to Sicily would be complete without sampling its world-famous dishes. "It's hard to find something that you won't like, but especially if you are into fish and vegetables, this is your island," enthused Michela. "The vegetables taste different here. It's the sun, the soil from Mount Etna. You forget you're eating at restaurants—everything tastes like it was home cooked. I recommend everyone try an arancini, a big rice ball filled with ragù or spinach and then fried—but they are so light, they don't taste like they are fried. There's a real art to them; it's not the kind of thing you can make at home. Then for dinner, you might have pasta alla Norma, which is pasta with vegetables and tomato sauce and this special, salty ricotta—you grate it on top like Parmesan. And for dessert, Sicily has a long tradition of making cannoli. There is a special Sicilian ricotta made here, fresh from sheep's milk. It's not the kind you find in the supermarket at home. It's next-stage ricotta. The whole experience is next stage. If you want to have an upgrade of all the food you've ever enjoyed in your life, go to Sicily."

Through centuries of cultural exchange, one of Sicily's greatest charms remains the character of its people, who welcome visitors with warmth. "One day, in Trapani, I had an issue with my rental car—it wouldn't move. The guy who owned the B&B I was staying at, he rode over on his bike, and he called his friend who is a mechanic. And then he just

put my luggage on his bike. I tried to refuse, but he insisted on driving it back to the B&B. When the car rental company brought the new car, that guy said, 'Relax, don't worry,' and he took all the pressure off me and made everything so easy. This situation would have been a headache in any other country. But that's Sicilians. They are the warmest strangers, which is perfect for a solo travel experience. They do it naturally. They do it because they want you to feel welcome and comfortable. Everyone is like friends."

MICHELA FANTINEL is the woman behind Rocky Travel, a website for women over fifty traveling solo to Italy and Australia. Michela swapped the life of a manager for a less ordinary life and started a passion project that turned into a small business. Her mission is to empower women to live solo lives without limitations and grow their confidence to travel safely and smartly to places they've always wanted to see. Since 2019, Michela has organized and led bespoke small-group tours of Sicily for solo travelers over fifty who enjoy exploring Italy with like-minded people and making new friends. For more information, please check out her Small Group Tours of Italy for Over 50 (rockytravel.net).

If You Go

▶ **Getting There:** Catania International Airport is a focus city for Ryanair (+3 531 582 5932; ryanair.com).
▶ **Best Time to Visit:** Spring and early fall have milder temperatures and remain relatively dry. Winter is rainy, and while summer is the best beach weather, be prepared for crowds.
▶ **On a Budget:** Major cities like Palermo and Catania host several inexpensive hostels. Syracuse is reputed as the most affordable city on the island. Renting a room in a private apartment is a classic and highly affordable option, and many are available on major booking websites. LoL Hostel Siracusa (+39 0931 465088; lolhostel.com) is a long-standing favorite for budget travelers.
▶ **Luxe:** Sicily has a variety of palatial hotels, many built from the bones of ancient monasteries and castles. The grand dame is probably the Grand Hotel Timeo (+39 0942 627 0200; belmond.com), with its tiered gardens, marble bathrooms, and an in-house, Michelin-starred restaurant.

Japan

TOKYO

RECOMMENDED BY **Stephanie Yeboah**

"I always had a fascination with Japan growing up," began Stephanie Yeboah. "I think I got it from my uncle—he's a huge anime and manga fan, and we used to watch loads of Japanese cartoons together. By the time I was thirteen, I knew I had to see Tokyo for myself someday. Also, as a self-professed nerd, I love everything gadgets. And Tokyo is *the* hub of gadgets—really, all modern technology. Something I love most about the city is this beautiful fusion of technology and tradition. You can go out and see a show that is centuries old, pulled from a book that is a thousand years old, and then one street over, go to a café and get a coffee served to you by robots."

With so much to experience, it's best to map your path neighborhood by neighborhood. "Tokyo is a city of subcultures," described Stephanie. "Every district is a different world. For example, you've got the Harajuku section, which is full of teenagers dressed to the nines in Y2K fashion or anime cosplay. The amount of shopping is almost overwhelming, but it's an awesome place to pick up unique clothing. Unfortunately, their clothing sizes are very small—so if you're small, that's great—but even if you're not, it's still a great place to pick up accessories, purses, things like that. You know you've hit a different district when everyone starts dressing differently. There are neighborhoods where everyone dresses like fairies, or another one for hipsters, another for city workers, another for rockabillies."

Although Tokyo is extremely walkable, it is also home to one of the most distinguished public transportation systems in the world, making a car rental optional, if not outright ill advised. "The public transportation is a joy," reflected Stephanie. "The bullet trains are on time, and as someone who's very punctual, this was lovely to me. It's so incredibly easy to get around, even if you don't speak Japanese.

DESTINATION 25

OPPOSITE:
Revered history and cutting-edge modernity collide under the neon lights of Tokyo.

"What's funniest about Tokyo is that it comes across as so busy and overwhelming," continued Stephanie, "but in fact, if you're introverted, it's perfect for you. For example, a lot of cafés and restaurants are set up with little booths with dividers to give single diners a bit of privacy. Eating alone can be so stigmatized elsewhere. But not here. You don't feel strange at all if you're out alone. Despite its hugeness, it's one of the safest cities in the world. People leave their laptops open in cafés while they run to the restroom. Everyone says hi to you and goes out of their way to try and help you find things. And, to be clear, I stood out when I was there. I'm plus size, dark skinned, with a huge afro. But I was never made to feel scared, or like I had to hide myself. To be fair, I did get some attention for my skin color—people called me Oprah and Beyoncé. But it didn't feel like it came from a bad place, you know? One day this group of girls in anime cosplay came up to me and started saying 'kawai, kawai!' and I was a little confused at first. A shop owner came out and explained that they were saying I was cute, and asking questions about my clothes. I'm used to standing out in almost every place I go. But this was the first time someone had ever called me out in public because they wanted to compliment me, rather than to insult me. I was thrown off. I'm so used to my size being a negative. And these girls were seeing my size, but I wasn't being seen negatively. It's hard to explain, but I didn't feel othered. If anything, I felt like a bit of a celebrity; I felt appreciated."

Although it's impossible to narrow down all of Tokyo's "must-sees" into one list, some popular items include a visit to Shibuya Crossing, the famous zebra-striped crosswalk where thousands of bodies pass each other like schools of fish. Consider taking in a traditional Japanese drama at Kabuki-za or the National Noh Theater. Visitors can be introduced to proper tea ceremony technique at Sakurai Tea Experience, or gain a glimpse of tomorrow's technological wonders at Miraikan (also known as the National Museum of Emerging Science and Innovation). Stay at the Henn na Hotel, where all your needs can be served by robots (some humanoid). "There is a café for everything in Tokyo," described Stephanie. "They have ones for Hello Kitty, and for every big manga and anime show, of course. But that's just the tip of the iceberg. There's a place called Vampire Café where the curtains are blood-red velvet, the waitresses are all dressed up as vampires, and the dishes come in little coffins. The cafés take their themes very seriously. Everything in Tokyo feels like it's turned up to an extreme. There's karaoke, right? We've all done that. But Tokyo karaoke is a whole other level. There's a bar called Ban x Kara Zone-R where you sing in front of a live band; they set it up so you kind of feel like you're a proper artist on tour, really performing.

"I think my only regret is that I wasn't there for a longer time," concluded Stephanie. "You want two weeks, just in Tokyo alone, just to experience everything it has to offer."

STEPHANIE YEBOAH is a thirty-something blogger, multi-award-winning content creator, author, host, freelance writer, public speaker, and body image/self-love advocate based in her hometown of London. With a blog spanning over fourteen years, Stephanie has been an active and influential presence within the creator space, creating content around plus-size fashion, beauty/skincare, travel, and lifestyle, as well as providing witty, raw takes and perspectives on all things to do with pop culture. In 2020, she released her debut nonfiction novel, *Fattily Ever After: A Black Fat Girl's Guide to Living Life Unapologetically*, which became an Amazon bestseller in its first week of publication. In the same year, she became the first British plus-size Black woman to grace the cover of *Glamour Magazine UK*. She has appeared on Sky News, BBC Radio 4, BBC Radio London, LBC, ITV News, MTV UK, BBC Ireland, BBC 1Xtra, BBC Radio 5 Live, *Channel 4 News, Good Morning Britain*, and a plethora of podcasts, and is the winner of the Blogosphere Blogger of the Year Award 2019, the rewardStyle Trendsetter of the Year 2020 Award, and the Navabi Fashion Writer of the Year 2020 Award. You can connect with her at stephanieyeboah.com.

If You Go

▶ **Getting There:** Tokyo is served by two airports: Narita and Haneda. While numerous international carriers service both airports, Haneda is closer to the city center.

▶ **Best Time to Visit:** The city is lovely any time of year, with spring offering a chance to see the famed cherry blossoms, and fall offering magnificent sunset-hued foliage.

▶ **On a Budget:** Price-conscious travelers have oodles of options in Tokyo. Budget hotels and hostels abound, but unique (and shockingly affordable) options include capsule hotels and *ryokan*: family-run guesthouses featuring tatami mats and historic hospitality.

▶ **Luxe:** There is no shortage of opulent lodgings. The best tend to be situated on the top floors of shared skyscrapers, offering million-dollar views to guests. The crown jewel is probably the Aman Tokyo (+81 3 5224 3333; aman.com), a jaw-dropping blend of modern lines and traditional Japanese spirit, where rooms average $2,000 per night.

Louisiana

NEW ORLEANS

RECOMMENDED BY **Leslie Burnside**

New Orleans is the home of America's most colorful Mardi Gras celebrations, indulgent Southern cuisine, and ghostly histories. Bourbon Street's twenty-four-hour bacchanal of live music, Jell-O shots, and Mardi Gras beads is worth experiencing at least once in your life, but this is merely one layer of what this city has to offer. New Orleans is a melting pot of Creole, Cajun, African, Caribbean, Native American, Spanish, and French cultures, which have blended together over centuries to create one of the most unique, compelling cities on earth.

"New Orleans is colorful," began Leslie Burnside. "It is not bland. It's not strip-mall-y in any sense. The people have taken great care to preserve the old buildings and architecture. And there are more manners here, more formality than on the West Coast. People say 'sir' and 'ma'am' and hold doors for each other. They get dressed to go out to dinner. Not everybody is gazing at their own navels. People are looser and calmer than in most parts of the country, which maybe comes from the horrendous summers. It's just too damn hot to be mad and obnoxious. It's easier to be nice."

Indeed, "Be Nice or Leave" is the unofficial motto of the city, embossed onto upcycled, flamboyant metal signs by artist Dr. Bob, and found hanging off just about everything. The best way to experience New Orleans is through three modes: food, music, and walking. "Just walk," advised Leslie. "There are no hills! During Mardi Gras I'll probably walk 12 to 14 miles a day. Poke your head into every doorway. Make an attempt to chat with people, see how they're doing. People want to talk to you. Even the street people want to talk to you. It freaks some visitors out, but really, a lot of the time they don't want anything. They just wanna see how you're doing this afternoon. And if you ever get lost, just ask someone for help and they'll tell you, 'Oh honey, go left, go right,

OPPOSITE:
Revelers overtake New Orleans every Mardi Gras, but the city's color is vivid year-round.

DESTINATION
26

then go right again, and when you get there you tell 'em I sent you.' There's a great sense of connection, and hospitality. And don't be in a hurry going anywhere. New Orleans has its own time schedule."

Haunted walking tours of the charming French Quarter are a great way to get a sample of the city's ghost stories. Stroll under the warm glow of gas lamps and under balconies framed in black cast iron, so intricate you'd swear they were lace, and revel in the famous tales of voodoo priestess Marie Laveau, or Père Antoine of Saint Louis Cathedral (the oldest in the country). There's no trouble finding a drink around here, but consider aiming for Lafitte's Blacksmith Shop, which has been serving pirates and tourists alike since the 1700s. "It's a great place to sit outside, watch the people go by, and just listen to the music. Most bars are music clubs in New Orleans."

Jazz, rock, and zydeco music seems to spill out of every doorway in the city. Brass bands parade regularly down streets lined with Spanish moss, heralding weddings, business openings, and even funerals. For a sit-down show, some of the best clubs are found on Frenchmen Street—a wood-paneled alternative to the neon cacophony of Bourbon Street. "My favorite music club down there is D.B.A.," noted Leslie. "It feels very comfortable, and people know each other. The Apple Barrel is also very nice, even though the entire venue is about the size of my car. Grab yourself a copy of the *Advocate*, or *Time Out*, to see what bands are playing where. But it almost doesn't matter—the bands are always good. There's never been a band that I walked out on in New Orleans." After a show, be sure to follow the twinkly lights to Frenchmen Art Market, where some of the best artists in the city offer their wares until midnight.

In addition to a bad music show, you'll be hard pressed to find a bad meal. Even the city's famous po'boys are arguably best when they are served from gas station deli counters and dives. "For a po'boy or a hot plate, go to Frady's in the Bywater neighborhood," advised Leslie. "It's a dive, and it's cheap, and it's incredible. One of my other favorite places is called Shawarma on the Run. It's in a gas station, run by a family, and oh my god, is their stuff good. They have the most amazing sandwiches." For a more upscale affair, head to Commander's Palace in the 11th Ward. "It's very fancy, very old school. They do dinner, but there's something especially fancy about the lunch. If you want classic Creole food, Jacques-Imo's is the best. It's a scene. You can take the trolley partway, but you'll still have to walk a bit outside of Saint Charles—which is fine, you'll be eating so much, you'll want to walk anyway. Another worthwhile stop is Central Grocery. You have

to get the muffuletta, but *don't* put it in the refrigerator; it needs to sit on the counter for twenty-four hours to let the flavors meld. After that, put it on some potato chips—it's the most incredible thing you've ever had."

The city takes pride in its heritage, preserving buildings and the stories that go with them. However, New Orleans' infamous hurricane season sometimes makes preservation impossible. The Presbytère museum offers its Hurricane Katrina exhibit to remember what was lost and what was overcome. "It's excruciatingly painful, but beautiful," reflected Leslie. "And then upstairs in the same museum, it's all Mardi Gras. It's a nice contrast. And I think it's only like $6 or something to get in. I would also recommend everyone go to the World War II museum. It's like the Smithsonian, but for World War II. Some of the docents actually fought in that war—you can talk to people who really rowed in that boat over there.

"New Orleans is also a very spiritual city," concluded Leslie. "And *be careful* around this aspect of it. But also, explore it. Explore Santeria, hoodoo, voodoo . . . go into these places where you are welcome to do so. Some people are scared to come here, but really all you need to do is not be drunk on Bourbon Street at one A.M. by yourself. Otherwise, don't be shy. There's a sharing, and a lightness, to New Orleans that feels good. It actually might be the weather that makes the people appreciate what they have more, because they know it can go in an instant."

LESLIE BURNSIDE is a restauranteur, world traveler, dual Irish–American citizen, and lifelong foodie. She was born and raised in Manhattan, graduated from culinary school, and owned several restaurants in the San Francisco Bay Area before she and her husband of forty-four years relocated to New Orleans in 2015. Her first impressions, arriving at 1:30 A.M. at what she calls "the corner of Hell and Vomit" (aka Bourbon Street) were questionable, but the summers reminded her of vacations in Staten Island, and she quickly fell in love with the whole city—"a real city." Her favorite things about New Orleans are the lovely people, weird thrift shops, and of course, incredible food. When she's not in New Orleans working in the restaurant business, she loves to travel—to see new architecture, talk to new people, enjoy new food, and see how other places work.

If You Go

▶ **Getting There:** New Orleans International Airport is a hub for Southwest (800-435-9792; southwest.com) and Breeze Airways (flybreeze.com), but is served by many carriers.

▶ **Best Time to Visit:** The crowds flock for Mardi Gras in late February, and again in late August for Southern Decadence (a citywide LGBTQ Pride extravaganza). Summers bring brutal heat and rainstorms.

▶ **On a Budget:** Prices surge during city celebrations, no matter where you're trying to book. Madame Isabelle's (504-509-4422; isabellenola.com/) and HI New Orleans (504-603-3850; hiusa.org) are two beloved hostels that flank the French Quarter with very affordable rates; otherwise, your best bet is to head to the Warehouse District for a variety of budget hotels.

▶ **Luxe:** New Orleans was home to some of America's first luxury hotels, and most of the gems are steeped in history. This includes Hotel Peter and Paul (504-356-5200; ash.world/hotels/peter-and-paul), a restored convent and schoolhouse that features custom Italian linens and red-draped canopy beds, or the restored elegance of the Roosevelt (504- 648-1200; therooseveltneworleans.com), with its rows of crystal chandeliers and art deco murals.

Maine

PORTLAND

RECOMMENDED BY **Kirstie Archambault**

"The geography of downtown Portland makes navigating the city easy and stress free," Kirstie Archambault recalled.

Portland, Maine, is walkable—just 3.5 miles long and .75 miles wide—and packed with food, history, and culture. "The city makes it easy to be as social or as unplugged as you like. There are group tours where you can find camaraderie. Thanks to the region's coastline, abundance of islands, and other landmarks, you can be an explorer or just enjoy your solitude. There's also something special about the welcoming nature of locals who live in Greater Portland. They want to share their love for the place they live. I have heard many stories about people going out to breakfast while in town and eating alongside fishermen and -women who give recommendations on their favorite places to go, eat, and see in the area. It's just a very communal, friendly place and that suits a solo traveler well so they can make connections and get the locals' point of view."

Portland, Maine—a picturesque and diminutive city (population around seventy thousand) that rests two hours north of Boston along Maine's Casco Bay—is regularly recognized as one of America's best places to live, work, and play. An extensive urban trails network, a thriving restaurant and beer scene, and out-your-front-door access to tranquil bays and beaches attract active-minded visitors from far and wide. Many travelers will begin their exploration of Portland with a stroll around the Old Port.

Developers recognized the area's potential in the 1970s and began buying and renovating buildings in Portland's Old Port. The cobblestones stayed, as well as many of the buildings' brick facades. But an array of shops, restaurants, local art institutions, and entertainment venues replaced the warehouses, creating a vibrant urban center frequented by locals and visitors alike. A number of guided tours are offered, if you want to

explore with other visitors and get a local's insight into Portland's history. "During the holiday season and through the winter, an evening stroll is brightened by a vibrant light installation by local artist Pandora LaCasse," Kirstie said.

A trip to one of the picturesque lighthouses dotting this section of the coastline is high on the list of many Portland visitors. Make a stop at Portland Head Light. Commissioned by George Washington in 1790, this lighthouse is in Cape Elizabeth (just ten minutes from downtown) and rests on a rocky promontory at the entrance of the shipping channel into Casco Bay. The lights were manned by a lighthouse keeper until 1989, when Portland Head Light was automated. The former lighthouse keeper's quarters have been repurposed as a museum that details the property's rich history. Fort Williams Park, the site of Portland Head Light, offers a number of walking trails on its ninety acres with expansive views across Casco Bay and the Atlantic beyond. On the East End, visitors will also enjoy resplendent views of Portland Harbor along the Eastern Promenade in downtown Portland. During the warmer months, there's a summer concert series and food trucks.

Touring Portland Head Light and the cobblestoned Old Port will start to give you a sense of the region. But some time on the water will give you an even better perspective. Kirstie recommends an expedition on the Casco Bay Ferry. "The terminal is right downtown," she enthused. "The ferry is affordable and visits a number of islands in the bay."

Go island-hopping or on a specialty cruise. "There's a popular myth that says there are as many islands in Casco Bay as there are days in a year—so some call them the Calendar Islands," Kirstie said. Peaks Island is the closest—just seventeen minutes from Portland. There are plenty of islands to explore, including Little Diamond, Great Diamond, Long, Chebeague, Cliff, and Bailey Islands. Each has their own charm and unique coastal elements.

Long Island has a bakeshop/café called Byers & Sons Long Island Bakehouse that's a short walk from the terminal. It's a great spot to hang out and get some island time. You're pretty sure to pass working fishing and lobster boats and curious harbor seals en route. If you're curious about the detailed workings of the lobster trade, Lucky Catch Cruises lets you tag along with a lobsterman and learn about the industry in an interactive way. Local businesses like Portland Paddle rent kayaks and stand-up paddleboards, as well as provide lessons and tours, should you wish to get closer to the water.

After exploring downtown Portland or navigating Casco Bay, you'll work up a hunger and perhaps a thirst. Portland can satisfy any craving—if you can make your way around the Food Network film crews and *Bon Appétit* photo shoots touting the city's latest offer-

ings. The magazine recently named Portland "Restaurant City of the Year." Seafood lovers should consider a stroll along the Working Waterfront, on Commercial Street. "The restaurants are serving seafood straight from Casco Bay," Kirstie continued. "Local establishments have collectively raised the bar. You're sure to find fresh, delectable Maine lobster—and anything else your taste buds crave." Those favoring more adventurous cuisine might opt for one of the venues that keep Portland on the culinary map, like Evo, Scales, or Sur Lie.

A good glass of ale is never far away in Portland, Maine, which boasts the most breweries per capita in the United States. Geary Brewing Company is New England's first craft brewery. They specialize in English-style ales and are located just minutes from downtown Portland. Rí Rá, an Irish pub on the waterfront, is a great spot for a solo traveler to get a taste of Portland, as there's live music and good mix of locals and travelers.

KIRSTIE ARCHAMBAULT is the digital marketing director for Visit Portland.

If You Go

▶ **Getting There:** Portland International Jetport is served by most major airlines, including Delta (800-221-1212; delta.com) and United Airlines (800-864-8331; united.com).

▶ **Best Time to Visit:** The summer and fall months are the most popular times to visit Greater Portland, though there are tons of things to do here year-round, including many winter sports.

▶ **On a Budget:** You'll find more affordable hotel options outside of the downtown area, in South Portland, including Best Western Merry Manor Inn (207-774-6151; merrymanorinn.com) or Tru by Hilton (207-221-3131; hilton.com). B&Bs like Inn at St. John (207-773-6481; innatstjohn.com) or the Percy Inn (207- 871-7638; percyinn.com) offer a more intimate experience downtown.

▶ **Luxe:** Some more opulent hotel properties in the downtown area include Cambria Hotel (207-800-3421; cambriaoldport.com), Aloft (207-761-6000; marriott.com), and Canopy (207-791-5000; hilton.com). Visit Portland (207-772-5800; visitportland.com) lists travel planning tips for the Greater Portland, Maine region.

Malawi

THE NORTHERN REGION

RECOMMENDED BY **Sabina Trojanova**

"Malawi doesn't have a big tourism scene," began Sabina Trojanova. "It doesn't have a big marketing presence, it doesn't have a lot of fancy frills—basically no one talks about it unless they've already been there. Different countries attract different types of visitors, you know? The people who visit Malawi tend to be adventurous, open minded, and—although I realize this is true of many countries—the locals are just so friendly."

The Northern Region of Malawi is characterized by rolling hills, unspoiled forests, and wildlife sanctuaries where zebras, baboons, and the occasional peeping leopard happily roam. But the crown jewel is Lake Malawi, a 350-mile body of piercingly teal water lined with white sand beaches. "It is quite warm," described Sabina. "You can swim, or go snorkeling among thousands of species of fish. Lake Malawi is famous for being the home of the cichlid, one of those tropical fish a lot of people have in their aquariums. Here, they are wild." If you want to get deeper into the water, diving is a popular pastime, especially at night. However, as many seasoned water-lovers know, with warm water comes risk. "There is a parasite in the lake," noted Sabina, "but it's dealt with very casually, by taking deworming tablets after your visit. If you don't have a reaction, you're fine. If you take them and have a reaction, well . . . now you're fine."

If you'd prefer to enjoy the majestic lake from above, rather than below the surface, a plethora of lodges and schools offer fishing, canoeing, and paddleboarding day trips, as well as wildlife tours and hiking trips. "Malawi also has a fantastic local music scene," reflected Sabina. "Jazz and gospel, but also hip hop and reggae. South African *kwela* music is also very popular here—Malawi has a few artists that specialize in it. And of course, Malawian jazz has some spectacular contemporary artists. There's a popular three-day international music festival called Lake of Stars where you can see some of the best acts."

OPPOSITE: *Sabina Trojanova of* Girls vs Globe *admires an epic waterfall near the shores of Lake Malawi.*

DESTINATION 28

When people first come to Malawi, they usually start in Lilongwe and work their way north, stopping at Nkhata Bay. Here, you can park your bags at the diving school Aqua Africa, which offers comfortable lodging and the opportunity to use (or obtain) your PADI license. "There's also a really lovely market at Nkhata Bay," described Sabina, "where both locals and tourists buy fish, veggies and fruit, and colorful *chitenge* fabric. A lot of people buy yardage there and then get a tailor to turn it into something."

Another lodging option is Butterfly Space, especially for those looking to give back. "Butterfly Space is a UK-based charity, and they have a volunteer package, where you get lodging and food and other activities all included in exchange for service. I haven't volunteered through them before, and it's important to mention that not every place does responsible volunteer projects," Sabina noted. "I always encourage people to do a lot of research before they volunteer their time, to see who they are really working for.

"One thing I especially liked about Malawi," Sabina continued, "is the strong sense of community within the tourism industry itself. People working at one place will signpost for other places; like, if you're staying at Butterfly Space and want to scuba, they will encourage you to go to Aqua Africa. You don't see a lot of that in other places."

Once you've had your fill of Nkhata Bay, head further north to explore more remote villages and sections of the lake. "The ferry is a very real experience. It's one of those old, rickety boats that smell like diesel, and it's prone to tardiness. You always want to check if it's really operating the day before you get on," chuckled Sabina. "But it's a wonderful way to see the lake and get to a beautiful village called Ruarwe." Ruarwe contains perhaps one of the best-kept secrets on the whole of Lake Malawi: Zulunkhuni River Lodge. "When you're there, you feel like you're on an island. I hate to use this word because it's so trite but—it's magical. You want to pinch yourself every morning and ask yourself, 'How the hell did I get here?' They have hammocks and books all over the place. You can go swimming under waterfalls. You can visit the local herbalist in the nearby village. It's a place where you can be playful, and recharge. And what I really like as well is that the managers work very closely with the locals. This isn't always the case in the travel industry."

A worthy final stop for any trip to the northern region is the Mushroom Farm Eco-Lodge. To get there, you must first survive a precarious mountain road apparently heading straight into the sky, with sheer cliff drops mere inches from your car seat. But endure this rite of passage, and you'll be greeted by a scene many find hard to describe. "You feel like an eagle. You are immersed in this green, verdant forest, looking down on waterfalls

and tree canopies, and all around you are these structures designed to blend in with the surrounding nature. They operate fully on solar energy, have permaculture gardens on site. Be sure to do the waterfall hike—you walk behind a cascading waterfall and swim in the rock pools nearby.

"I really think the most remarkable thing about Malawi," concluded Sabina, "is the type of tourist it attracts. I was traveling by myself, and I was staying in a hostel in Lilongwe. One night I was chatting with a girl, and she mentioned she was going up north. She asked me, 'What are you up to tomorrow?' and I replied, 'I don't know, I just got off a work project.' And the next morning I went off with her to Nkhata Bay, and we traveled together for ten days. That's just the kind of people you meet in Malawi."

SABINA TROJANOVA is the content creator behind @girlvsglobe, with more than five hundred thousand social media followers following her travels. She is also a published author (*#wanderlust* from HarperCollins), photographer, and travel presenter, with work featured by the *Telegraph*, the *Independent*, and various other publications. Sabina holds a degree in political science and has experience working in the nonprofit sector. She has lived in five countries, speaks seven languages, and is currently in the process of launching her own group tours to adventurous destinations around the globe, working closely with local travel experts.

If You Go

▶ **Getting There:** Most tourists opt to fly in to Lilongwe, a hub for Malawi Airlines (+265 992 991 125; malawian-airlines.com), and then take a bus or taxi to Nkhata Bay.
▶ **Best Time to Visit:** Summers are long, temperate, and relatively dry from May through October.
▶ **Accommodations:** Zulunkhuni River Lodge (+265 988 560 251; facebook.com/Zulunkhuni), Aqua Africa (+265 0 999 921 418; aquaafrica.co.uk), and Butterfly Space (+265 0 999 156 335; butterflyspacemalawi.com) are best booked by contacting directly. Most stays on Lake Mawali are of the hostel and ecolodge variety. A longer list of options can be found at malawitourism.com.

Massachusetts

BOSTON

RECOMMENDED BY **Fred Smith**

"I always tell people Boston varies by season, in terms of what you are going to get," began Fred Smith. "It is sweltering in the summer and freezing in the winter. In the fall, leaf peepers flood into the city, and there's nice brisk winds coming off the ocean. In spring, in the outer neighborhoods, it's bright green, and there are bunnies everywhere. But if you're looking for what's constant: Boston is loud and brash. It's essentially a small town that got too big."

Boston is an enduring symbol of America's revolutionary passion, commitment to knowledge—and, also, its love of donuts (this is the home of Dunkin', after all). The streets display an old-world charm reminiscent of the back alleys of Europe, yet are home to some of America's most advanced universities and cutting-edge medical centers. "Boston can best be described as a density of novelty," continued Fred. "Wherever you are, there is a lot to see, both in terms of history and modern amenities. Walking around town, you'll occasionally feel like you're in some kind of anachronistic movie set. You've got modern storefronts next to two-hundred-year-old cobblestone streets, and crumbling churches right next to skyscrapers. Nothing is linear. The streets change names every three hundred feet. For this reason, most people use landmarks for directions, rather than street names."

One of Boston's nicknames is "America's Walking City." For a great cross-section of the city's various cultures, begin at the Prudential Center, aka "the Pru." Top off your energy reserves at Flour Bakery and Cafe, the local chain run by James Beard Award–winning chef Joanne Chang, and consider a peek down Newbury Street—a posh row of haute couture boutiques tucked inside immaculately preserved Victorian brownstones. From the Pru, head north toward the Harvard Bridge, which crosses over the Charles River. In the summer, this central waterway is a haven of kayakers, college crew teams, and duckboat tours. In the winter, it freezes over to become a vast, milk-toned mirror of the sky. Walk across

OPPOSITE:
Boston's North End, with its old world cobblestones and pillars of steam, invites hours of meandering.

during sunset on a clear day, and find yourself inside a halo, with the Boston skyline surrounded by ethereal pastels and golds. Once on the other side of the bridge, you are now in Cambridge and at the feet of the world-renowned MIT campus. It's worth it to take a peek at the top of the neoclassical Great Dome, the unofficial landing site of the students' most audacious pranks (which at one point included installing an entire police cruiser on top, complete with dummy cop and a box of Dunkin' donuts).

For a more historically detailed walk down America's memory lane, consider the Freedom Trail—a 2.5-mile, red-brick road that snakes through the heart of Boston's downtown. The trail officially begins at the Boston Common (America's oldest public green space), and leads to such sights as the Paul Revere House (the patriot's preserved seventeenth-century home) and the Old North Church, (where the American war for independence began). A few of these sites are located inside Boston's historic North End, a labyrinth of cobblestone alleys, wrought iron gates, and red-brick apartments. "The North End is always something I recommend to people," reflected Fred. "The food is great, especially the Italian and the pastries. Mike's Pastry and Modern Pastry are the popular places, though any Bostonian will tell you they're both overrated—possibly because the line got too long, and we don't have the patience for that.

"A foodie advantage of Boston," continued Fred, "is caused by the sheer number of academic institutions. Boston has a very diverse population, and many of the people living here are students. So you have incredible food at pretty acceptable prices. Right outside Harvard Square, there's a small diner called Zoe's, in the basement level of a strip mall. It's a proper Greek diner. A lot of the diners in the area are Greek, and the Greeks in Boston had a massive influence on the food scene for many decades. Another great watering hole is a place up in Davis called the Burren. It's a proper Irish pub, and they host live Irish music nights. If you wanna get the true Boston-Irish feel, that's a great place to go."

Of course, no visit to Boston would be complete without trying the lobster, and for this, your best bet is to head down to the waterfront. "You don't need to pay this huge amount to get great lobster," explained Fred. "A lot of the time, you can get them for cheap right off the boats. But if you don't want to prepare it yourself, Legal Sea Foods is a great spot. They have excellent chowder as well."

Boston's high student population has other unique effects. During summer break, the city's population drops by nearly one-third. Sublet apartments become easily rented, for anyone looking to stay for more than a few nights.

MASSACHUSETTS

"Most people in Boston are what we call 'Massholes,'" concluded Fred. "They will complain to you the whole time after they've pulled over to help you change your tire. It's a great place to travel alone because you are expected to look after yourself, but if you need help, or directions, and you ask someone, people are helpful. In basically any circumstance, Bostonians would rather be helpful."

FRED SMITH spent his formative years in and around Boston. As a child, he always wanted to see the distant places that he heard about in stories. As an adult, he eventually convinced an employer to let him travel to see them. After years of bouncing around the globe, he eventually immigrated to Europe, where he spends his days trying to wrangle ones and zeros into the faerie bargain we call "software." He remains hooked on traveling for concerts and events, and loves exploring new cultures, cuisines, and languages. Outside work, he can be found tinkering, traveling, and encouraging other solo travelers to explore as much of the world as they can.

If You Go

▶ **Getting There:** Boston International Airport is served by most major carriers and is a hub for Delta (800-221-2262; delta.com).
▶ **Best Time to Visit:** Boston has notoriously frosty winters and hot summers. Autumn is a great time for temperate weather and to see the famous changing leaves of New England.
▶ **On a Budget:** There are a number of affordable, historic guesthouses in Cambridge and the South End, usually featuring shared baths. Near the Boston Common, the HI Hostel Boston (617-536-9455; hiusa.org) and FOUND Hotel Boston (617-426-6220; foundhotels.com/cities/boston) offer the cheapest lodgings near the most action.
▶ **Luxe:** Boston is rich with top-tier luxury hotel brands, like Omni and Ritz-Carlton. Most are tucked against the shoreline in Seaport, or overlook the Common. For more historic-flavored opulence, check out the Newbury (617-536-5700; thenewburyboston.com), with its mahogany and leather library-turned-lobby, or the bright, quintessentially New England sophistication of the Boston Harbor Hotel (617-439-7000; bostonharborhotel.com).

Mexico

OAXACA CITY

RECOMMENDED BY **Matt Kepnes**

Tucked in the mountains of southwestern Mexico, Oaxaca City is surprisingly small considering its titanic reputation. The city of only three hundred thousand residents is a beacon for pre-Columbian Mexican heritage and some of the best mezcal in the world. "Oaxaca is old," began Matt Kepnes. "It's been inhabited by the locals for thousands of years. The modern city is small, built in the colonial style, and covered in colors and murals set against the backdrop of the mountains. The region is known for its artistry in clothes, ceramics, woodworks, and mezcal production. Mezcal truly is an art here. Ninety-four percent of all mezcal in the world is made in Oaxaca state. The food culture is very rich, and by that I mean, deeply cultured. Overall, it's great place to relax, eat, hike to a waterfall, and imbibe. It's like Napa, but for mezcal."

The magic of Oaxaca begins with its people. While the city has become a hub for digital nomads—thanks to its relative safety, affordable hostels, and plethora of international flights—the original inhabitants of the valley have maintained their culture over thousands of years. For an eye-popping archeological display, travel about thirty minutes outside Oaxaca City to Monte Albán, the political capital of the Mixtec and Zapotec civilizations. Pyramids, plazas, and *tlachtli* ball courts, preserved from 500 to 800 CE, make this ancient city one of the most important archaeological sites in Mesoamerica. Despite this, it receives less tourism than similar sites in Mexico; visitors tend to report it has a less commercial feel, with short lines and an atmosphere that allows you to appreciate the wonders at your own pace. An hour east of Monte Albán is Mitla, the spiritual and religious counterpart to Monte Albán. Archeologists believe the Zapotec and Mixtec considered Mitla to be a dwelling place of ancestors from a previous epoch—an era of the gods. The elite of these powerful civilizations were interred here, in ornately patterned temples, connected to tunnels to the underworld.

OPPOSITE:
Oaxaca's colorful old town is a hub for premium mezcal and world-famous cuisine.

Surrounding these archeological wonders are Oaxaca's even more timeless mountains. Mountain bike tours can be chartered into the hills, and although there are numerous day hikes that lead from Oaxaca's city center, the trails with the best views usually necessitate a drive out. The misty cloud forests of San José del Pacifico, with its abundance of mushrooms, waterfalls, and emerald vegetation, are well worth the three-hour drive. If that feels too far, just an hour and a half away lies the surreal site of Hierve el Agua. In Spanish, *hierve* means "to boil"—an ironic title for a place that looks like a waterfall frozen in time. The eerily still "waterfalls" of Hierve el Agua are in fact the result of thousands of years of calcium deposits trailing down the mountainside. The result is a fantasy-worthy scene of waterfalls made from solid stone. Beside these cliffs, an infinity pool of natural spring water offers endless views of the surrounding mountains. Bathers are welcome, but the site is sometimes capped during the high season to avoid damage to the area. Be sure to arrive early or book with a reputable guide.

After working up an appetite exploring the region's historic and natural wonders, the epicurean delights of Oaxaca City await. Oaxaca is one of Mexico's—and the world's—most famous gastronomic regions, a hub of modern fusion and traditional staples. These include spiced chicken served with savory chocolate mole, and crispy grilled *memelas* topped with fresh beans, sautéed beef, and *queso fresco*. At the indoor Mercado 20 de Noveimbre, visitors can peruse lanes of gourmet food stalls and try it all. If you're looking for an upscale, sit-down restaurant experience that also isn't too expensive, Matt recommends Terraza Los Amantes. "They do modern takes on traditional Oaxacan dishes—beautiful dishes, probably the best restaurant experience I had in the city."

No visit to Oaxaca would be complete without tasting the sweet, smokey mezcal. Dozens of *mezcalerías* are located within the colorful avenues of Oaxaca City itself, as well as at the production sites in the surrounding hills and valleys. "Salvadores is a great mezcal brand, one of the oldest distilleries in the community," reflected Matt. "The family has been making mezcal for over a hundred years. I actually got introduced to someone from the family, this guy named Aziz. And by that I mean I randomly texted him after a friend said I should. And he just . . . invited me out to his bar. His family, the house of Cortez, has a huge presence in the city. They are very old, very well known. I was expecting this huge ego. But he was so humble, he just took me in and showed me around. I couldn't believe it. This bigwig gets a text from this random gringo, and instead of snubbing me, he just treated me so well. That's very Oaxaca, they're very humble and kind people, very easygoing and approachable.

"My last bit of advice," concluded Matt, "is to be open minded and respectful of the culture. Don't be afraid to talk to people; they are friendly. Anyone in the mezcal shops will talk your ear off. And be sure to get out of the city as much as possible, using local operators. There are some non-Oaxacan tour groups, but to help keep the benefits of tourism there, within the community, be sure to use Oaxacan-based companies. They know all the best spots too."

MATT KEPNES runs the award-winning budget travel site Nomadic Matt. After a trip to Thailand in 2005, Matt decided to quit his job, finish his MBA, and head off into the world. His original trip was supposed to last a year. More than a decade (and nearly a hundred countries) later, he is still out roaming the world. His writings and advice have been featured in the *New York Times*, CNN, the *Guardian*, Budget Travel, BBC, *Time*, the *Wall Street Journal*, and countless other publications. When not traveling the world, he lives in New York City.

If You Go

▶ **Getting There:** Oaxaca's Xoxocotlán International Airport is served by Aeroméxico (800-237-6639; aeromexico.com). From there, a taxi or tour guide is the best way to get to the city center.

▶ **Best Time to Visit:** The Día de los Muertos celebrations in Oaxaca are famous for their lavishness. October also marks the beginning of the dry season, which lasts until April.

▶ **On a Budget:** Price-conscious travelers will be pleased to see a large number of affordable lodging options located in Oaxaca City's Centro District. Some favorites are the clean-line comforts of La Casa de María (+52 951 514 4313; lacasademaria.com.mx;) and the colorful Azul Cielo Hostel (+52 951 205 3564; azulcielohostel.com).

▶ **Luxe:** There are a limited number of five-star hotels in Oaxaca City, including Hotel Casa de Sierra Azul (+52 951 514 7171; hotelcasadesierrazul.com), with simple but comfortable rooms in a nineteenth-century alabaster mansion.

Mexico

TULUM

RECOMMENDED BY **Shelley Marmor**

"Tulum is one of those places that I kept seeing online," Shelley Marmor recalled. "I was living in Playa del Carmen—just forty-five minutes or so north—when I first visited in 2018, and ended up staying for several months. I fell most in love with the natural side of Tulum—the beaches, the cenotes, the jungle terrain of the Sian Ka'an Biosphere. But there's also an easy proximity to Mayan ruins, and the comforts and amenities of a town. It's the best of both worlds."

Mexico's Yucatán Peninsula—the land that juts north and east into the Caribbean from Belize and Guatemala—was once the center of Mayan civilization. More recently, American and European travelers have discovered the region's rich blend of steady sunshine, unblemished beaches, and Mayan culture. For visitor purposes, the Yucatán can be divided into three segments: the quite-developed environs of the city of Cancún in the north, the modestly developed resort communities adjoining Playa del Carmen (30 to 60 miles south), and the less developed terrain below Tulum (90 miles south of Cancún). While Cancún, with its beachside strip of high-rise hotels and high-energy nightlife, draws spring break–minded revelers, more discriminating sojourners may prefer the quieter charms to be found around Tulum. Tulum is the gateway to the 1.3-million-acre Sian Ka'an Biosphere Reserve, which extends along the coast to the Belizean border. It's home to more than 340 bird species; endangered jaguars; and deserted, palm tree–fringed beaches that have changed little since the Spanish conquest. Small, ecoconscious lodges, yoga retreats, and cantinas dot the rough road that cuts through the reserve en route to the fishing village of Punta Allen, at the end of the peninsula. Old-town Tulum straddles Highway 307, Quintana Roo's primary north–south road.

MEXICO

"The nicest hotels in Tulum are down on the beaches," Shelley continued, "but you're starting to see nicer places in town as well. Relative to most of Mexico, Tulum is one of the more expensive destinations. But it's still possible to travel here on a budget." Given the Sturm und Drang of the drug trade, one can't help but ask—Is it safe to travel alone in Tulum? "If you mention that you're going to be traveling anywhere in Mexico, people will say, 'Be careful!'" Shelley added. "I think it's good to have safety in front of mind wherever you are. I'd say that Tulum is safe, but it can also be unsafe. It's a party town, and given the laws of supply and demand, there are people around hoping to sell drugs. But it's pretty easy to avoid them. I'm not sure that Tulum is the best place for the first-time solo traveler. But if you're prepared and aware of your surroundings, it's a wonderful destination."

A special facet of the greater Tulum experience is the chance to swim and explore cenotes (pronounced "say-no-tays"), a geological phenomenon found through much of the state of Quintana Roo. The region's surface strata consists of porous limestone, remnants of what was not so long ago (in geologic terms) an ocean floor. Over thousands of years, rainwater filtered through the limestone, creating an extensive series of underground rivers, with accompanying caverns. Cenotes are essentially sinkholes that occur when the limestone surface crumbles. The water can be amazingly clear, which highlights the colors of the stalactites and stalagmites. The Mayans revered cenotes, viewing them as portals to a spiritual world below the earth. On a day-to-day basis, cenotes were extremely important to eastern Yucatán residents as a source of fresh water for drinking and irrigation.

Today, cenotes give causal passersby a wonderful spot to take a cooling freshwater plunge, snorkelers interesting chambers to inspect, and divers an entrance to a vast underwater cave system. "I find the cenotes just amazing," Shelley enthused. "There are more than two hundred in the Tulum area, some in remote areas, and a few, like Cenote Escondido, are right in town. Most have simple walkways leading to the water; some diving platforms." If saltwater swimming is of greater appeal, Tulum offers wonderful snorkeling and diving. "There are a number of idyllic beaches in the area," Shelley continued. "There are private beach clubs where you pay a set fee that gives you access to towels, lounge chairs, and a certain amount of food and beverages. There are also public beaches that are equally beautiful, but a little tougher to access and offering no services. As Tulum has become discovered, the hidden gems are becoming a bit less hidden. But you can still

find a slice of paradise." For more serious snorkelers and divers, the Mesoamerican Barrier Reef (the Atlantic's largest coral reef) lies just a few miles offshore and is home to more than five hundred fish species—both colorful reef fish and larger pelagic species (like whale sharks) that are drawn to the reef from the depths beyond. If you prefer the shallows, snorkeling in Akumal Bay to the north virtually guarantees an opportunity to swim alongside sea turtles.

The native population of the Yucatán is made up predominantly of people of Mayan heritage, and grand remnants of their earlier civilization are readily accessible to visitors. Serious archaeology aficionados may want to make the two-hour trip inland to the spectacular ruins at Chichén Itzá, one of the centers of the Mayan domain one thousand years ago. The ruins at Tulum, overlooking the Caribbean, offer an excellent (and much closer by) primer to Mayan culture. The site is surrounded by a thick rock wall (*tulum* means "wall" in Mayan) and rests on a bluff thirty feet above the sea. Carvings of plumed serpents (representative of the god Kukulkan and a common Mayan design motif) grace several structures. Large flesh-and-blood iguanas laze about the rock walls, and a path leads down to a beautiful stretch of beach where you can cool off. One of Shelley's favorite sites is Cobá, northwest of Tulum. "It was a thriving city in its heyday, a place for commerce and worship," she explained. "Now it has the largest pyramid in Mexico that you're allowed to climb."

It's not hard to find a little nightlife in Tulum. "Once a month there's a full moon party at Papaya Playa, an all-night affair. Some of the restaurants—like Casa Jaguar and Gitano Jungle—turn into bars after ten. There is also a series of music festivals in the winter. One of my favorite spots is in town, Batey Mojito and Guarapo Bar. There's a converted VW Bug in front where they grind the sugarcane for mojitos."

SHELLEY MARMOR is a former Miami travel magazine editor who ditched the office for the world. After traveling alone all over Mexico for one year, she decided to become a full-time Mexican expat in 2018. She's lived in several places, including Mexico City, Oaxaca City, Playa del Carmen, Huatulco, and Mérida. To date, she's visited nineteen out of thirty-two states, many as a solo female traveler. She uses her knowledge and insider tips to help travelers plan the Mexico trip of their dreams, travel to Mexico confidently and safely, and cross Mexico off their bucket list. Her blogs—which have been featured in many prominent publications—offer the perspective of a solo female

traveler who lives in Mexico. Visit her various travel blogs (*Travel To Mérida, Travel To Oaxaca, Tulum Travel Secrets,* and *Travel Mexico Solo*) and her *Dream To Destination* podcast, to learn more.

If You Go

▶ **Getting There:** Felipe Carrillo Puerto International Airport (TQO) is served by Aeroméxico (800-237-6639; aeromexico.com) and Viva Aerobus (866-359-8482; vivaaerobus.com). Cancún, which is roughly 1.5 hours' drive from Tulum, is served by many major carriers. Many visitors opt to bus to Tulum, and then rent a bike to get around. Car rental is not essential.

▶ **Best Time to Visit:** The dry season runs from November to May, and sees slightly cooler temperatures.

▶ **On a Budget:** If you're on a budget, you'll want to stay in town, where rooms can be found for around $50. Several hostel options include Mayan Monkey (+52 984 122 1301; mayanmonkey.com) and Moonshine Tulum (984-121-5290; moonshinetulumhotelhostel.com). Entry fees to the ruins are very reasonable, and once you reach public beaches, entry is free.

▶ **Luxe:** Any number of more luxurious ecolodges can be found along the beach that stretches from Tulum to Punta Allen, including Maya Tulum Retreat and Spa (888-515-4580; mayatulum.com) and La Valise Tulum (386-301-4831; lavalisetulum.com). Shelley's website, tulumtravelsecrets.com, provides an excellent overview of higher- and lower-end options.

Montana

WHITEFISH

RECOMMENDED BY **Brian Schott**

Brian Schott arrived in Whitefish, Montana, in the early nineties in search of an undiscovered ski town. "Driving north, I still remember seeing Flathead Lake for the first time, with the Whitefish Range in the background," he recalled. "There was something magical about Montana then—deep woods, tall mountains, lakes, rivers, public land access. Though there are more people now, the magic is still there. When I reached Whitefish, I found potholed streets and super-friendly people of a welcoming nature. I didn't expect to stay, but ended up meeting my wife and raising a family here. In my early years, Whitefish was working to attract visitors. Now, we've shifted from tourism to destination stewardship. One of our campaigns is 'Be a Friend of the Fish.'"

Whitefish, Montana, sits at the northern end of the Flathead Valley, on the southern shore of Whitefish Lake. Since it was established in 1905 to serve as the regional headquarters of the Great Northern Railway, Whitefish has become the unofficial gateway to Glacier National Park, which rests twenty-five miles to the east. Though it lacks the bison and geysers of Montana's *other* national park, Glacier is a jewel unto itself. Contrary to popular perception, the park is not named for existing glaciers (of which a few do remain), but for the work earlier glaciers did at the conclusion of the last ice age. These glaciers slowly scoured away deep valleys and sharp ridges, carving rugged mountains and deep lakes en route. Much of the high country in Glacier is above the tree line. Glacier is home to all of the big game animals that were here when Lewis and Clark pushed west on a path south of the park in 1805—wolves, mountain lions, elk, bighorn sheep, mountain goats, wolverines, lynx . . . and of course, grizzlies. The presence of these predators, especially the bears, lends any experience here more of a wilderness feeling, a little extra electricity.

OPPOSITE:
Fly-fishing is one of many ways visitors can enjoy the beautiful scenery around Whitefish.

DESTINATION
32

There are many ways for solo travelers to experience Glacier. One way is to drive or ride the Going-to-the-Sun Road, a 51-mile WPA engineering marvel that cuts across the park from the West Entrance to the Saint Mary's Entrance, crossing the Continental Divide and elevations of more than 6,600 feet along the way. "I'd guess that 90 percent of Glacier's visitors may not leave the Going-to the-Sun Road, but it is one of America's most beautiful drives," Brian continued. "To control the amount of traffic and help maintain a positive visitor experience, the National Park Service is experimenting with a car reservation process. There are several commercial bus tour services in the park you can take. The Red Bus Tours have used open-air buses dating back to 1933 and offer round-trip service. Blackfeet cultural tours by Sun Tours give you an idea of the importance of the Glacier region for Native American people like the Blackfeet. If you're going to really dig into the heart of the place, you need to think of its Indigenous people."

Many come to Glacier to hike, and there are more than seven hundred miles of trails to choose from. Some take you deep into the backcountry; others can be easily accessed from Going-to-the-Sun Road. "A favorite is Avalanche Lake," Brian described. "It's about 1.5 miles each way, and brings you to the most gorgeous glacial cirque, with waterfalls pouring in. Highline Trail is another classic that begins at Logan Pass (the high point of Going-to-the-Sun Road, at 6,646 feet) and goes roughly seven miles. It's more arduous. But as it's at a high vantage point, its's a great wildlife viewing trail." Visitors will almost always encounter mountain goats and bighorn sheep on the trail; it's also a good trail to see grizzlies at a comfortable distance—namely, in the valleys below.

A boat ride on one of the park's glacier lakes provides another perspective of the park and a taste of the park's history. Glacier Park Boat Company's wooden boats, some of which have been touring since 1926, offer tours on Lake McDonald, Swiftcurrent Lake, Lake Josephine, Saint Mary Lake, and Two Medicine Lake.

If you enjoy skiing, Whitefish will hold your attention from early December to early April. "In the thirties, a community group—the Hellroaring Ski Club—skinned up the mountain, built a simple cabin (with a sturdy fireplace), and essentially brought Alpine skiing to northwest Montana," Brian explained. "From the vision of a few scrappy people, Whitefish Mountain Resort is now rated among the top ski resorts in North America. There's a new guide service that can take seasoned skiers off-piste, with all the safety gear and an understanding of avalanche conditions. There's a great Nordic ski center, with forty kilometers of groomed trails. (You can also cross-country ski portions of the Going-

to-the-Sun Road.) If you want something different, Whitefish Bike Retreat rents 'fat bikes'; snowshoes are also available. If you're going to be in Whitefish all winter long, it's good to have an outdoor pastime and a hearty disposition, as it's cold and dark much of the time."

With the arrival of spring, the Whitefish sporting scene shows off its sunnier side. "There are some great golf courses in the area—we used to do a ski/golf tourney in April," Brian said. "There's whitewater rafting and kayaking in the Flathead River (and some overnight wilderness river trips on the South Fork Flathead), fly-fishing and lake fishing, mountain biking and road biking, and of course, trail hiking. We even have a world-class skate park. Again, guides are available for all outdoor pastimes, and they add a great deal to the experience."

While a good burger and beer are close by (as you'd expect in a mountain town with several craft breweries), many other options are available. "We have a fantastic sushi joint that has fish flown in from Seattle. Other great options include Abruzzo Italian Kitchen, which offers fine homemade pasta and wood-fired pizza, and Tupelo Grille, a go-to for locals.

"I have to say that Whitefish's arts scene was part of my initial attraction to the town. There are two theater companies in town, including Broadway émigrés. The Stumptown Art Studio lets guests dabble in ceramics and painting. Each July, there's a great music festival—Under the Big Sky—that attracts fifteen thousand attendees and stars like Hank Willliams Jr., Zach Bryan, and Caamp. In September, some of the nation's best songwriters visit as part of the Whitefish Songwriter Festival."

BRIAN SCHOTT is a freelance writer and the founding editor of the *Whitefish Review*, a literary journal that features the writing, art, and photography of mountain culture. As a freelance travel and outdoor writer, his award-winning stories have been featured in *Backcountry* magazine, *Big Sky Journal*, the *Boston Globe*, *National Geographic Traveler*, *Forbes*, *Life Mountain Time*, *SKI* magazine, *Skiing* magazine, *Montana Living*, *Sailing World*, *Mountain Magazine*, *New York Post*, *New York Daily News*, and the *New Hampshire Sunday News*. His photography has appeared in national publications like *USA Today* and the *Seattle Post-Intelligencer*.

If You Go

▶ **Getting There:** Visitors can fly to Kalispell (twenty-five miles west of the park's headquarters), which is served by Alaska Airlines (800-252-7522; alaskaair.com) and United (800-864-8331; united.com). There's also Amtrak service to Glacier (800-872-7245; amtrak.com).

▶ **Best Time to Visit:** Peak season is June through September, but this is a very crowded time. October can be beautiful, but winter weather can blow in at any time. Skiers and winter sports lovers should consider a winter visit.

▶ **On a Budget:** The Whitefish Hostel (406-863-9450) is situated downtown. Explore Whitefish (877-862-3548; explorewhitefish.com) highlights other more modest options around town.

▶ **Luxe:** The Firebrand Hotel (406-863-1900; firebrandhotel.com) and the Lodge at Whitefish Lake (406-863-4000; lodgeatwhitefishlake.com) are two of the region's more upscale properties. Or, you could opt to stay in the park at Lake McDonald Lodge, Many Glacier Hotel, or other properties in the park (855-733-4522; glaciernationalparklodges.com).

NEW YORK

RECOMMENDED BY **Dani Heinrich**

The iconic city that never sleeps, New York is one of the premiere culture capitals of the world; a microcosm of global diversity and extraordinary dreams, where people of all backgrounds intermingle. The city's towering skyscrapers, bustling art scene, and career-making (and -breaking) business centers have been capturing the imagination of tourists, immigrants, and artists for hundreds of years. Step out into the electric cacophony of Times Square, and it's easy to see why this is a bucket-list destination for every traveler the world over.

"Honestly, I was inspired to go simply because I had seen it so much on TV and in movies," began Dani Heinrich. "It always looked like the coolest city in the world. I'm from a very small town in Germany, and I had been to other US cities like Chicago. But New York . . . New York has this thing that you can't quite put into words. There is no other place like it on earth. There is this electric feeling in the air. You're in the midst of so much going on, so many impressions and sounds, so many cultures mixing all at once. It's deeply inspiring.

"I live in Brooklyn now," continued Dani. "I love going to Manhattan, but I also love going back to Brooklyn when I'm done. Sometimes I think people think the whole of the city is busy like Manhattan, where everyone is in a rush and no one knows their neighbors, but that's not the case. Brooklyn is quieter, greener, with seventy unique neighborhoods that each have their own distinct feeling."

Unlike many American cities, the New York City subway system runs 24 hours a day, facilitating constant movement between the five boroughs. For the tourist, this access is a blessing, because perhaps the only thing wrong with New York is that there's no way you could see it all in one trip.

NEW YORK

"It's particularly great for solo travelers because you have so many things you can do by yourself," reflected Dani. "I meet a lot of women traveling to New York solo. Their husbands didn't want to come, or their friends couldn't get time off, so they just go on their own. They spend a whole happy week going to museums during the day and then seeing a show at night. Because that's the thing about New York: You never get bored. And you actually don't need other people to enjoy an art gallery, the theater, a comedy show, or Central Park. It's totally normal to see people sitting in a bar by themselves or dining out solo. If you want to meet people, you can give off that vibe, but if you don't, nobody tends to bother you. This is not the case for a lot of cities. I do tons of things alone here, but almost never feel lonely.

"On the other hand," continued Dani, "There are so many solo travelers that if you wanted to, you could easily connect with other travelers by joining a walking tour or another activity. Travelers can find something on Meetup.com for every day and night of the week, and there are also activities like guided walks of Chinatown, rooftop bar crawls and speakeasy tours, or running tours in Central Park—activities that make it easy to meet other travelers."

It's hard to narrow down a list of New York's must-dos, but any visitor should be sure not to miss The Met, the Whitney, the Brooklyn Museum, or a show on Broadway—the street that named the genre itself. If you do go, be sure to leave time for a stop at Sardi's. "It's a famous bar right off Times Square," noted Dani. "Often, actors, writers, and producers will drop in. The walls are lined with pictures of Broadway stars. The waiters wear traditional white jackets and make a killer martini. I have a friend who's been going there since the eighties, and he says he sees almost all the same waiters. If you like these more old-school, classic New York institutions, there's also a bar in the West Village called Dante. It's more than one hundred years old, with this charming vintage interior. You'll always find a seat there. That's actually the other great things about traveling alone—even if places are booked up, you can usually find a seat at the bar." This is a handy tip for exploring any of New York's seventy-one Michelin-starred restaurants, which usually are booked up months ahead of time.

As with any large city, crime is often a question that comes up for tourists, especially those traveling alone. But according to Dani, generally speaking, there is little to worry about. "I often get asked about safety. But I think it is perfectly fine to travel solo here as a woman. It's not any more unsafe than any other big city. I take the subway night and

OPPOSITE: New York offers an endless number of options for solo travelers, from Broadway shows and museums to biking and kayaking.

day. I walk at night. If you have someone yelling in the subway, or making you feel uncomfortable, you just go to a different train car.

"I also think every person who comes to New York should make a point to try and see it from above," advised Dani. "There are five observation decks throughout the city, and the tickets usually cost around $50. So, you can do that, or you can do what I do, and buy a beer in a rooftop bar and get nearly the same view. Dear Irving on Hudson is an excellent choice, no mediocre cocktails or plastic glasses, just spectacular drinks with views. They take a lot of pride in what they do. But wherever you go, the view from above is something special. You're in the canopy of the concrete jungle, looking down at the street canyons."

Back on the ground, grab a bagel and a coffee and wander the trails of Central Park, rent a paddleboat and go out on the lake, or just sit on a bench and enjoy the skyline and the people-watching. "There's also great people-watching in Washington Square Park or Madison Square Park," noted Dani. "Or you can go over to DUMBO and sit on Pebble Beach with a picnic and enjoy the Brooklyn and Manhattan Bridge skyline. The best part is that all of this stuff is really affordable. That's the thing about New York—it can be very expensive, but you don't actually need to pay much to have a good time, so many things are free. This city can really be whatever you want it to be."

DANI HEINRICH's mission is to inspire curiosity about the world and provide the tips and tools to help you see as much of the world as you can for yourself. She is the founder of Globetrotter Girls and has been living in New York City since 2014. With Globetrotter Girls, she aims to make traveling easier for you, sharing what she's learned on her journey: the good, the bad, and the ugly mistakes (so you don't have to make the same ones), along with money-saving tips and travel hacks. She is also a licensed tour guide and runs walking tours in New York City.

NEW YORK

If You Go

▶ **Getting There:** New York City has three major airports served by a multitude of international and domestic carriers. John F. Kennedy is the most popular and has direct subway connections to downtown; LaGuardia has fewer convenient public transportation options, but is technically closer to Queens and Willamsburg; Newark tends to have cheaper flight options, but it may cost you more to get to actual NYC.

▶ **Best Time to Visit:** New York has iconic American four-seasons weather, and every time of year has its own charms. Late spring and early fall typically see fewer crowds.

▶ **On a Budget:** Budget hotels exist in NYC, but have questionable policies and closet-size rooms. You may find cheaper lodgings outside of Manhattan, but be sure to factor in the bridge toll in your cab fare to get to downtown (which can be avoided by taking the subway). A favorite in Manhattan is the Chelsea International Hostel (212-647-0010; chelseahostel.com), and in Brooklyn, the Brooklyn Riviera (212-470-0216; facebook.com/thebrooklynriviera) is a great spot for solo travelers.

▶ **Luxe:** New York City was built to celebrate opulence. All the major luxe brands are on display, and some grand dames include the Mark Hotel (212-744-4300; themarkhotel.com), renowned for its classic New York glamour; the Plaza (212-759-3000; theplazany.com), where chair legs and mirror frames are laced in real gold; or the unapologetically glitzy Baccarat (212-790-8800; baccarathotels.com), which has eponymous crystals in every room.

New Zealand

THE NORTH ISLAND

RECOMMENDED BY **Nicole Snell**

New Zealand is split into two distinct islands. While both are renowned for epic landscapes and world-class wilderness playgrounds, the North Island is the site of more geothermal hotspots, warm coastlines, and verdant, green forests than its glacier-laden southern sister. On the North Island, you'll also find more instances of important Māori heritage sites, like the Waitangi Treaty Grounds, as well as the country's two most populous cities: Auckland and Wellington. All of this makes it an ideal spot for urban comforts and heritage combined with iconic New Zealand nature. "The North Island is breathtakingly beautiful," began Nicole Snell. "I felt like I was transported to another time, to another planet. The nature is the greenest of greens. The air smelled so crisp. Everything was so lush. And the sheep! The sheep were everywhere. There are more sheep than people in New Zealand, and it's obvious. You'll be on the road and see them run up the mountain with their little bouncy white sheep butts. It's so cute."

A particular gem of the North Island is Waitomo Glowworm Caves, where visitors descend into the dark belly of a thirty-million-year-old limestone cavern. Here is a rare chance to enjoy black water rafting underground, test your fear of the dark, and stare in awe at the surreal ceiling. "I'm in this thick, eight-millimeter wet suit and boots, and my glasses are taped to my helmet because I can't wear contacts," remembered Nicole. "We couldn't have our phones or our cameras, either. We practiced rappeling down the waterfall, and I remember thinking, 'This is the most beautiful place I have ever been.' I wanted to freeze time just for a moment so I could soak it all in. And then sometime later, we're all crawling through the water and rappeling down this really, really deep hole—150 feet or something—into total darkness. Everyone gets down there and turns their headlamps off, and then you look around. You can see all the glowworms. They look like stars in the dark."

OPPOSITE: *Nicole Snell takes a moment of reflection next to the surreal Emerald Lakes at Tongariro Alpine Crossing.*

DESTINATION 34

Another sight not to be missed is Waiotapu, a wonderland of neon lakes, bombastic geysers, and sizzling mud pools. "There are a lot of geothermal parks in the North Island, but this is one of the more well-known ones," explained Nicole. "The tour guides told us that day that we could either go to Hobbiton or to Waiotapu. And I really wanted to do both, but I picked Waiotapu because I wanted to see more of the natural beauty of New Zealand. And no one else came with me! So, I was like, 'See you, bye!' That's a fun benefit of traveling solo.

"One thing I really loved," reflected Nicole, "was getting to see the connection that the Māori have with the land. We got the opportunity to visit A Mari Marae, a Māori meeting house. And in the Māori culture, they told us that the meeting house is an ancestor. It's not just a building, it's an entity.

"Later," continued Nicole, "we also got the chance to visit Lake Aniwhenua and stayed at the Kohutapu Lodge, where I got to meet the Māori family that runs it. I learned about Māori weaponry and had a lesson with the taiaha (Māori spear). They are known as the Eel People, and they told us one story that I will never forget. Even though New Zealand tends to be very progressive when it comes to environmentalism and sustainability, there was a dam that was built on their land that cut off the eels' spawning season. The eels would normally go up the river to the ocean, breed, and then come back, but this dam blocked their path. So, what the Māori people did was drive to the side of the dam where all the eels were getting stuck, put them in buckets, load them onto trucks, and drive them around the dam. And that's how the humans became part of the eel cycle—because they knew what the eels needed, what the environment needed, and this went on and on. These people had to make sure that not just their livelihood, but the connection to the earth and to the animals stayed true, and I was just blown away by that. What they've experienced echoes what so many other Indigenous, Black, and people of color have experienced around the world with colonization and trying to reclaim your history, your culture, and your language.

"My last bits of advice are that if you're going there to hike, such as the Tongariro Alpine Crossing, which is a twelve-mile hike from point to point, make sure you have the appropriate gear and be flexible. The day we were supposed to arrive in Tongariro to do the crossing, there were storms that came in. The government will shut down the trail if it's not safe—which they did. Thankfully, I had an extra day built into my itinerary and was able to wait out the storm and go two days late. That hike through volcanic land-

scapes was truly epic and ignited my passion for longer and more technical hikes. New Zealand will always have a place in my heart."

Nicole Snell is an award-winning international speaker, facilitator, trainer, and self-defense expert specializing in sexual-assault and violence-prevention education, gender-based violence prevention, personal safety, and empowerment-based self-defense. She is the owner and CEO of Girls Fight Back, the world-renowned personal safety and empowerment self-defense company for women, girls, and people of all genders. She is also a lead instructor for IMPACT Personal Safety and IMPACT Global, which teaches realistic self-defense skills around the world using adrenalized, realistic, scenario-based training. She is a hike and adventure leader for the LA-based nonprofit Black Girls Trekkin', and in 2019, she created Outdoor Defense, a YouTube series that provides safety strategies to encourage people to enjoy the outdoors solo. Visit her at nicolesnell.com.

If You Go

▶ **Getting There:** The North Island is served primarily by Wellington and Auckland Airports, both served by Air New Zealand (800-262-1234; airnewzealand.com).
▶ **Best Time to Visit:** Summer (November to January) brings the best weather.
▶ **On a Budget:** Stray Tours can be booked at straytravel.com, and Nicole's favorite hostel was Karioi Lodge (karioilodge.co.nz) in Raglan.
▶ **Luxe:** A plethora of five-star lodgings are across the North Island, usually set in solitude for visitors to better commune with the grand landscapes. Some highlights include the upscale farmhouse charm of the Wharekauhau Country Estate (+64 6 307 7581; wharekauhau.co.nz) outside Wellington, or the plush comforts of Solitaire Lodge (+64 7 362 8208; solitairelodge.co.nz) on Lake Tarawera.

North Carolina

ASHEVILLE

RECOMMENDED BY **Billy Zanski**

Billy Zanski found his way to Asheville, North Carolina, in a somewhat roundabout way—via Western Africa. "I was living in Wisconsin, and a visiting troupe of musicians from West Africa came through. They had a drum circle, and someone offered me a drum. I didn't know what I was doing, but I loved it. We made a connection, and they encouraged me to visit them to continue my drumming education. So, I went to West Africa to study. My teacher was eventually asked to come to Asheville to teach, and the people who brought him here brought me along in 2004. I never left."

Asheville is an eclectic small city in the Blue Ridge Mountains of western North Carolina where New Agers, outdoor enthusiasts, musicians, and local food advocates all coexist, under a patina of Southern charm. There's a progressive, hip vibe here that some might not expect in southern Appalachia at the gateway to the Great Smokies. Thanks to its elevation (2,134 feet above sea level), Asheville avoids the intense heat one might associate with a Carolina summer. The city's thriving foodie and brewing scene represents another powerful draw. And for those who like to travel with their dog, Asheville has earned the reputation as America's most dog-friendly city.

One of Asheville's great appeals is its restaurant scene. Its position at the nexus of Southern and Appalachian cuisine—and a great farm-to-table scene—has helped propel it to the top of many "foodie" lists. Cúrate (from Katie Button), which boasts Spanish cuisine, and Joe Scully and Kevin Westmoreland's Chestnut have received broad recognition, while chef and restaurateur Meherwan Irani (of Chai Pani) has received four James Beard Award nominations for "Best Chef in the Southeast." Add in the gourmet Mexican fare found at Mountain Madre and French Quarter–inspired creations at Bouchon—plus the vegetarian offerings at Plant and the Laughing Seed I—and you'll have no problem

OPPOSITE:
The Biltmore Estate, which first opened in the 1890s, attracts many visitors to greater Asheville.

DESTINATION
35

being well fed. "Asheville is very community oriented," Billy continued. "There are lots of groups doing their own thing on the land. People have embraced conscious capitalism."

"Asheville has had a great tourism base for many years," local beer entrepreneur Hilton Swing observed. "We are a gateway to the Great Smokies and the Blue Ridge Mountains, and have the Biltmore Estate. The growth of the beer scene here has been a great addition for visitors coming to Asheville. With the Asheville Ale Trail, we've tried to focus on the overall experience and keep things accessible to someone who might not yet be a beer aficionado but wishes to learn more."

One of Billy's favorite aspects of Asheville is its multiple and multifaceted natural amenities. "Drive 30 or 45 minutes in about any direction, and you're in a beautiful place," Billy enthused. "I love getting out to hike, visiting the waterfalls and lakes. Even a drive along the Blue Ridge Parkway is affirming." Thanks to its Blue Ridge Mountain location, Asheville has hundreds of hiking trails within a short drive of town, winding past waterfalls or snaking to summits with staggering views. To enjoy water sports, consider visiting Chimney Rock State Park and Lake Lure, especially in the summer.

George Vanderbilt (of *the* Vanderbilts) certainly recognized the special qualities of the region in the 1880s and went on to create a site of great appeal to history buffs and architectural enthusiasts alike—the Biltmore Estate. The grandson of shipping entrepreneur and industrialist Cornelius "the Commodore" Vanderbilt, George began slowly acquiring land around Asheville, eventually amassing more than 125,000 acres for what would eventually become his country estate. He retained architect Richard Morris Hunt to design the 250-room château that would become the largest house in America (including thirty-five bedrooms, forty-three bathrooms, and sixty-five fireplaces), and broke ground in 1889. Landscape architect Frederick Law Olmsted (of New York's Central Park fame) was brought on to design formal gardens and sculpt former farmland into bucolic, pastoral parklands. Visitors can opt to tour the Biltmore on their own or with a guide. For a special treat, you can book a room at the Inn on Biltmore Estate and luxuriate in the Inn's spa treatments and the culinary feats of the four-star Dining Room restaurant. Horseback riding, fly-fishing, and guided nature tours are available on the grounds.

Given the region's rich bluegrass heritage, music has long been a pivotal part of the Asheville experience; many insiders see the city as a major up-and-comer on the national music scene. There may be no better way for a solo traveler to tap into the gestalt of the town than by joining one of Billy's drum circles or attending a sound healing. "People

always connect with music," he ventured. "It's very easy to take part in a drum circle. Visitors might start standing at a distance. Then they'll get closer and maybe dance around a bit. Stand close enough, someone will offer you a try on their drum. Usually, it's a pretty random selection of drummers—some talented, some less so. But it's a free and open scene, and people come for the appreciation of the good vibes.

"The sound-healing practice is more a meditation. You utilize your interest in hearing music with an inward awareness, a journey into yourself. We have a profound selection of gongs and crystal balls with great harmonics. I can do almost an orchestration. Sometimes we'll have twenty people from around the United States and other countries. It has a spiritual undertone. People are looking for a connective, peaceful, nurturing experience. People are converging in Asheville not just to be in the Blue Ridge Mountains and near waterfalls, but to connect with a community of like-minded folks. I'm not trying to heal people with the sound, but it hopefully opens up awareness."

BILLY ZANSKI is a percussionist by trade. After a sound-healing journey took him from Wisconsin to Guinea in West Africa, he followed his *djembe* teacher to Asheville and opened Skinny Beats Sound Shop. Today, he leads Asheville's sound-healing scene, offering private and group sessions from Skinny Beats Sound Shop (828-768-2826; skinnybeatsdrums.com) in its downtown Asheville location.

If You Go

▶ **Getting There:** Asheville is served by a number of carriers, including American (800-433-7300; aa.com) and Allegiant (702-505-8888; allegiantair.com).
▶ **Best Time to Visit:** May through October, with fine foliage displays in the fall.
▶ **On a Budget:** Asheville offers several hostel options, including Asheville Hostel and Guest House (828-423-0256; avlhostel.com) and the Lazy Tiger Hostel (828-782-3157; lazytigerhostel.com). Other cost-effective options are highlighted at exploreasheville.com.
▶ **Luxe:** The Hayward Park Hotel (828-232-8217; haywoodpark.com) is a luxury property located downtown. The region's most luxurious option is the Inn on Biltmore Estate (800-411-3812; biltmore.com/stay/the-inn).

Norway

THE FJORDS

RECOMMENDED BY **Spencer Seim**

A lofty network of snow-crowned cliffs jutting into the sea, painted in lush greenery with cascading ribbons of waterfalls—the beauty of the fjords has inspired hundreds of years of songs, poems, and even Monty Python sketches. There are technically more than one thousand fjords in Norway, but most tourist infrastructure is centered on just ten. The largest ones, such as the Sognefjord, are frequented by international cruise ships. Narrower channels, such as the Aurlandsfjord and the Nærøyfjord, are dedicated UNESCO World Heritage sites, and have branches only navigable by small ferry boats. In fact, some of the villages located in these remote regions consist of little more than a house, a flock of sheep, and an apple orchard. Many did not have road access until very recently.

With so many fjords over so much ground, planning an itinerary can be a daunting exercise. Joining a pre-planned bike, cruise, or kayak tour can help you make the most out of your time. But no matter how you choose to tackle this epic landscape, most journeys begin in Bergen, Norway's second-largest city. Wander the salty-air aisles of historic Bryggen, where the Hanseatic League's unique trading history with the rest of Europe has been preserved in medieval buildings. At Bergen's famous indoor fish market, enjoy some of the best salmon of your life at Fish Me restaurant. Alternately, spend an elegant evening at the Unicorn, whose eighteenth-century, wood-paneled décor pairs perfectly with a bowl of traditional Norwegian *fiskesuppe*—a velvety, spiced fish chowder that will leave you feeling like a wealthy sea baron.

Bergen is an ideal jumping-off point to explore the quaint villages of the Sognefjord (Norway's longest fjord), or take an epic day tour through the misty, mythical cliffs of the Hardangerfjord. Most tours you'll book (or put together yourself) can be extended by choosing to stay in some of the villages encountered along the way. Some of Spencer's

OPPOSITE:
Some villages in the fjords are so remote, they only recently attained roads.

favorites on the Sognefjord include Fjærland, a funky book town perfect for kayaking, glacier views, and floating saunas; Balestrand, one of of Norway's oldest tourist destinations, known for a magical light and a hike overlooking three fjords; and Solvorn, a peaceful fjordside hamlet across from Norway's oldest stave church (while there, be sure to check out the Walaker Hotell for sophisticated farm-to-table fair).

Kayaking is a common day trip and a way to explore more narrow sections of the fjords that cannot be reached even by ferries. In the warmer months, paddle between emerald-green cliffs decorated with blooming orchards and cascading waterfalls while tinkling sheep bells echo through the canyon walls. "The water is calm inside the fjords," reflected Spencer Seim, "so it's a perfect kayak playground. On our Multi-Adventure Tour, we kayak from Halhjem, a quaint village set where the Bjørnafjorden meets the North Sea and its barrier islands. With the Rosendal Alps soaring overhead, it's really quite spectacular."

Other favorite pastimes include day hiking, camping, and mountain biking. "Biking down from the heights of the mountains to the fjord at sea level is such a thrill," described Spencer. "As is hiking all the way from sea level to the top of Europe's largest plateau, with views of glaciers hanging over the fjords. All the little villages and local encounters along the way make exploring this area really unique and special, and the best way to do that and to really connect with your surroundings is to travel under your own power."

Whatever your outdoor pleasure, a favorite way to warm back up is, of course, in the sauna. "It's a rich tradition in Norway," enthused Spencer. "And after a day of hiking, cycling, or skiing, there's nothing quite like unwinding in a traditional sauna. Some say the best sauna sessions end with a jump into the fjord!"

Each fjord village has its own specialties, from hotels to eateries. Some of Spencer's favorites include Ciderhuset in Balestrand, a local-run restaurant surrounded by a hundred-year-old apple orchard with a cool international youth cooking program. In Nå, Siderhuset Ola K offers excellent food with local ingredients and a fixed menu that changes weekly, served in an atmosphere of warm wood beams and cool old black-and-white photos.

You could spend two weeks, or two months, adventuring the fjords and still perhaps be left feeling like you didn't see enough. But rather than feel rushed, don't forget to stop and savor the magic. "It's really about the people," concluded Spencer, "and how this landscape has helped to shape the culture. I want to highlight the warmth and generosity of the folks in this beautiful region, as well as the traditions that mean so much to them."

SPENCER SEIM grew up among many other Norwegians in the Seattle area, where he spent as much time as possible on skis. After years of racing and coaching, he traded in life on the slopes for Southern California's sunny skies and surf culture and pursued a bachelor's degree at the University of California at Santa Barbara. Spencer has guided hiking and cycling trips around the world as a Backroads trip leader and field expert since 2006, during which time he has also earned his MBA in sustainable business systems and pursued entrepreneurial passions around the world, all with the overarching goal of making a positive impact. Backroads offers active adventure tours for travelers of all ages and experience levels in nearly sixty countries around the world and on all seven continents. To learn more about Backroads and their expertly designed itineraries or to book your next adventure, visit backroads.com.

If You Go

▶ **Getting There:** Bergen is a focus city for Scandinavian Airlines (800-221-2350; flysas.com).

▶ **Best time to visit:** Summers have fairy-tale weather, but villainous crowds. Consider traveling in May or September, when most of the hiking trails are snow free, and the crowds are the slimmer side.

▶ **On a Budget:** In some villages, there is only one place to stay, so budget-conscious travelers should check out prices well in advance. Some budget-friendly options include Eplet Hostel in Solvorn (eplet.no) and Jaunsen Gjestgjevarstad in Granvin (+47 90 55 36 79; jaunsen.no). Camping places usually have small cabins available, and bedding can be easily rented (with separate, communal WCs/showers on site).

▶ **Luxe:** Among the fjord villages, some highlights include Solstrand Hotel (+47 56 57 11 00; solstrand.com) in Osøyro, with its stunning spa and pool facilities; The Walaker Hotell (+47 57 68 20 80; walaker.com) in Solvorn, which is one of Norway's oldest and most traditional hotels; and the Kviknes Hotel (+47 57 69 42 00; kviknes.no) in Balestrand, which boasts a solarium, sauna, and dining room with jaw-dropping views.

SPECIALS
Smoked
Salmon
Mousse

Rojo Burger

It comes with the territory

FREE GROWLER FILL!

DESCHUTES BREWERY

Oregon

BEND

RECOMMENDED BY **Holly Goode**

Holly Goode appreciates a good beer. So much so, she contributes to her livelihood by blogging about pilsners, pales, IPAs, porters, and other sundry hopped and malted beverages. Not surprisingly, her travels eventually brought her to Portland, Oregon, which as of this writing, boasts more than eighty craft breweries. "While I was visiting," Holly began, "people said that you've got to visit Bend. There's a lot of interesting beer things going on over there too. The opportunity arose, and I made the trip."

Resting against the eastern slopes of the Cascade Mountains in central Oregon, Bend has a dry, sunny climate where cool mountain breezes meld with the scent of high-desert sage and juniper to create an intoxicating perfume. (It takes its name from a prominent "bend" in the Deschutes River, which flows through the center of town en route to the Columbia.) Once a modest timber town, Bend has evolved into a four-season outdoor playground, with just enough quirkiness that's snuck over the mountains from Portlandia to keep things interesting. Many come here to vacation, and no small amount end up staying (the population has grown from twenty-three thousand people in 1990 to more than one hundred thousand today). For the outdoors-oriented citizen, an argument could be made that one is *always* on vacation when living in Bend.

"Bend is very much a lifestyle community," commented Gary Fish, the founder of Deschutes Brewery, Bend's first brewery, which opened its doors in 1988. "People come to vacation, and a fair amount end up staying. Whatever your context for enjoying Bend—whether your favorite activity is biking, skiing, golfing, or kayaking—you can finish off the day by relaxing with a great craft beer."

For longtime central Oregonians who remember Bend from its timber heyday, its incarnation as a beer mecca must be as mind-boggling as its transformation to an outdoor-

OPPOSITE:
Deschutes Brewery, Bend's oldest brewer, first opened its doors in 1988 and offers great tours.

recreation hub. Bend now boasts nearly thirty brewing concerns within the city limits and surrounding towns. Gary opened Deschutes Brewery in 1988 in the then quiet downtown Bend. The plan was to focus on quality and the brewpub's operation (Gary's background had been in the restaurant industry). Not long after opening, Gary had a call from a distributor in Portland interested in stocking Deschutes beers—at that time, Mirror Pond Pale Ale, Black Butte Porter, and Obsidian Stout. Soon, Deschutes was unable to make enough beer to cater to its brewpub customers. Today, it brews most of its beer at a state-of-the-art facility on the banks of its namesake river, produces more than twenty styles. (Deschutes offers great tours, where visitors can see the full system at work and taste a number of the company's brews.)

"When I visit a new beer destination, I try to reach out ahead of time so I can make plans to meet the brewers and perhaps get a tour," Holly continued. "I was captured by the positive vibe I encountered in Bend, as well as the breweries' aesthetics. I was made to feel very welcome and found the scene very locally grounded and artsy. Everything felt very authentic, mom-and-pop."

From sours to saisons to hop-heavy IPAs, Bend has most beer tastes covered. For Holly, one brewer that particularly stood out was Crux Fermentation Project, an entity that has been willing to push the brewing envelope with rare yeast strains, experimental aging processes, and other nontraditional methodologies since opening its doors in 2012. (On their website, Crux states that "if you can't come in the door and find a beer you like, you may not like beer!") "Crux really stood out," she enthused. "They have a big outdoor space, with lawns and picnic tables looking west toward the Cascades. Dogs are welcome. The inside is big too, and their equipment is beautiful. Their design ethos is clean and crisp, and this extends to their merchandise. An overall aspect of the Bend brewing scene that I appreciated is that almost all the brewers had a nice outdoor space. It's in keeping with the feel of the place."

For the solo traveler hoping to try their hand at a variety of outdoor sports, Bend is an ideal venue. Would-be fly-fishers can choose from a number of rivers and lakes teeming with trout, and an accomplished cast of guides who can help you understand the appeals of the long rod and master your casting and fly presentation. Greater Bend also attracts mountain bikers from far and wide. While seasoned riders can get a map and head off on their own from downtown, several guide services are available to help new riders ease onto the trail without getting in over their head. Just north of Bend, Smith Rock attracts

thousands of rock climbers each year. It's easy to join a beginner's class to liberate the "free solo-er" within you. Whitewater rafting is available on a number of rivers, and ample trails beckon both road bikers and hikers to explore the Cascades.

The easygoing camaraderie of Bend extends from the brewpub to the river to the mountain bike trail . . . and even to the line-dancing bar. "One night, a woman I befriended and I found ourselves at the Cross-Eyed Cricket Watering Hole," Holly shared. "It was a true country bar, with two-step and line dancing. People weren't scared to dance with anyone else—younger guests, older guests, it didn't matter. It was very welcoming. We met people there and hung out. Everywhere we went was like that. We just made friends."

Holly Goode is a digital-marketing freelancer, working for small- to medium-size companies and marketing agencies as an independent contractor. She wears many hats, including copywriting, web design, web management, social media campaigns, graphic design, and more. In a world where marketing is always changing, Holly's knowledge of this field continues to grow, and she can honestly say that's her favorite part. When she's not writing, she an avid beach volleyball player and craft brewing aficionado.

If You Go

▶ **Getting There:** Visitors to Bend can fly into nearby Redmond, Oregon, which is served by several carriers, including Alaska (800-252-7522; alaskaair.com). Portland (a 3.5 hours' drive) is served by most major carriers.

▶ **Best Time to Visit:** Bend is a true four-season resort, though probably busiest in the summer months. You can generally rely on a good deal of sunshine whenever you visit.

▶ **On a Budget:** Bend has several hostel options, including Bunk+Brew (458-202-1090; bunkandbrew.com), which includes an outdoor beer garden and is located near downtown.

▶ **Luxe:** The centrally located Oxford Hotel (541-382-8436; oxfordhotelbend.com) remains Bend's premier boutique hotel. Tetherow (844-431-9701; tetherow.com) is a bit outside of the city and offers award-winning golf and other amenities. Visit Bend (877-245-8484; visitbend.com) provides a comprehensive list of properties in town.

Portugal

LISBON

RECOMMENDED BY **Chantel Loura**

Portugal's capital seamlessly blends a thousand-year-old history with vibrant modernity. With architectural landmarks from over seven historical eras, renowned seafood, a warm climate, and a booming start-up community, Lisbon has emerged as a cultural gem in Western Europe. "The city is a beautiful blend of traditional ideals and new waves of creatives," began Chantel Loura. "The art and music scenes are thriving—there's always some kind of showcase going on, a market, a gallery event, a performance. Traditional fado music and traditional meals are blended with this beautiful acceptance of all the new things coming in. And I feel very safe being who I am here. There are more conservative parts of Portugal, but those are usually the rural villages. Lisbon has a modern outlook. I was nervous to register my marriage with my wife at first when I arrived. But the consulate worker was delighted to see us."

Portuguese locals, sometimes stereotyped by other Europeans as being depressed or cold, in fact, have an amiable attitude toward visitors. "Portuguese people by nature are extremely friendly," reflected Chantel. "There's a stereotype that they are stiff, but in reality, it's just that respect and politeness go a long way here. All you have to do is say hello in Portuguese, and they'll quickly warm up. It's not uncommon to just have someone start talking to you. They'll ask if you speak Portuguese, and even when you say no, they'll keep talking to you anyway and you just figure it out. If you try and eat out alone—you know, have a quiet meal, sit and reflect on your day—that's not happening. The owner of the restaurant will come up to you and pour you a glass of wine and ask you about your day and end up showing you pictures of their family."

One of the best times to visit Lisbon is June when the Santos Populares festival takes over the entire city. Officially celebrating the feast days of Saint Peter, Saint John, and of

OPPOSITE: Sintra Penta's enchanting palaces and fairy tale palazzos are a mere day trip from Lisbon.

DESTINATION 38

course, Saint Anthony—the patron saint of Lisbon—colorful parades take over Avenida de Liberdade, and neighborhood parties erupt across the city. "You'll be walking down a little alley in the old part of the city where everything is quiet. Then you turn a corner and all the sudden, bam—there's a stage and people grilling sardines and grandmothers selling beers out of their front door. People are singing and dancing. It's amazing." Later in the month comes the city's Pride parade. "It is a party!" enthused Chantel. "It's usually held in the middle of June and goes from three in the afternoon to three in the morning. June is definitely the best month to be here; it's the best kind of mayhem."

The ocean, the fishing industry, and the resulting seafood are integral components of Portuguese culture, and for a sample of the best, head to Cervejaria Ramiro. Partake in clams swimming in garlic broth, dip fresh bread into a whole crab shell filled with cream sauce, or grab a mallet and pound out the morning-fresh meat yourself. "Ramiro's is one of those places that's been written about in a lot of magazines . . . it's a place you think you'd want to avoid because everyone knows about it. But everyone knows about it for the right reasons. The food is so fresh and so authentic." To get even more in touch with the water during your dining experience, consider taking a six-minute ferry to Ponto Final, located in Almada, just across the Tagus River. "It's right on the dock, and the tables jut out right onto the water. There's no better place for a romantic meal or to treat yourself."

Day-trip options outside of Lisbon are abundant, and public transport is fantastic. "The buses, trams, and metros can get you just about anywhere in the city, and ride-sharing apps are easy to find," noted Chantel. One destination that should not be missed is Sintra, the summer resort town of bygone Portuguese nobility, now a UNESCO World Heritage site. Picnic in the shade of the iconic red and yellow towers of Palácio Nacional da Pena, or admire the views from the stone-laced terraces of Palácio de Monserrate, which combines Arabian, Indian, and Gothic design elements into one palace.

If you worry about having enough time to explore all Lisbon has to offer—don't. The locals will not sympathize. "One time, right after I had just moved, I was in an Uber and I was talking to my driver, going on about how much I felt I had to do: catch up with my family, learn the language, get all this paperwork done, on and on. And he just stopped me dead and said, '*Querida* [which is a polite way of saying dear], in Portugal there is time for everything.' The Portuguese don't do things in a rush. When you go out to get a coffee, you sit and chat. You enjoy the terrace with your friends. People take lunch breaks that last 2.5 hours. Sundays are reserved for spending time with family. This attitude toward

time is so refreshing, especially if you're coming from the United States, where so much of life is about devoting yourself to your job. There is an emphasis on enjoying the smaller parts of life, and always this sense that there will be enough time for everything."

CHANTEL LOURA is a travel writer and a passionate advocate for travel inclusion, body positivity, and the empowerment of plus-size travelers. Through her blog, *Voyaging Vagabond*, her social media, and her various travel essays, she offers a fresh perspective on plus-size travel while also challenging beauty standards and promoting body acceptance. Chantel's relatable narratives along with her practical advice resonate deeply with her audience, inspiring individuals to break free from societal constraints and embark on life-changing adventures. With her authentic storytelling, vibrant personality, and empowering messages, she is reshaping the travel industry by creating a space where all bodies are celebrated and included. Chantel's work serves as a catalyst for change, encouraging individuals of all sizes to embrace their wanderlust and explore the world without limitations.

If You Go

▶ **Getting There:** Lisbon has one main airport—Humberto Delgado—and is served by more than twenty international carriers.

▶ **Best Time to Visit:** Spring and fall offer fantastic weather without the massive crowds of summer.

▶ **On a Budget:** Price-conscious travelers will be pleased by the number of high-quality budget hotels and hostels in downtown Lisbon, each often having its own theme, from historic and colorful to modern and minimal. Turismo de Lisboa (visitlisboa.com) lists many options.

▶ **Luxe:** Lisbon has become a vacation hot spot for Europe's wealthiest travelers. It shows at locations like Bairro Alto Hotel (+351 21 340 8288; bairroaltohotel.com), built into an eighteenth-century building and decorated with premium, artisanal Portuguese details throughout, or at Verride Palácio de Santa Catarina (+351 21 157 3055; verridesc.pt), where ancient frescos blend with contemporary lines, and a rooftop pool overlooks the ocean.

Puerto Rico

SAN JUAN

RECOMMENDED BY **Lisa Eldridge**

Like most islands in the Caribbean, Puerto Rico's terrain features lush, tropical mountains, and swaying palm trees presiding over white sand beaches. In the capital, San Juan, fiesta-colored, colonial-style apartment blocks climb up hillsides, and in San Juan Antiguo, old-world elegance reigns, with sixteenth-century fortresses and cobblestone streets framed by the azure waters of the Atlantic. Salsa, jazz, and bomba music permeate the air, the fusion soundtrack of the country's Spanish, African, and Taíno heritage. "Puerto Rico has a vibrancy to it," began Lisa Eldridge, "it's like the island itself is alive. Music runs in the DNA of the people. It's warm in every sense of the word. As you step onto the island, it's like you're being enveloped in this hug. I was only intending to stay for two weeks, but I ended up staying for five, just to keep exploring the island."

Puerto Rico's main island is only one hundred miles long, but boasts nineteen state forests and thirty-six nature preserves. Manatees, sea turtles, and dolphins play in the waves, and the forests are home to thirteen native species of bats, as well as a host of rare, colorful birds, such as the Puerto Rican parrot and the Hispaniolan parakeet. "I went to El Yunque National Forest, which is the most well-known nature reserve," reflected Lisa. "It's so different from San Juan: You leave the city and enter this green, lush oasis, with waterfalls and nature trails. I don't have the best sense of direction, but the trails are very well marked, so it's easy to navigate if you are by yourself." Many trails in the park clock in at less than five miles round trip, but don't let that fool you. While the half-mile Caimitillo Trail is ideal for an afternoon picnic in the rainforest, the El Yunque Trail takes you up 1,400 feet through cloud-wreathed palms to the very top of the park—leave the salsa heels at home; this one is muddy.

"There is another part of the island that's difficult to get to unless you have a car, but it's worth it. It's called Ponce," continued Lisa. "It's on the south coast, and it's this haven

OPPOSITE:
Old San Juan is a maze of colorful art, vibrant food, and intoxicating music.

for art and artistic heritage. The Museo de Arte there has permanent collections of incredible Puerto Rican artists, and the Museum of Puerto Rican Music has a historical instrument library you can see. The south side of the island is also a great jumping-off point to visit coffee plantations."

Driving across the island for a sip of premium coffee or a perfectly roasted slice of pork is a must-do activity. The island's most famous "food road trip" is along the so-called "Pork Highway" in Guavate, forty minutes south of San Juan. Here, the road is lined with dozens of *lechoneras*—breezy, patio-style restaurants that spend all day slow-roasting whole pigs and serving them fresh.

Puerto Rico is made up of four major islands: Vieques, Mona, Culebra, and Desecheo, and it is highly worth it to explore them all. "I took the tiniest plane I've ever taken to the smallest island, Culebra—basically flying behind the pilot for ten minutes," remembered Lisa. "They have one of the best beaches in the entire world, called Flamenco Beach. You walk along this tree-lined path, and then the forest opens up on this white, sandy beach that seems to go on forever. It's picture perfect. There's lots of scuba diving there, because the water is so clear, and a place called Dinghy Dock where you can get fresh fish the fishermen bring in that day. You literally watch them pull up in their boats with the day's catch. You can see turtles on Tamarindo Beach, which is such a beautiful experience.

"My favorite island, though," continued Lisa, "was Vieques. It has a different vibe to Culebra. It's a wildlife refuge. They have wild horses roaming around. I mean, you're just walking around, and you'll see horses running. They have also one of the world's best bioluminescent bays, at Mosquito Bay. I went out on a kayak after dark, and was just out in the middle of the bay . . . very tranquil, calm, quiet, with the moon shining down onto the water. Then we took our oars out of the water, and suddenly the algae came to life. Then we gently pushed our paddles through the water, and all the water lit up. You leave a trail of lights as you move."

Of course, no trip to Puerto Rico would be complete without a trip through the famous music and dance clubs of San Juan. "You can just go into a salsa club solo and watch the band, and wait for a guy to ask you to dance," laughed Lisa, "and then you dance! Just tell them you're a beginner, and they can decide if they want to dance with you or not. This only works if you're a woman, obviously. If you're a man, though, and you want a partner, you can just ask anyone. Salsa is one of the top things to do in

Puerto Rico. There are performances constantly in the main square in San Juan, people are always dancing outside, everywhere.

Lisa Imogen Eldridge is a self-confessed solo travel addict; divorced, blonde, and free, and rediscovering her lust for life. As a forty-something unconventional divorcée, Lisa has traveled to 143 countries—111 of these solo. A former travel journalist, Lisa runs the award-winning solo female blog *Girl about the Globe*, empowering women to travel solo and helping vulnerable girls about the globe. She believes that, as travelers, we have a duty to give back to the communities of the countries that we visit, and to empower the lives of the children we meet. *Girl about the Globe* aims to create 100,000 conscious travelers and to impact the lives of 100,000 vulnerable girls about the globe by the year 2025. She believes that every girl should have access to shelter, education, water, love, and protection, and she aims to empower and help those who don't with her nonprofit, the Girl about the Globe Foundation.

If You Go

▶ **Getting There:** San Juan Airport is a focus city for JetBlue (800-538-2583; jetblue.com), as well as a number of smaller Caribbean-based airlines. If you want to explore beyond San Juan, a rental car is highly recommended; public transportation in Puerto Rico is limited.

▶ **Best Time to Visit:** December through April is the best season for calm weather and clear water. At the end of January, the epic Fiesta de los Reyes Magos takes over the island, marking the end of the Christian winter holidays.

▶ **On a Budget:** Some *paradores* (hostels) are more affordable than others. Puerto Rico's tourism board has a full list at discoverpuertorico.com. In San Juan, there are a handful of hostels throughout the city, with Fortaleza Guest House (787-721-7112; hostelworld.com) being the most—if not only—affordable place to stay in the Old Town.

▶ **Luxe:** Glitzy resorts hug the entire shoreline of Puerto Rico; the nicest include the stately Dorado Beach Ritz-Carlton (787-626-1100; ritzcarlton.com) just west of San Juan, or the immaculate contemporary lines of the Condado Vanderbilt (787-721-5500; condadovanderbilt.com) in San Juan's Old Town.

Slovenia

BLED AND BEYOND

RECOMMENDED BY **Vivien Urban**

Are you interested in spectacular Alpine scenery? Beautiful Adriatic beaches? A European crossroads where the schnitzels and lagers of Germany cross-pollinate with the pastas and crisp white wines of Italy? Then you might want to book a ticket to Ljubljana and put Slovenia on your travel list.

"Slovenia is wonderful place for solo travelers," project manager Vivien Urban enthused. "Locals are friendly and welcoming. Most of our clients are surprised that everything is so clean (roads, towns, nature). All are amazed by the spectacular mountains. It is safe to visit local pubs, bars, and restaurants alone, and English is widely spoken. The country also has an efficient public transport system, which makes it easy to travel there. Nearly half of Exodus Adventure Travels' clients who visit Slovenia go as solo travelers."

Slovenia is a republic whose identity—let alone location—may have been little known to North Americans before Melania Trump moved into 1600 Pennsylvania Avenue. The small, mountainous nation is on the Balkan Peninsula, bordered by Austria to the north, Hungary to the northeast, Croatia to the south and southeast, and Italy and the Adriatic Sea to the west. Physically balanced between Eastern and Western Europe, Slovenia strikes a happy blend between the Italian, Austrian, and Slavic cultures that have come to bear upon it. In the north, it has a German/Austrian flavor in terms of food and culture. In the south, close to Italy, it more mirrors Italian customs. (The conflicts and ethnic unrest that have plagued the other republics that once formed Yugoslavia have been absent here.) The diversity of Slovenia's geography is quite impressive given the nation's small size; you can drive west to east in three hours, and north to south in two.

Much of Slovenia is defined by the Julian Alps, an extension of the Central European Alps. Though not quite as high as the Alps to the west (Triglav, the highest peak, has an

OPPOSITE: Lake Zelenci is a fine example of the natural beauty that abounds in Slovenia.

elevation of 9,397 feet), the rugged Julians are tailor made for walking, offering up a smorgasbord of alpine pastures, pine forests, clear streams, and long ridgelines offering up expansive vistas. Much of the Julians are contained in Triglav National Park, Slovenia's only national park. At 340 square miles, the park comprises 3 percent of the young nation's total landmass, and is home to chamois, ibex, red deer—and occasionally, brown bears and lynx. Triglav is also home to some fifty-two mountain huts, making it ideal for a trekking holiday. "Many of our clients who visit Slovenia will do walking trips," Vivien continued. "It's not an end-to-end hike, but a week with five different day hikes with a guide who has great local knowledge. These are very popular with solos who want to join a group of like-minded people for a more social experience."

Given Slovenia's modest size, it's quite possible to experience all it has to offer in the course of a week—or even a day! (Hiking in the Julian Alps after breakfast, sipping world-class wine at a local cellar over lunch, and relaxing by the Adriatic for dinner.) But a few days in Ljubljana, Radovljica, and Bled are a great beginning. "Ljubljana is a very picturesque place, and it has the reputation of being a romantic city," Vivien described. It's a leafy place, a tangle of cobbled streets, terracotta rooftops, and cafés scattered along the eponymous river that flows through the center of town. (Visitors have the option of cruising the river for a different perspective of the city.) Ljubljana is one of Europe's smallest capital cities (with fewer than three hundred thousand people), but the presence of more than fifty thousand university students conveys a constant sense of energy.

Radovljica and Bled are just a short ride north of Ljubljana, and offer a glimpse of a more rural Slovenia, with the Julian Alps providing a rugged backdrop. Parts of the Old Town of Radovljica are preserved to reflect their medieval roots; at least one building dates back to the sixteenth century. Linhart Square, the focal point of the Old Town, boasts a number of museums, galleries, and restaurants; there's even a defensive moat that dates to around 1500 CE. A number of fine eateries await you, including the Hiša Linhart Hotel and Restaurant, Restaurant Avguštin, Vinoteka Sodček, and Baffi House of Pizza.

Beyond Melania and Mount Triglav, Bled and its namesake lake may be Slovenia's best-known symbols. Bled is consistently ranked as one of Alpine Europe's most picturesque villages; earliest settlement dates back to the seventh century CE. Anyone who visits Bled is likely to visit Bled Island, and the Church of the Mother of God that was first dedicated in 745, replacing an ancient Slavic temple (and later renovated to its single-nave, gothic style in 1465, with further enhancements coming in the seventeenth century).

The church boasts a famous staircase of ninety-nine stone steps; anyone who wishes to exchange their wedding vows here is expected to carry their bride or groom up all ninety-nine steps. Many who visit will also ring the wishing bell.

Vivien Urban is a travel professional with more than fifteen years' experience in the travel industry. She joined Exodus Adventure Travels in 2011, where she works as a product manager looking after destinations in Eastern Europe. Vivien has traveled extensively in Europe and all over the world. Adventure travel has become a lifestyle to her; she enjoys learning about different cultures and believes that traveling opens the mind and is the best way to learn about the world around us and the history that shaped it.

If You Go

▶ **Getting There:** Visitors to Slovenia generally fly into the capital city of Ljubljana, which is served by many airlines, including Air France (800-237-2747; airfrance.com) and Lufthansa (800-645-3880; lufthansa.com).

▶ **Best Time to Visit:** The most popular time to visit is July through mid-October; later-season visitors will see lighter crowds.

▶ **On a Budget:** Ljubljana offers many hostels, which are highlighted at Ljubljana Tourism (visitljubljana.com). Bled also is home to many hostels and guesthouses, highlighted at Turizem Bled (bled.si).

▶ **Luxe:** Ljubljana boasts several five-star hotels, including InterContinental Ljubljana (+386 0 59 128 000; ihg.com/intercontinental/hotels) and Zlata Ladjica Boutique Hotel (+386 1 421 11 11; zlataladjica.com). Several luxury hotels hug the shore of Lake Bled, including Adora Luxury Hotel (+386 51 603 858; adorabled.com) and Grand Hotel Toplice (+386 4 579 16 00; sava-hotels-resorts.com).

Spain

THE CAMINO DE SANTIAGO

RECOMMENDED BY **Sherry Ott**

The Camino de Santiago, also known as the Way of Saint James, is a network of walking trails that cross the body of Spain. They were paved not by park rangers, but by the feet of thousands of medieval pilgrims. According to legends, in the ninth century, the Catholic hermit Pelayo saw a shower of stars in the hills outside his home in Libredón. Upon investigation, Pelayo discovered the remains of the apostle James. Dubbed a miracle by the church, the site began to draw in monks, priests, and devotees across the Catholic world, all walking the same handful of paths to see the sacred tomb and having their pilgrimage certified with a scallop shell–shape badge known as a *Compostela* (field of stars). Today, the Camino de Santiago beckons all seekers of divine adventure, passing through quaint villages, rustic farms, medieval inns, open plains, and ancient churches.

There are many routes that lead to Santiago de Compostela (the Camino's official terminus), but the most popular is the Camino Francés—a five-hundred-mile path beginning at the Basque village of Saint-Jean-Pied-de-Port. "I would describe it as a long-distance walk," reflected Sherry Ott. "You're often walking on dirt farm roads, going over rolling hills that alternate between farms and cities. There's one section where you do more traditional hiking in the mountains, but for the most part, it's fairly flat. Because of this, it's not too difficult to walk fifteen or even twenty miles per day. It's the distance, rather than the technical aspects of hiking, that make it challenging."

For many, the pilgrimage of the Camino de Santiago is often seen as a metaphor for life's journey, allowing individuals to connect with their inner selves, the divine, and nature. "I began my walk in April," remembered Sherry, "and spring was unfolding in front of me. When I started, everything was still, and fallow. By my fifth week, everything was blooming. I have never been outside every day, watching a season transform the earth like that."

OPPOSITE: *The ancient footpaths of the Camino de Santiago are a profound way to explore the Spanish countryside.*

The trail also crosses some of the most magnificent parts of the Spanish countryside, including famed wine and food regions of the Basque Country. Local delicacies such as Ossau-Iraty cheese, *jambon de Bayonne*, and foie gras are frequently on the menus at hiker rest stops. Farther west and down into the warmth of the valley, La Rioja country offers famous garnacha wine blends, fresh olives, Manchego cheese, and piquillo peppers.

"Most places you stay along the Camino serve something called a 'pilgrim meal,'" explained Sherry. You get salad, soup, or pasta; meat or fish; then dessert. And a whole bottle of wine."

In keeping with many European thru-hikes, most walkers of the Camino prefer to forego a tent in favor of staying at local inns, known as *albergues*. "The villages are about five to ten kilometers apart," noted Sherry. "The *albergues* are a cross between a dorm and a hostel. You could be sharing a room with four people, or thirty. It's probably the cheapest way to see this part of Europe. If you want to upgrade, you can stay in a pension where you have a private bathroom. And on the very high end, there are *posadas*, which are historical buildings that have been refurbished into upscale lodgings. The nice thing, however, is that you don't usually need reservations for any of these. You make a plan every day and think, 'I'm gonna aim to get this far today,' but it doesn't matter where you actually end up. You will have no problem finding a room. This was a very cool exercise for me in not having a plan."

Perhaps one of the most notable and unexpected takeaways that a pilgrim of the Camino de Santiago experiences is community, braided with long periods of reflective solitude. "It probably took me a week to embrace the quiet," remembered Sherry. "I downloaded all these podcasts and all this music, but there was only one day where I put on headphones. I found that I actually loved being in the now and having the time and the space to think. But, importantly, you'll never be alone on the Camino if you don't want to be. The Camino is a river. The people are twigs. Sometimes you swirl together, and sometimes you swirl away and fall in with another group, and then you swirl away again and someone from before catches up with you again. I was walking across Spain, but because there were so many people there, from all over the world, I ended up feeling like I was a in a small version of the globe."

Regardless of if you are traversing the path for spiritual reasons, an inner peace tends to settle on all pilgrims who decide to embark on the Camino for any significant length. "When you're on this trail every day and all you are focusing on is walking, eating, and

sleeping, things suddenly get quiet," concluded Sherry. "The experience allows you to listen to what life is telling you, what your mind and body are telling you. When I finished, I felt like I had direction again, and an appreciation for things that were normal in our everyday lives. It's like a good cleansing."

SHERRY OTT is a pioneer in the world of new media, writing about her travel lifestyle and around-the-world adventures on ottsworld.com since 2006. In her eleven years of living nomadically, she's circled the globe multiple times, visiting all seven continents and providing continuous blog coverage. She primarily writes about outdoor adventure travel for women, with the goal of inspiring and teaching women how to get outdoors and travel. She is an avid hiker, completing many thru-hikes and pilgrimages around the world. She is also currently biking from capital to capital in the United States, finishing a project her father started by foot in 1984. Named as an "Influencer to Follow" on OprahMag.com, she continues to seek out epic adventures in intriguing places, inspiring people to overcome their fears and reap the benefits of travel.

If You Go

▶ **Getting There:** If you chose the Camino Francés, beginning at Saint-Jean-Pied-de-Port, the best airports would be Charles de Gaulle or Barcelona, served by numerous international carriers. From the airport, a bus or train can take you to your starting point.
▶ **Best Time to Visit:** Most people opt to walk in the summer, but spring and fall offer fewer crowds and relatively mild weather.
▶ **On a Budget:** Dorm rooms in *albergues* are the most affordable option and are located all along the Camino. Walk-ups are the norm, and most do not require reservations.
▶ **Luxe:** The Camino is a pilgrim's journey, so upscale accommodations are rare. However, the route goes through many towns and cities with splendid hotels. The Palacio de Burgos (+34 947 47 99 00; nh-hotels.com) offers alabaster luxury in a restored sixteenth-century monastery. In Santiago, the Parador de Santiago de Compostela (+34 981 58 22 00; paradores.es/es/parador-de-santiago-de-compostela) is an ancient resting spot for travelers of the Camino where original medieval trappings are paired with modern, exquisite service.

Taiwan

TAIPEI

RECOMMENDED BY **Cody Harris**

"The first time I went to Taiwan, I had no idea what to expect," Cody Harris recalled. "But within forty-five minutes, my mind was blown. It's a great place to do Chinese language immersion: The locals are very supportive and encouraging. Some people might ask why not do language immersion in China . . . the truth is, I don't feel comfortable living in an authoritarian country. Taiwan's history is far from perfect, but their democracy is both younger and less corrupted than a lot of other places, and it shows."

Officially called the Republic of China, Taiwan is a melting pot of Indigenous Pacific Islanders, Japanese colonists, Iberian sailors, Qing nobility, Dutch traders, and an almost nonstop flow of students, refugees, and dreamers from seemingly every part of the globe.

"The main island of Taiwan straddles the Tropic of Cancer, but some parts feel less 'island-like' than others," described Cody. "It's covered in mountains and forests, and the tropical beaches in the south are iconic, with warm water and white sand. Then on the flipside, you have cities like Taipei: a massive, dense, 24-hour city, which makes you forget you're on an island at all. Taipei is cleaner than New York, but less regimented than Tokyo."

Thousands of visitors fly in each year to participate in the dreamy Pingxi Sky Lantern Festival, the extravagant parades of Chinese New Year, and the operas and sacrifices of the Ghost Festival. "There are so many different enterprises present in Taipei," reflected Cody. "You have board game stores and music shops, restaurants, gardens and green spaces, financial institutions and manufacturing buildings, all packed together. And I can't emphasize enough the variety of different things you can do in Taipei: There's yoga studios, dance classes, glassblowing lessons, music clubs. One in particular that I loved is called Sappho Live—they have really good jazz and blues jam sessions on Tuesdays and Thursdays with no cover. There's also a ton of cat cafés. And by that I mean, actual cat

OPPOSITE:
Sky-high gondolas are part of Taipei's public transportation system, ferrying passengers to the tranquil teahouses of Maokong.

DESTINATION 42

cafés, but also just about every café you walk into has a cat on staff. Taipei also has some traditional nightlife clubs, but just about everything else also stays open late."

At the city's famous MAJI Square, cargo containers and wooden barns have been transformed into a gleaming modern market of international food shops, creative art pieces, and music stages. "MAJI Square is full of foreigners," Cody admitted, "but there's a good reason everyone goes there. It's so nice. If there's ever a big sports event going on, like the World Cup, they play it on a big projector so everyone can watch and cheer together."

"I felt welcome as a foreigner in Taipei," continued Cody. "I mean, I don't want to pretend it doesn't matter where you are from. If you're from a wealthy country, there will be positive bias working for you." He added that people with mobility challenges should be prepared for stairs, as "a lot of the older buildings don't have elevators, and you may have to duck your head a lot on low ceilings. But newer public infrastructure like high-speed rail and MRT are all accessible."

At a minimum, one thing you can be sure will be fun is the food. Taipei is a mecca for foodies, from the night-market stands listed in the Michelin Guides, to the haute cuisine temples inventing the next fusion craze. "There is every type of food you can imagine," reflected Cody. "Many restaurants are run by foreigners who come to Taipei to show their craft. Swiss bakers come here to open Swiss pastry shops. Japanese masters come and open ramen shops. But there's also a lot of fusion going on, these genius chefs taking their home cuisine and spinning off of it with everything else going on around them. Lots of food fads pop up, and everyone is trying to find and chase the next hot thing. Bubble tea, for example, started in Taipei and became a global phenomenon." Some favorites include Bravo Café, a hole-in-the-wall coffee shop that roasts their own beans on-site (a common feature of Taiwanese cafés) and specializes in raised-dough waffles. Run by deaf owners, guests order by marking up a menu with a grease pencil. Another favorite is Rebirth. "If there were a coffee-shop equivalent to a dive bar, this would be it," enthused Cody. "The menu is updated daily in chalk on a wall in the back and smudged to the point of illegibility for even native speakers—and they frequently run out of things, so you really need staff to tell you what's for sale. It's kind of dirty, but has ridiculously tasty food and huge portions. It's open until three A.M. and is often filled with brilliant people from nearby NTU, Taiwan's top university.

"I think one of my favorite memories," concluded Cody, "is riding the gondola from the Taipei Zoo. This is a twenty- to twenty-five-minute ride above the forest, that is also

just part of the public transit system. It takes you high up into the mountains to the Maokong tea plantations (an area that is, randomly, also full of cats). So, you get on a car in this huge, bustling city, and then five minutes later, you're hanging in silence from a cable in the air, hundreds of feet above jungle-covered mountains. You can hear all the birds and the animals below you, and the wind, and that's all. That's Taiwan. You can be inside an urban core, and then five minutes later, floating above the wilderness."

CODY HARRIS is a software engineer, frequently traveling the world to attend various conferences. Based in Seattle, he regularly volunteers with the Connections Museum, repairing antique telephone switches and giving tours to the public. At Seattle Community Network, he installs 4G LTE base stations, troubleshoots problems, and teaches educational seminars, among other things. He is an amateur Chinese speaker, internet-history enthusiast, and an advocate for democratic systems and transparent technological infrastructure the world over.

If You Go

▶ **Getting There:** Taipei is served by Taoyuan International Airport, a hub for China Airlines (800-227-5118; china-airlines.com) and EVA Air (800-695-1188; evaair.com), among others.
▶ **Best Time to Visit:** The weather is warm in spring and fall, damp and gray in the winter (but not too chilly), and scorching hot in the summer, with showers popping up regularly to keep the forests green. Many popular festivals are held in spring, when the flowers are blooming, or the fall, when the leaves change colors.
▶ **On a Budget:** Taipei has several extremely affordable hostels scattered throughout the city.
▶ **Luxe:** Many luxury hotel brands are represented in Taipei, such as the Mandarin Oriental (+886 2 2715 6888; mandarinoriental.com) and W Taipei (+886 2 7703 8888; marriott.com). Most feature clean, modern lines and top-floor skyscraper views.

Tennessee

NASHVILLE

RECOMMENDED BY **Colleen Creamer**

"I moved to Nashville in 1998," began Colleen Creamer. "It was a culture shock because the entire previous decade I'd spent in Los Angeles—which is three times bigger than Nashville. The first night here, I remember watching the news and being floored that their feature story was about how to get a racoon out of your attic. But once I figured out how easy it would be for a lone woman to put down roots, I did just that. It quickly felt like home."

Nashville is America's Music City, a hub of Southern hospitality, mouthwatering cuisine, and twanging guitars. Tourists pay homage at career-launching country music temples, sip rare whiskey in refined quarters, and stroll luxuriant public gardens. "Nashville's general politeness transfers particularly well to lone travelers," described Colleen. "People will pull over and help you with a flat tire long before triple A arrives, and if you rent an Airbnb in a residential area, the owner has to live on the premises, so you're not at the mercy of some person who's just trying to make some money on a spare room. You can easily brave the fever dream that is downtown on any given Saturday night—have a beer at Tootsie's, our oldest bar—and feel safe while entirely alone. You will get jostled, but this, more often, seems to be the start of new friendships. Honky Tonk Tuesday at the American Legion Post 82 in East Nashville is a popular, no-frills place where anyone can show up and learn how to do the two-step. The music—old-school country, rockabilly, or bluegrass—is always good. Nashville's cultural landscape is rapidly changing, but at its heart it's still a friendly place that welcomes newcomers. That is in Nashville's DNA."

For a taste of the Nashville music scene, the hippest place in town is Lower Broadway—a wall-to-wall corridor of Victorian brick buildings painted in neon light, set to an unapologetic honky-tonk soundtrack. Up-and-coming artists perform in multifloor venues, and revelers stare down from rooftop bars. "Country music is still

OPPOSITE: Nashville's neon lights and booming bars have given rise to countless American music legends.

king in Nashville," continued Colleen. "But we have a growing jazz scene, specifically at Rudy's Jazz Room in the Gulch and at the Jazz Cave in the Buchanan Arts District. We certainly have the best original singer/songwriters in the country, and there are dozens of open-mic nights and writer's nights to wander into throughout the week, nearly all without a cover or drink minimum."

For music historians, no trip to Nashville would be complete without a pilgrimage to Ryman Auditorium. This is "the Mother Church of Country Music" and home of the *Grand Ole Opry*, the show that sparked the careers of hundreds of country stars. "The acoustics are great, and the amphitheater layout means you always have a great view of the stage," described Colleen. "They generally have outstanding shows and tours that walk you through the old church's past." For more music history, head to the freshly minted National Museum of African American Music and watch how country, bluegrass, gospel, R & B, and hip-hop have collided in the American South to create some of the world's most toe-tapping, heart-wrenching music.

Nashville has enough delights to keep anyone entertained for weeks, but day trips out beyond the official border allow for a broader experience of this unique part of the American South. "The quaint town of Franklin, about an hour south of Nashville, is where the Civil War's Battle of Franklin was fought in 1864," noted Colleen. "But my favorite day trip is going to Leiper's Fork, thirty miles south of Nashville, to shop and eat. Leiper's Fork is also right at the beginning of one of the best of the All-American Roads, the Natchez Trace Parkway: 444 miles of roadway without traffic lights or signs. Tupelo, which is halfway down and about three hours away from Nashville, is one head-clearing drive, and you get to see where Elvis was born."

Foodies will delight in Nashville's exploding gastronomic scene. Traditionally famous for generous plates of hot chicken, sautéed greens, and warm biscuits, today, posh brasseries rub shoulders with ancient and beloved dives, and you'll be hard pressed to find a bad meal at either. "Hattie B's stands out for hot chicken because the sides are great, and you can order at the level of heat," advised Colleen. "For an unmatched dive-bar experience, I go to Dee's Country Cocktail Lounge in the Madison neighborhood. The clientele is varied and interesting, the margaritas are fresh, and the music is live. For something a little fancier, Henrietta Red in Germantown is respected for their inventive seafood, but they also have an outstanding raw bar.

"When I first moved here," concluded Colleen, "I was taking a walk around my new

neighborhood, and I found a beautiful open field of newly cut grass. I decided to lie down and watch the clouds go by for a while—something I would never have done in Los Angeles. Within five minutes, two elderly women came over to make sure I was horizontal by choice. Apparently, one had called the other one, and they thought I may have just fainted, or worse, and were concerned enough to come out and check on me. We were all amused. It was a very Southern thing to do."

COLLEEN CREAMER is a freelance writer and reporter living in Nashville, Tennessee. She has been a regular contributor to the fine arts publication *Black & White*, the *New York Times* travel section, and the national rural-issues magazine *Out Here*. She has also written for Salon.com and Vanderbilt's science magazine, *Lens*. A former features writer and editor for dailies in middle Tennessee, Colleen's fiction and poetry have appeared in the *Painted Bride Quarterly*, *Kaliope*, the *Sun Magazine*, and the *Nashville Scene*. Interests include travel, dogs, yoga, mindfulness, and anything Scandinavian. While not on deadline, she spends most of her time with her two look-alike mixed terriers, Happy and Maddie. She is an alumnus of the University of Florida.

If You Go

▶ **Getting There:** Nashville International Airport is served by several carriers, especially Southwest (800-435-9792; southwest.com).
▶ **Best Time to Visit:** Nashville has something for every season: spring flowers, summer festivals, autumn colors, and wonderful winter Christmas decorations.
▶ **On a Budget:** Most budget hotels are clustered near the airport, east of downtown Nashville. Hostels are oddly hard to find in the city. Vacation rentals have dominated much of the market and are available on Airbnb.com
▶ **Luxe:** Nashville has a large number of premium hotels on offer, most clustered downtown. Some fun highlights include the unapologetically country Urban Cowboy (347-840-0525; urbancowboy.com), with its copper-lined clawfoot tubs and reclaimed-wood walls, or the famous Hermitage Hotel (615-244-3121; thehermitagehotel.com), situated in a historic Beaux Arts building with stained-glass ceilings and marble columns.

Thailand

PAI

RECOMMENDED BY Jacklynn Botwe

A tiny, unassuming village in Thailand's northern mountains, Pai has begun to earn a strange reputation among the international travel community. No giant skyscrapers, epic museums, or avant garde restaurants are here. Instead, the undefinable allure of Pai lies in its authentic simplicity. "You're effectively in the middle of nowhere," began Jacklynn Botwe. "It's very green and rural, surrounded by terraced rice fields and jungle. It isn't so much what you do in Pai . . . it's the vibe of simply being there. There's a level of spirituality that's just immediately accessible—you don't have to be a yogi or a Buddhist to feel it."

Although it sees a healthy stream of visitors, Pai is not a tourist town in the typical sense. Most of the homes are owned by local families with children, and the expats are trying not to change the scene. "It doesn't feel overrun by tourists," reflected Jacklynn. "Pai has a unique culture. For example, every bar has a live singer. When I was there, I met a guy who was traveling with his violin, and I watched him up walk right up to a band at the bar and ask if he could jam with them. They said yes, and then they played together all night. That kind of thing happens all the time in Pai. There's no planning in this place, it's very spontaneous, very subject to free will, and yet also moves at a very slow place. People arrive with no expectations, and I think that's part of why it blows people away."

Despite the appearance of being a sleepy mountain town, Pai's streets are hardly empty. Art markets, food stands, and craft jewelry and clothing stores commonly grace the main streets, "and it's not cheap imports they're selling," noted Jacklynn. "It's all locally crafted."

"In November," Jacklynn continued, "Thailand has the Yi Peng festival, to mark the end of the monsoon season. I was in Pai when it happened, and everyone began to light up these lanterns and send bowls with candles floating down the river. It was like a scene out

OPPOSITE: *When visiting Pai, visitors risk falling into the so-called Pai Hole: being too overjoyed to ever leave.*

of a movie, but I was there; it was real. In a way, that's all of Pai. It's whimsical, dreamy . . . you're almost in a bit of haze the entire time you're there. It's the one place—in the entire world—where I walked home from a night out in complete darkness and I did not feel any sense of danger. I actually had two street dogs basically escort me back to my hostel. Locals smile at you, ask if you're doing OK. And you kind of stop caring about what's going on in the rest of the world. I was in there when the queen died, and the British pound was plummeting. Someone came into the hostel and announced all this to a room full of Brits, and we just all went, 'Huh?' Nobody cared. It was like we were on another planet."

If simply being in Pai is not enough to make you feel unplugged from the concerns of the rest of the world, the town also makes an excellent base for exploring the green majesty of the Thai mountains. "You have to figure out a lot of things on your own, there's not a lot of organized tours. This is a word-of-mouth place," explained Jacklynn. "You really have to talk to people. But on the other hand, there's so much you can do without planning, so many things you can just walk up to."

Although most of the best places are discovered via word of mouth, some of the popular secrets are already out: Wander through walls of sandstone-colored cliffs at Pai Canyon, or escape the jungle air in the teal waters under Pam Bok Waterfall. Take a walk up to Wat Phra That Mae Yen (also referred to as "the Big White Buddha") and watch the horizon melt into the fire of sunset. Visitors can also stop at Santichon Village, inhabited only by a group of Yunnan Chinese who immigrated to Pai hundreds of years ago. Martial artists can partake in numerous Muay Thai classes in Pai's main village, for which the town has a growing reputation. Or simply while the day away on a "tipsy tubing" excursion, floating downriver on an inner tube next to a net of your favorite drinks. "The river is sometimes very fast," reflected Jacklynn. "I don't know if tipsy tubing was the smartest thing I've ever done. But I can't pretend it wasn't fun.

"There's also lots of underground volcanic activity around Pai," Jacklynn explained. "Sometimes you are simply driving out to holes in the road that are literally bubbling and boiling, with a piece of string around them to prevent people from falling in. We went to one, and there was a woman there in a hut selling sticks and eggs. You buy an egg, and cook it over the spring.

"It's best to come here with no expectations," concluded Jacklynn. "They just don't work well in this place. Buses don't leave on time. Pickups don't happen on time. You have to allow yourself to be malleable and spontaneous. There's a saying here: 'I've fallen

into a Pai hole,' and it means you've fallen in love with Pai and can't leave. Pai was actually my first travel romance—I had met this Belgian man in Bangkok, we spoke a bit and then parted ways. And then I met him again in Pai, completely unplanned, and we spent the next four to five days together in this whimsical travel romance on the back of his bike. And then we parted again, and we've never seen each other since. That's the kind of thing that happens in Pai."

JACKLYNN BOTWE has been been traveling the world with a backpack since August 2022. She was born in Ghana in 1997, moved to the UK a few years later, and grew up between London and Luton. Her passion for travel wasn't spurred into action until quite a bit later in life. She went to university to study fashion design and did that for a few years before doing a complete 180 and joining the police. Her two years there was an eye-opener, and she realized that, toward the end of her life, she wanted to be able to recount awesome adventures and mildly perilous journeys. So, she quit her job, sold everything, and took a one-way flight to Bangkok. She shares her travels with the world through social media, on TikTok at @lifelikejacki and on Instagram at @ladyjackie.i.

If You Go

▶ **Getting There:** Most people fly into Chiang Mai, served by China Airlines (800-227-5118; china-airlines.com), and then hop a large, public bus for the two-hour ride to Pai.

▶ **Best Time to Visit:** Come in November for the Yi Peng festival; good weather tends to last from then until February.

▶ **Accommodations:** Pai offers a handful of shockingly affordable upscale lodgings like Reverie Siam (+66 53 699 870; reveriesiam.com), with its vintage hipster décor, or the Oia Pai Resort (+66 89 939 3574; facebook.com/TheOiaPai), whose spacious rooms are built right on the edge of a saltwater lake. But the town really specializes in affordable backpacker hostels. Nolo hub (+66 91 698 0638; nolohub.com) is known for its chill vibes and daily excursions, Mad Monkey (+66 65 587 3222; madmonkeyhostels.com/pai) for its social scene and late night parties. Reservations are not usually needed.

Tuvalu

FUNAFUTI

RECOMMENDED BY **Thor Pedersen**

"I visited Tuvalu during my attempt to visit every country in the world without flying," began Thor Pedersen. "This is a destination for more adventurous people, not people who want to go to an all-inclusive resort. I was essentially stranded there for two months, because the ferry boats between Tuvalu and Fiji were broken down, which happens more often than you'd think. The result is that I'm passionate about Tuvalu. I really like the people, and I don't like what's coming their way."

For many globe-trotters, Tuvalu is a coveted destination due to its profound inaccessibility. When viewed from the air, Funafuti (the country's capital and main atoll) resembles a golden, god-sized bracelet, half-sunk into the lapis lazuli blue of the South Pacific. And sinking it is. Tuvalu's reef islands and atolls have no mountains; the highest point in the entire country is fifteen feet above sea level. As ocean waters rise, climate change experts expect Tuvalu to vanish completely underwater within fifty to a hundred years. This makes it a compelling destination, simply because not many people can say they have been there—and soon, we will not be able to go at all.

"There are pros and cons to traveling to Tuvalu," reflected Thor. "There are nine main islands in the nation, but the only one with an airstrip is Funafuti. People live on all nine islands, though, relying on supply ships and ferries for just about everything. Jobs and education are limited by the geography. The ferries are rough, and they often break down because it takes a long time to get spare parts. The economy is reliant on a big network of international aid. And the people know it; there are no illusions about any of this, to anyone living there. But it's also their home."

Based on its location, it might seem that the main draw to Tuvalu would be its beaches. But in fact, this is not the highlight for many who come. Most visitors land in Fongafale

OPPOSITE:
Thor Pedersen
snaps a candid
photo with
a new friend on
a pristine beach
in Tuvalu,
which may not
be around for
many more years.

(the largest of the islets making up Funafuti), but then make the unfortunate mistake of remaining there. Although the water is warm, brilliantly blue, and full of colorful fish, sandy beaches are not common. A trip around the rest of Funafuti, however, reveals picture-postcard beauty. The Funafuti Conservation Area, on the western side of the atoll, is a haven for dolphins, manta rays, green turtles, and countless species of rare birds. Snorkeling and diving in these rarified waters is a once-in-a-lifetime experience.

Beyond Funafuti, Tuvalu's smaller, less inhabited islands offer even deeper isolation. "Every island has its own fingerprint, its own little stories," explained Thor. "Over hundreds of years, they all developed slightly differently. Niulakita has twenty-five people living on it. That's it. But getting there can be dangerous. It's too small to have a port, so a small boat comes and takes you off the ferry to the island, and then you hope that you're lucky and a swell doesn't roll that little boat over and run you into coral. But if you do get there, the beaches truly look like you're the first person to have ever stepped on them."

Perhaps the most precious thing about Tuvalu, however, is its people. "The community here is just incomparable," reflected Thor. "I saw nothing else like it on the planet. I also think Tuvaluans spend less time on their phones than any other people I've met. It's incredible to see how people get together, in church, at celebrations, and especially sports." The favorite game is *te ano*, which is played by both men and women, young and old, involving two teams and two balls. "I'm not sure I ever did figure out the rules," confessed Thor. "But the losing team all sits down, and the winning team does a *fatele* dance, in a little bit of a gloat. There is so much laughter.

"Because it's so small, everyone on the island kind of knows everyone else," continued Thor. "And they love visitors. If you come here, you will be invited to everything. When someone comes, especially someone who isn't part of an NGO, they are so surprised, so excited. People will call at you across the street because they've heard about you. They'll say, 'Did you come all the way out here to see my island?'"

To get an authentic taste of Tuvaluan culture, your best bet is to head to the tarmac—the same one that supports the thrice-weekly flights from Fiji. "It's 1,400 meters long, with no lighting," described Thor. "Three times a week, a plane lands, and it's like an alien invasion. Then it leaves, and everything goes back to tranquil peace. So, for the most part, this runway is empty. It is *the* central gathering place. People go for walks. They play volleyball and cricket, or *te ano*. They'll even sleep there, because you get a breeze you might not get at home. Young people will go there for a date—because it's so dark, you can be a little secre-

tive. Or someone might go there for some alone time, just to get away from their house. Easily four hundred people every evening will gather there out on that tarmac.

"To give you an idea of the culture: I stayed at a guesthouse called Filamona, run by a woman named Penny," concluded Thor. "She let me borrow her motorbike to get to the ferry, and when I asked how she would get it back, she said, 'Just give the keys to one of the workers at the dock, he'll bring it back.' That's Tuvalu. They are the most special people I have met on earth, and it's heartbreaking if the world were ever to lose that. If you go to Tuvalu, you get to come home with stories that no one else has. You get to go to a place that might not be around when you die. You're seeing the end of an era."

THOR PEDERSEN is the only person in history to have reached every country in the world completely without flying. He grew up between North America and Denmark, where he finished school and military service before finding his feet within shipping and logistics in the private sector. At the end of 2009, he became an independent businessman, and after years of working on other peoples' projects, decided to create his own: *Once Upon a Saga*. Thanks to the help of friends, it was initially planned to take just four years; however, it ended up taking nearly a decade due to unforeseen challenges such as visa issues, political unrest, and the COVID-19 pandemic. On May 23, 2023, Thor Pedersen reached the final country, Maldives, completing the project and claiming a place in world history. In 2013, he was made goodwill ambassador of the Danish Red Cross and has as of today visited and brought attention to the movement in more than 185 countries.

If You Go

▶ **Getting There:** Flights to Tuvalu depart from Hawaii, Fiji, or Australia, via Fiji Airways (800-227-4446; fijiwairways.com). There is also ferry service between Fiji and Tuvalu that runs every few months.

▶ **Best Time to Visit:** Tuvalu is generally warm all year, with a rainy season from November to April, and a dry season from May to October.

▶ **Accommodations:** Filamona Lodge is conveniently located next to the airport. The handful of other guesthouses in Tuvalu can be found at timelesstuvalu.com.

THE OUTDOORS IS FOR EVERYONE

Utah

MOAB

RECOMMENDED BY **Parker McMullen Bushman**

In his classic book *Desert Solitaire*, memoirist Edward Abbey described Moab as "the most beautiful place on earth." A wonderland of ruddy, titanic rock shapes that seem to be melting upward out of the earth, Moab is famous for inspiring a solitary reconnection with nature; a place to savor the stark beauty of the desert and what it causes us to reflect upon. But this was not always its reputation. A true Wild West frontier outpost, in 1891 it was noted to be the toughest town in Utah, with the vast network of surrounding canyons making the perfect cover for passing outlaws. Today, those same canyons have transformed from bandit hideaways into protected wilderness parks, and the town itself has become a base camp for exploring the solar-flare parabolas and geologic chaos of nearby Arches and Canyonlands National Parks. More importantly—the people are much more friendly.

"When I'm traveling alone, I like to go to places that have been vetted," began Parker McMullen Bushman. "I don't like to go to uncharted space by myself. As a Black, femme, plus-size traveler, I like to see if there are reviews and stories I can hear about a particular place ahead of time. My career is in environmental education, which has given me a chance to work in very remote spots across the country. That helped me and my business partner, Crystal Egli, form the Inclusive Guide, an online review platform where people can rate how they felt treated in a particular place, whether they're a white woman in a wheelchair or a Black man with tattoos, and so on. As far as my own identity, Moab was well vetted, and I'd always wanted to go because of photographs I'd seen. I initially went with my family on vacation, then I returned for work, and then just me. I just kept getting pulled back. The whole area around Moab is such an amazing ecosystem, with stunning natural scenery and incredibly unique geology. It's a desert region, surrounded by mesas

OPPOSITE: Parker McMullen Bushman prepares to take on Moab's otherwordly monuments.

and towering rock formations. You can hike, mountain bike, rock climb, river raft, or even just drive the scenic byway, and you'll have an incredible time."

For many visitors, Moab's main draw is its proximity to Arches National Park, with its sky-high crescents that seem to be made of liquid rather than solid rock. "But Arches is not the only thing there," continued Parker. "The whole area is whiz-bam amazing, a kind of moonscape. Canyonlands is superb, and has arches that are really beautiful and also a little easier to see. There's also Dead Horse Point State Park, which has tons of trails along the Colorado River that are absolutely gorgeous." Highlights include the overland views on Dead Horse Rim Loop Trail and the descents down deep into the canyons themselves at Grandstaff Canyon Wilderness Study Area.

Within Arches National Park, be sure not to miss the petroglyphs at Courthouse Wash Panel Trail, or the gravity-defying Balanced Rock Viewpoint and Trail. "I hiked Delicate Arch, which is a three-mile hike," described Parker. "And I thought three miles? This is gonna be so easy! But it's actually rated moderate to difficult, and somehow I missed that. I went off by myself a couple hours before dark, and you start off going straight uphill. I'm immediately thinking, 'This arch better be amazing,' and then the trail levels off, but you still don't actually see what you're aiming for during the hike. I kept looking around like, 'Where is this dang arch?' I'm asking everybody and nobody really gives me a straight answer. I hear twenty minutes, forty minutes, a half a mile, a mile. And I was really pushing myself. There's a part of the trail that isn't a trail at all, it just goes straight up a side of slanted rock and it's a false summit . . . so I'm really starting to lose faith, but everyone along the way just told me, 'Keep going. It's worth it!' And then you turn the very last corner, and it's there. This huge, epic, amazing structure. There's a bowl at the base, people are sitting in it, awestruck, staring up at the arch. You're just this little teeny person in this little geological wonder. It was one of the hardest hikes I had done at the time, and the reward was so amazing at the end. I was really glad I brought my poles, especially coming down. There's a faith element involved, you have to stick to it and you have to believe and trust what the strangers are telling you. And it's so worth it."

If hiking is not your bag, consider a forty-four-mile scenic drive on U-128. Also known as River Road, the highway is surrounded by panoramic views of red-rock formations and painted canyon walls. "A drive is sometimes nice because you can take your time and enjoy your landscape; you don't have to worry about someone else's schedule," reflected Parker. "The scenic highway is definitely worth driving down."

The town of Moab itself offers its own unique charms, with craft boutiques, excellent restaurants, and rich history displays. In particular, the Moab Giants Dinosaur Park and Museum is a fun stop for armchair paleontologists, and the Moab Museum offers natural history and cultural exhibits on the first inhabitants of the Moab Valley. After a day of sight-seeing around town, consider a stop at Gilberto's Mexican Taco Shop. "I love a *sope*, and they have amazing ones," noted Parker. The Moab Food Truck Park also beckons, with a colorful, rotating galley of local fare.

"Every time I've gone, there's been people at the hotel or campground who have been really friendly. I love to tell people to go to Moab," concluded Parker. "It should be on your bucket list."

PARKER MCMULLEN BUSHMAN is the chief operating officer and cofounder of Inclusive Journeys, a tech company with a mission to create data-driven economic incentives for businesses to be more inclusive and welcoming to people who typically face discrimination. She is also the founder of Ecoinclusive Strategies, which provides training and resources for nonprofit, cultural, and environmental organizations. Her background in the nonprofit leadership, conservation, environmental education, and outdoor recreation fields spans over twenty-four years, and she has a passion for equity and inclusion in outdoor spaces. For nine years, Parker has worked with businesses to catalyze action to build culturally diverse and culturally competent organizations that are representative of the populations they seek to reach and serve. Parker has served as the vice president for community engagement, education, and inclusion at Butterfly Pavilion, an invertebrate zoo located in Westminster, Colorado, as well as the director of education for the Marine Science Consortium, a research and education center located on Virginia's Eastern Shore. Parker has a master of natural resources from the University of Wisconsin–Stevens Point, with a focus in interpretation and environmental education.

If You Go

▶ **Getting There:** The closest international airport hub, with the most options, is Salt Lake City. However, this is still a four-hour drive away. Closer airports, albeit with fewer options, are Canyonlands Field Airport, serviced by SkyWest, and Grand Junction Airport, serviced by American, United, and Allegiant.

▶ **Best Time to Visit:** Although summer temperatures can reach well over 100 degrees, it is still a popular time to visit. Consider a spring or fall trip to avoid crowds and triple-digit temperatures.

▶ **On a Budget:** Camping in nearby Canyonlands National Park or Arches National Park are popular (and competitive) choices. There are several other campgrounds on BLM, state park, and national forest lands, where it may be easier to find a spot. A nice overview can be found at Discover Moab (discovermoab.com).

▶ **Luxe:** Vacation condos and "adventure hotels" abound in Moab, but there are few luxurious resorts. The most well known is Sorrel (435-259-4642; sorrelriver.com), a 240-acre ranch offering a holistic wellness vibe, along with quiet suites overlooking the Colorado River.

Utah

ZION NATIONAL PARK

RECOMMENDED BY **Michelle Liu**

"I first went to Zion as a result of recommendations from friends. I had seen the posts on Instagram and I thought, 'This place looks incredible!'" began Michelle Liu, "so I planned a road trip through Arizona and Utah, stopping at Cathedral Rock, Antelope Canyon, Bryce Canyon, Arches National Park, and Canyonlands National Park. The whole experience really exceeded expectations. And with Zion, the first word that really comes to mind is 'majestic.'"

Zion National Park was originally called Mukuntuweap by the Paiute First Nations people, meaning "straight canyon." Its borders are home to raging rivers; sun-charred rocks; the alien, water-smoothed walls of slot canyons; and the airy sounds of pine and juniper trees whistling in the desert breeze. The landscape has inspired countless works of art and bouts of spiritual fervor—in fact, the name "Zion" was bestowed upon the land by Mormon settler Isaac Behunin in 1863, remarking of the landscape that "a man can worship God among these great cathedrals as well as he can in any man-made church; this is Zion."

"I remember the moment I first drove in," reflected Michelle. "I was inside this long, dark tunnel, and then suddenly the entire world opened up into this vast view of huge rocky mountains, enveloped in a beautiful reddish-orange hue. It's not a huge national park, but everywhere you look is amazing."

Zion is smaller than California's Yosemite or Alberta's Banff. There is a central area that offers a few grocery stores and simple restaurants, but that's about it in terms of amenities. Like most national parks, permits can be scarce and crowds can be thick in the summer, but "if you go in the off-season, you can drive your own car, and then explore at your own pace," explained Michelle. "I'm a people pleaser, and when I'm with friends or

UTAH

my boyfriend, I'm always mindful of what other people want to do. But when I'm traveling alone, it's relieving for me, because I am able to focus on what I want to do. Zion is an ideal destination for a solo person. You can take the hikes at your own speed, stop, and take the pictures you want. You might have a better chance getting a permit. But also, it's popular, so there are enough people around that you're not in extreme danger. You're able to experience peace with nature, but you're not remote."

Zion's interior lends itself to epic rock climbing, backpacking over ninety miles of trails, canyoneering through cathedral-height slot canyons, whitewater paddling, and horseback riding. The most famous day hike in the park, Angels Landing, earns its name well, sweeping hikers up the sides of the main valley and vaulting them to the top of a rock tower. "The initial sections of Angels Landing were more paved than I had expected," remembered Michelle. "I'm used to rocks and twigs and dirt, and this was totally different. You keep going up the steep incline, holding on to the chains at the top, passing people as best you can. I didn't realize how high we were until, near the top, we saw three California condors, at eye level. They were flying and resting on the ledges next to us. I was raised in the suburbs and I didn't experience a ton of wildlife growing up, so this was really special to me. It feels like you are on top of the world."

Other popular day trips include the Narrows, a slot-canyon hike in the Virgin River that meanders through water-smoothed sandstone walls sometimes reaching more than 1,500 feet in height. "At Angels Landing, you're at the tippity top of the canyon, and in the Narrows, you're at the very bottom, looking up at these huge rock formations. Be sure you time your desired entry time, though. You can't go to the Narrows at all times of the year due to the dangers of flash floods, so double-check before you go that the water levels are manageable. It can be a very popular area, with particularly large crowds at the beginning of the hike. But I ended up renting a full set of canyoning gear with waterproof shoes and neoprene socks. The shoes and walking sticks really helped me keep my balance. The water gets higher, so if you don't have the gear, you probably aren't going that far in. But if you do, the crowds thin out and the quiet is serene. It's just you and the walls, and the sun comes in to hit the rock formations, making these hues of glowing color. I felt like I was practically swimming at some points. It was completely surreal.

"This was truly an ideal trip where nothing really went wrong," concluded Michelle. "I went in November and everything was just . . . perfect. The thing about Zion is that as you go, almost wherever you go, you're being rewarded with these incredible views. It's not

OPPOSITE: *A solo hiker traverses the awe-inspiring streams of Zion's Narrows.*

one of these places where you hike all day, trudging uphill waiting for a reward. The reward is all around you. I felt like there was no rush, I could go as little or as far as I wanted. Here, the journey really is the destination."

MICHELLE LIU is an adventurer in her late twenties who loves exploring new places, both solo and with family and friends. She found her love of travel when she studied abroad in Vienna during her junior year of college and was able to explore different areas of Europe. This is also when Chinventures was born. Michelle loves making others smile through her platform and bonding with others around the world. It's a joy for her to share this community and passion for building new experiences. In her daily life, she is based out of Massachusetts and works at a travel-focused company. She spends her free time catching up with others, cooking, playing pickleball and tennis, plus hiking and skiing. She's always looking for her next destination, and taking "chinfies" along the way, at @chinventures.

If You Go

▶ **Getting There:** The closest airport to Zion is Saint George Regional Airport, from which you can rent a car. For a car-free option, fly into Las Vegas' Harry Reid Airport and book a shuttle to Zion's doorstep. There is free shuttle service within the park.

▶ **Best Time to Visit:** Fall is considered the best time, as it avoids the crowds of summer, and the Narrows water is at manageable levels. The trail is closed in winter and spring.

▶ **On a Budget:** Campgrounds in the park can be reserved ahead of time at nps.gov/zion. There are also BLM lands surrounding the park, where you can disperse camp for free. A variety of budget hotels line the road leading into Zion's west entrance as well.

▶ **Luxe:** LaFave (435-632-3667; lafavezion.com) is the Zion area's only five-star resort, offering spacious villas and grand suites to guests who want to splurge. Magnificent, amenity-laden canvas tents are available for rent at Under Canvas (888-496-1148; undercanvas.com/camps/zion) for those who want to enjoy glamping. The only hotel within the actual park is Zion Lodge (435-772-7700; zionlodge.com), offering rustic but comfortable hotel rooms and cabins.

Vietnam

HANOI TO HO CHI MINH CITY
RECOMMENDED BY **Kelly Reid**

"Vietnam is a melting pot of rich culture, stunning landscapes, and natural wonders, and a food lover's paradise," enthused Kelly Reid. "The people are warm and welcoming, and the history (both ancient and recent) makes this a truly memorable destination to visit. It's an incredibly diverse destination, perfect for those seeking a real adventure! It also must be noted that it is a very affordable tourist destination that is suitable for all kinds of budgets. It's a wonderful destination for those traveling solo as it's an exceptionally safe destination and has a low crime rate; it's considered one of the safest places in the world to travel, especially for solo female adventurers. Whilst tourism is still developing in certain lesser-visited areas, there is an established tourist infrastructure for travelers covering most of the main highlights of the country. The Vietnamese have an openness and a friendliness that's welcoming to all visitors. It is always helpful if you try to learn a few Vietnamese words; even just 'hello' and 'thank you' will go a long way. A fun way to interact with the locals is to use Google Translate and other language apps. And always remember to smile."

Many American visitors will note that, while there are still remnants of the war here and there in the countryside, there's not a sense of heaviness about it. "From my experience, learning about the recent history and Vietnam War was one of the most memorable and sobering experiences I've had anywhere throughout my travels," Kelly continued. "The Vietnamese tour leaders are always very keen to educate and share their personal experiences with our clients. Of course, it remains a delicate subject, but the Vietnamese are kind, patient, welcoming, and open to sharing their history with all travelers, of all nationalities (including Americans), which to me is one of the main reasons why I consider it such a rewarding and special destination to travel to."

Roughly the size of New Mexico, Vietnam boasts an incredibly varied topography. Kelly broke down the unique qualities of each region. "The north is known for its lush mountainous and hillside landscapes—the Sa Pa region with its rice terraces is especially scenic—and of course, the iconic Hạ Long Bay with its limestone peaks and pillars set among the sea. The mountainous regions in the north are home to many ethnic hill tribes that all have their own cultural traditions and languages. Generally, people from the north of Vietnam are considered more conservative than the south. The central region is also known for its mountainous landscapes, but equally for its beautiful coastline and beaches. The people here have deep pride in their culture. The lowlands of the south are defined by the famous Mekong Delta region, known as the 'rice bowl' of Vietnam, consisting of rivers, rice cultivation, and other farming. People from the south are considered quite laid-back and progressive."

Trying to see and make sense of the complexities of Vietnam over the course of a ten-day trip may seem daunting, but Kelly feels it's not too far a grasp. "If I were to set off on a tour within this kind of time frame, I'd start my journey in the north, in the capital of Hanoi. The capital, with its French colonial architecture, is a perfect introduction to the culture and cuisine and a great place for travelers to get their bearings. It holds a special place in my heart. One of the most special travel experiences I encountered in Vietnam was when I first visited Hanoi (right off the plane, with a good dose of jet lag). I spent a wonderful first evening strolling around the magical Hoàn Kiếm Lake, first observing the locals living their life (socializing, playing games, dancing), and before I knew it, I was invited to sit and enjoy a drink and picnic with a young family who were eager to practice their English. It was a lovely first encounter full of laughs and smiles, and it really gave me such a wonderful first impression of the Vietnamese.

"Next, I'd recommend that you head out of the capital and take the four-hour journey by road to spend a night on board a traditional junk boat in Hạ Long Bay," Kelly said. "Cruising and spending a night on board a boat is the best way to experience and witness the magnificent limestone peaks along the bay. This is one of Southeast Asia's most iconic landscapes that cannot be missed. From Hạ Long, I'd suggest heading back to Hanoi to start your journey down south (and travel like the locals) by catching the Reunification Express (an overnight train), stopping in the ancient capital of Huế (located in central Vietnam) for a night if time permits.

"From Huế, visit Hội An, the historic and utterly charming old trading town that boasts a UNESCO-listed ancient town. It is then recommended to take a flight down

OPPOSITE:
The Golden Bridge, a pedestrian bridge in the mountains near Danang

south to Ho Chi Minh City (or Saigon) a true contrast to the capital, Hanoi. From here, you may opt to also visit the Mekong Delta region for a night and perhaps stay with a family in a homestay before taking a day or so to explore Ho Chi Minh City, where the itinerary would end."

Wherever you are in Vietnam, the cuisine is likely to exceed even the most exalted expectations. Kelly highlighted a few experiences that she always recommends:

- Bún Chả: A famous delicacy from Hanoi that comprises of rice vermicelli noodles, grilled pork, and an abundance of herbs.
- Egg Coffee in Hanoi: Vietnam is the second-largest coffee producer in the world, and the locals of Hanoi are serious about their coffee. Their specialty in Hanoi is known as "egg coffee": a strong, dark coffee mixed with sweetened condensed milk and whipped egg yolks.
- Pho: You can't visit Vietnam without trying this globally known dish. This steaming bowl of noodle soup is the national staple served up and down the country.
- Mì Quảng: Hailing from central Vietnam, this dish is made up of noodles, peanuts, rice crackers, pork, and broth and is served on special occasions.

"I'd also recommend that while visiting Hội An, you should experience a Vietnamese cooking class where travelers can visit the market, choose the ingredients, and learn to cook a selection of dishes under the careful instruction of a local chef! And of course, the best part is you get to enjoy the food afterwards."

KELLY REID has nearly twenty years' experience in the travel industry. She began as a tour leader traipsing through Europe, later moving to behind the scenes, working in various operational and product roles within the industry. She joined Exodus Adventure Travels in 2014 and has been the product manager for Vietnam and other destinations in Asia since 2018, having lived London, Berlin, and now in her hometown, Melbourne, Australia. A self-confessed foodie, tasting the local cuisine when she travels is always a real highlight for her—especially in Vietnam. When not traveling or working, she stays active in her local swimming pool, by trying out a new restaurants, or by spending time gardening.

If You Go

▶ **Getting There:** The trip described here begins in Hanoi, Vietnam, which is served by many carriers, including American Airlines (800-433-7300; aa.com) and Cathay Pacific (800-233-2742; cathaypacific.com). It ends in Ho Chi Minh City, which is served by many carriers, including Air France (800-237-2747; airfrance.us), and Cathay Pacific.

▶ **Best Time to Visit:** Spring and summer are very hot and humid; late fall and winter are cooler and drier.

▶ **On a Budget:** Vietnam Backpacker Hostels (vietnambackpackerhostels.com) lists low-cost properties in Hanoi and Huế. Hostelworld (hostelworld.com) lists many options in Ho Chi Minh City (Saigon) and Hội An.

▶ **Luxe:** Exodus Adventure Travels (+0203 131 5081; exodus.co.uk) offers a number of all-inclusive Vietnam tours with experienced guides, including the ten-day itinerary described here.

Washington

OLYMPIC NATIONAL PARK

RECOMMENDED BY **Emily Pennington**

The Pacific Northwest is famous for its dark evergreen forests, moody beaches, and perpetually dewy atmosphere. Few regions display the quintessence of this unique bioregion more than Olympic National Park. "It puts a lot of genres of national parks on display, all into one place," began Emily Pennington. "I like to joke that it's a great park for people with short attention spans. It has huge tracts of old-growth temperate rainforests, and also beautiful high alpine zones. You can hike up to a glacier, and then drive to the coast and watch the driftwood at the beach. In 2020, I decided to set off in Gizmo (my minivan) and go to every national park. By the time I made it to Olympic National Park, I was coming out of a hard breakup. Olympic National Park was a codifying moment in my journey because it gave me the solace I needed, when I needed it most. So much of the magic that people romanticize and deify when they think broadly about reconnecting with nature is actually here."

The one million acres that make up Olympic are mostly protected wilderness, teeming with deer, elk, bald eagles, mountain goats, and black bears. On a map, the park appears to take up almost the entire western side of Washington state: a giant heart of forest, with veins of roads heading into the center from all directions. It is impossible to see the entire park in a day, but with at least three to five days, you can pick and choose where to focus your efforts. "The Hoh Rainforest was the first place I went," reflected Emily. "It is one of the greenest places in the country, if not the world. It gets more than twelve feet of rainfall every year, more than any other place in the Lower 48. I hiked the Hall of Mosses trail, which is quite touristy, but also a perfect forest bath. If you want a similar landscape with fewer people, though, the Hoh River Trail leads from the same parking lot, goes for about seventeen miles, and connects to the high peaks of the interior

OPPOSITE:
Olympic National Park has a landscape for every mood, including forests of dark moss and comforting evergreens.

of the park. Either way, you get that maximalist, lush, moss-everywhere sensation that the forest is holding you, and you are safe."

The green splendor of the Enchanted Valley, the hot springs and waterfalls of Sol Duc, and the verdant Quinault Rainforest (which often sees fewer crowds than the Hoh) beckon those seeking to plug into the great green heart of the wilderness. "You can absolutely backpack all over the park. People create these huge, interconnected loops through different regions. But also, you can just day hike through the trails. They are maintained very well by the Park Service."

Down and west from these temperate rainforests, the Washington ocean crashes its hellos. Rugged sea stacks, tide pools teeming with anemones, and long stretches of driftwood-strewn beach can be found, along with the occasional sea otter and snuggling harbor seal families. At Shi Shi Beach, frigid Pacific waters rarely warm above 53 degrees, but surfers in thick wet suits can be found taking on the waves. Other surf spots can be found just outside the park boundary at First Beach on the nearby Quileute Indian Reservation and Hobuck Beach at the Makah Indian Reservation. Late spring and autumn mark whale migration season, with ample chances to catch once-in-a-lifetime sightings of orcas, humpbacks, and gray whales. "I got a tide chart and went out to Rialto Beach to hike up to Hole-in-the-Wall, a very popular photo spot," reflected Emily. "Ruby Beach is another good choice if you want fewer crowds. I like the beaches in Olympic because they challenge this sunny, SoCal, beach-babe vibe I grew up with. Here, it's very dark. There's driftwood and storms."

Finally, drive back inland for an hour, break through the mossy forests, and you can find yourself several thousand feet above sea level in the park's alpine regions. Hurricane Ridge sits in the high mountain zone, offering snow-play parks in the winter, wildflower-strewn meadows in the summer, and breathtaking views of the Olympic Mountains range at any time of year (when it's not raining). "From Hurricane Ridge, I hiked the three miles to Hurricane Hill," reflected Emily. "It's a paved trail, and the slope is gentle. If you want to go up a thing and feel like you hit a real summit without too much effort, this is your hike."

The park offers fourteen developed campgrounds, most of which are first come, first serve (although a few take advanced summer reservations). For those looking for more plush accommodations, the park offers sumptuous lodges. "I stayed a night at the Lake Quinalt Lodge, and the sunsets were absolutely incredible," enthused Emily. "Most

national parks only have one official lodge, but Olympic actually has five, which is just another indicator of how accessible certain aspects of this park are. It's the perfect mix of vastly different trails, lodging options, and environments . . . it's very much a choose-your-own-adventure park.

"I think that there's something kind of ancient and magical about how peaceful so many of us feel in the thick forest," concluded Emily. "I was going through such a difficult time when I was there. And I just felt held. Even on the easy hikes, you will feel this. You don't have to go hard. All those little city noises are gone, and you fall asleep inside the sound-dampening space of all that lushness and plant life. Nature is one of the few things that is big enough and raw enough to hold our most extreme human emotions. You can be at one of the lowest points of your life and be in a landscape that can mirror that internal intensity. You feel really validated."

EMILY PENNINGTON is a columnist and longtime contributor to *Outside* magazine. Her work has appeared in the *New York Times*, the *Guardian*, the *Wall Street Journal*, *Condé Nast Traveler*, *Lonely Planet*, CNN, *Adventure Journal*, REI, and *Backpacker* magazine, among others. She has visited every national park in the United States, and her book, *Feral: Losing Myself and Finding My Way in America's National Parks*, came out in 2023.

If You Go

▶ **Getting There:** The nearest airport is Seattle–Tacoma, a hub for Alaska (800-252-7522; alaskaair.com). From there, private tours can be booked, or a car rented. The park itself has no public transportation, and distances between attractions are far.

▶ **Best Time to Visit:** Summer has the best weather by a large margin, but also the biggest crowds. Spring and fall showcase more days of quintessentially misty Pacific Northwest weather, and fewer crowds all around.

▶ **Accommodations:** Campground and lodge information can be found at nps.gov/olym, along with backcountry camping permit information. Olympic's four historic lodges offer cabins and comfortable hotel rooms, but the nicest is probably Lake Crescent Lodge (888-896-3818; olympicnationalparks.com).

Washington

THE PACIFIC CREST TRAIL

RECOMMENDED BY **Jac "Top Shelf" Mitchell**

Hiking is a classically solo activity. And there are few hikes in the world that can rival the length and wonder of the Pacific Crest National Scenic Trail (known to many simply as "the PCT"). The trail traverses 2,650 miles of protected backcountry, laid out along the mountain spine of the American West. "The PCT is magnetizing," Top Shelf Mitchell began. "It's like there's a morphic field around it. It has taken on a personality and an energy all its own. So many people have been touched by it—and some of them haven't even been on it. They've just read stories, or talked to someone who has been affected by it. Every time I step on the PCT, even if I'm just day hiking eight miles, it feels like I'm stepping into a portal, into Narnia."

The northern terminus of the PCT rests at the border of Canada and Washington, making the Evergreen State the light at the end of a green tunnel for hikers walking the trail south to north. "Washington is most people's favorite section of the PCT," explained Top Shelf. "In California, the Sierra Nevadas are widely known for their grandeur and their granite peaks. But the North Cascades in Washington are more under the radar. They don't get as much publicity. So, people get up here and they're pleasantly shocked at what they're seeing."

The northern section of the Cascades averages slightly lower peak heights than the Sierra Nevadas, reducing concerns for altitude sickness while still delivering a quintessential West Coast mountain experience. Summer visitors can expect vivid green forests, fragrant meadows bursting with wildflowers, and cobalt blue lakes nestled in the bowls of glacier-carved granite peaks. In the fall, larches drape the normally green subalpine regions in gold, and regular showers leave behind constant dewdrops, casting the entire scene in prismatic light.

OPPOSITE:
The Pacific Crest Trail traverses three states, but some say the best views are found in Washington.

Many people venture onto the PCT to test themselves, to reconnect with the quiet parts of their souls, or to start a new chapter of their lives. To complete any significant section of the trail requires deep psychological work, thoughtful preparation, and impressive physical stamina. However, despite the personal nature of the quest, the thing that many PCT hikers reflect on the most is how supported they feel while upon it, from other hikers, hiker supply stops in small towns, and trail angels (generous souls who take it upon themselves to furnish hikers with free shelter, rides, food, or supplies). "The PCT for solo travelers, as an outdoor experience, is great because the trail is well funded and well maintained by a huge network of volunteers," described Top Shelf. "It's known well in the communities that it travels through, and there's a lot of community support. Washington has the fewest stops along the PCT compared to California and Oregon—there's only six in the whole state—so this is the part of the PCT where you are likely to be alone the longest. But when you do get to a town, you are welcomed so warmly. There's this tiny convenience store just off the PCT in Washington called Montezuma Market, and they have geared their entire business to hikers. This store is literally the size of a bedroom, and yet they stock specialized ultralight hiking gear. This stuff isn't cheap, right? And they don't mark it up. So, for the owners to have purchased it, on what appears to be a limited budget, and sell it at MSRP, is actually quite generous. And this kind of attitude is common. A lot of the people you meet along the PCT just offer you things: food, a ride, whatever you need. There are even hiker boxes where people take and give things, like a free library. Nobody expects anything in return."

Many hikers begin the trail with warnings about the dangers of submitting themselves to the whims of nature for such an extended period. However, as time goes on, many hikers find these warnings to be unfounded. "I had a transcendental experience one time when I saw a sow, an adult female bear, literally sprinting through a field of huckleberries above the tree line with her cub running behind her. I was watching this bear literally teach her baby how to frolic, basically how to live her best life at eight thousand feet above sea level. It wasn't my first encounter with a bear, but it's what comes to mind whenever I'm asked if I've seen a bear. We're told bears are terrifying and have malicious intent. But then on the PCT you get to see this real version of something you've been told is a monster. It makes you wonder who the real monsters are.

"You can't help but become a little spiritual," Top Shelf concluded. "It's so beautiful that sometimes you feel like you're in a hologram. You realize you're witnessing the

beauty that is in nature that you know you came from. If you need evidence that there is a higher power, it is here. And then there's the generosity you experience. People who walk the PCT who have not remotely broached these topics in their heads before will start asking themselves questions like, 'What is this I'm feeling? How and why are people so willing to help me?' Hikers and hitchhikers are a really clear example of a way to satisfy the human need to give to others freely, directly, without expecting anything in return, and to see their gratitude immediately. You discover that when people are given this opportunity to be generous, they rise to the occasion. They desire it. And we're choosing to put ourselves in this position as hikers. You often question your worth when you're on the trail, but the trail says maybe you are worthy simply because you exist. I have developed an inordinate amount of faith in my fellow Americans and humanity in general after walking the PCT."

JAC "TOP SHELF" MITCHELL has hiked more than eleven thousand miles on fourteen different North American trails since 2014. She has been featured in *Outdoor Life* as a thought leader on thru-hiking, and frequently tests and reviews ultralight gear. Top Shelf lives nomadically across the Western United States and Canada.

If You Go

▶ **Getting There:** The Washington section of the PCT officially begins at the Bridge of the Gods at the border of Oregon, but you can also do shorter routes, and even day hikes, through various trailheads throughout the state.
▶ **Best Time to Visit:** Most of the trail is open by mid-July (just be sure to bring your bug spray). August through October often see the largest crowds, as hikers who started at the southern terminus are reaching the end of their journey.
▶ **Accommodations:** Backcountry campsites are usually available on the PCT without reservations. The Pacific Crest Trail Association offers excellent advice, maps, and permit information at pcta.org.

Library of Congress Control Number: 2024931510

ISBN: 978-1-4197-7363-1
eISBN: 979-8-88707-282-1

Text copyright © 2023 Chris Santella and DC Helmuth

Photo credits: Page(s): 2,22: Ashlyn George, The Lost Girl's Guide; 8: Anna Sullivan/Unsplash; 10: Kate McCulley; 16: Anna Christen; 18: Uncruise Adventures; 30: Erwin Widmer/Shutterstock; 34: John Lazenby/Alamy; 38: Filip Hudcovic/Unsplash; 43: Leyre/Unsplash; 46: Jessica Nabongo; 54: Kyle Thacker/Unsplash; 58: Alina McLeod; 62: Jon Bilous/Alamy; 67: Sabrina Middleton; 70: Keith Levit/Alamy; 74: Alexander Kunze/Unsplash; 78: seligaa/Shutterstock; 90: Jeff Appleyard; 96: Sean Pavone/Shutterstock; 100: Tânia Mousinho/Unsplash; 104: Amanda Williams; 108: Anna Church/Unsplash; 112: Rolf Svedjeholm; 116: Erik Eastman/Unsplash; 120, 216: Diana Helmuth; 128: @girlvsglobe; 132: Sydney Angove/Unsplash; 136: Roman Lopez/Unsplash; 144: Drian Schott; 150: Dani Heinrich; 154: Nicole Snell; 159: Stepahnie Klepacki/Unsplash; 163: Denoît Deschasaux/Unsplash; 166: Wolfgang Kaehler/Alamy; 170: Maria Ku/Shutterstock; 174: Ramiro Collazo/Unsplash; 178: Littleaom/Shutterstock; 182: @ottsworld; 186: Taweepat/Shutterstock; 191: mana5280/Unsplash; 194: Jacklynn Botwe; 198: Torbjørn C. Pedersen; 202: Parker McMullen Bushman; 208: Photo Volcano/Shutterstock; 212: Ling Tang/Unsplash; 220: Rebecca Ross

Cover © 2024 Abrams

Published in 2024 by Abrams Image, an imprint of ABRAMS. All rights reserved. No portion of this book may be reproduced, stored in a retrieval system, or transmitted in any form or by any means, mechanical, electronic, photocopying, recording, or otherwise, without written permission from the publisher.

Editor: Juliet Dore
Designer: Anna Christian
Design Manager: Danny Maloney
Managing Editor: Annalea Manalili
Production Manager: Hayley Earnest

This book was composed in Interstate, Scala, and Village.

Printed and bound in Malaysia
10 9 8 7 6 5 4 3 2 1

Abrams Image books are available at special discounts when purchased in quantity for premiums and promotions as well as fundraising or educational use. Special editions can also be created to specification. For details, contact specialsales@abramsbooks.com or the address below.

Abrams Image® is a registered trademark of Harry N. Abrams, Inc.

ABRAMS The Art of Books
195 Broadway, New York, NY 10007
abramsbooks.com